MODIGLIANI

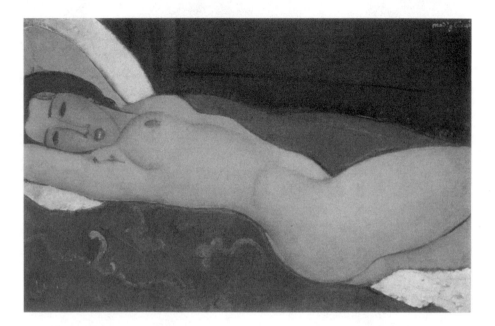

Reclining Nude, 1918

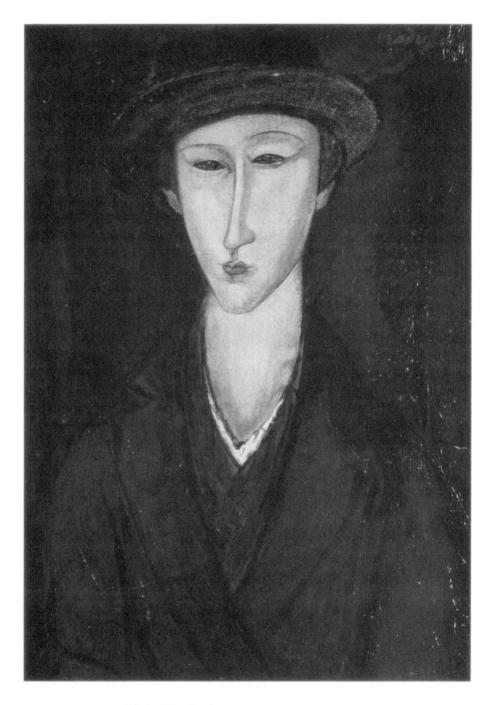

Marevna, 1919, published for the first time

JUNE ROSE

MODIGLIANI

The Pure Bohemian

St. Martin's Press
New York

For Otto and Renata

MODIGLIANI: THE PURE BOHEMIAN. Copyright © 1990 by June Rose. All
rights reserved. Printed in the United States of America. No part of this
book may be used or reproduced in any manner whatsoever without written
permission except in the case of brief quotations embodied in critical
articles or reviews. For information, address St. Martin's Press,
175 Fifth Avenue, New York, N.Y. 10010.

Library of Congress Cataloging-in-Publication Data

Rose, June.
 Modigliani, the pure bohemian / June Rose.
 p. cm.
 ISBN 0-312-06416-0
 1. Modigliani, Amedeo, 1884-1920. 2. Painters—Italy—Biography.
 I. Title.
 ND623.M67R59 1991
 709′.2—dc20 91-21769
 [B] CIP

First published in Great Britain by Constable and Company Limited.

First U.S. Edition: November 1991
10 9 8 7 6 5 4 3 2 1

'Your real duty is to save your dream'

By the same author

The Perfect Gentleman
A Biography of Dr. James Miranda Barry (1977)

Elizabeth Fry (1980)

For the Sake of the Children
A History of Barnardo's (1987)

Contents

Illustrations

All works reproduced in the text are catalogued in the Legal Archives of Amedeo Modigliani, Livorno and Paris, unless stated otherwise. All the photographs from the Legal Archives were taken by Franzin-Coupreau, I.A.V., Orléans.
All measurements given below are in centimetres.

Acknowledgements

So many people, friends, colleagues and Modigliani experts gave me so much generous help and encouragement with this book that it is a particular pleasure to be able to thank them publicly. First of all I must record my gratitude to the Modigliani family for their generous help in the early stages of my research: to the artist's daughter, Jeanne; his brother Umberto and his wife Ida and his aunt, Laure Garsin. They all responded readily to my questions and Jeanne and Umberto lent me family documents. I am also indebted to those many friends and acquaintances of Modigliani who shared their memories with me: Paul Alexandre, Constantin Brancusi, Blaise Cendrars, Jean Cocteau, M. Chwat, Silvano Fillipelli, Madame Gris, Henri Hayden, Léon Indenbaum, Paulette Jourdain, Pinchas Kremegne, Misha Kikoine, Alberto Lorenzi, Chana Orloff, Anders Osterlind, Gino Romiti, Sir Osbert Sitwell, Leopold Survage, Ossip Zadkine and Anna (Hanka) Zborowska. M. Apollonio of the Biennale, Venice, Ambrogio Ceroni of the Galerie de Milione, Milan, Giovanni Schweiller and Professor Lionel Venturi all guided my steps.

More recently, particular thanks to Giorgio and Guido Guastalla, the directors of the Legal Archives of Modigliani, Livorno and Paris and to Christian Parisot, their archivist in Paris, for their generosity, patience, help, encouragement and loan of many photographs. Dr Vera Durbe, Curator of the Giovanni Fattori Civic Museum, Livorno was most kind in her gift of photographs and to her too I am grateful, and to all the Museums and Art galleries who granted permission for reproduction of their works.

In Livorno, M. Belforte, Sam Sendak and M. Azempiere all helped me to retrace Modigliani's footsteps.

Sincere thanks to Giorgio Cortenova, Curator of the Gallery of Modern Art in Verona and his helpful assistant, Jennifer Karch Verzé for their generous help. To the staffs of the British Library, the London Library, the libraries of the Tate Gallery and of the Victoria and Albert Museum, the Westminster Central Reference Library and the Bibliotheque Nationale, Paris, my thanks

for their patience and courtesy. I would also like to thank Professor Giorgio Colombo of the Italian Cultural Institute and the staff of the French Cultural Attaché for their help. I am indebted to Shirley A. Martin, Head of Special Collections at the University of Saskatchewan, Canada, for permission to quote the letter from Max Jacob.

Many personal friends reached out to help me. Mona Gordon of Stockholm translated passages of Thora Dardel's autobiography and interviewed Countess Dardel Hamilton on my behalf. Renata Koenigsberger translated from the German, and she and her husband Otto were immensely helpful and encouraging at every stage. Madelena Golby translated from the Portuguese; Ruth Taylor advised on the translation of Blaise Cendrars' poem; Miryana Harding read the manuscript and offered valuable suggestions and Christine Casley was always ready to lend an expert ear. I owe them all an enormous debt of gratitude.

From the beginning, my agent, Mark Hamilton encouraged me generously by his great interest, which I much appreciate. Special thanks to my publisher, Ben Glazebrook for his wise counsel.

Finally I would like to thank Gabrielle Morrison who typed the manuscript with meticulous care and offered helpful suggestions. Everyone involved entered with such striking enthusiasm into the project that it buoyed me up throughout my long search.

Foreword

AMEDEO MODIGLIANI wrote few letters and dated less. He disliked documentation and was always losing his passport and his identity papers. During his lifetime his family in Livorno, to whom he wrote most often, had no idea that Amedeo would become a cult figure. Although they kept the postcards he sent, they were never certain where he was living at any given time. For good reason: Modigliani must hold the record for the artist who moved house the most. New housing developments in Paris and a congenital restlessness sent him from one seedy hotel or dilapidated studio to another, and there are diligent researchers in America still engaged in locating his many addresses.

The meteoric rise of his reputation and the market value of his paintings soon after his death made the Modigliani 'industry' so profitable that writers told and retold his story through eager witnesses who remembered, misremembered, embroidered or distorted. In later life, as those witnesses recalled the past, some were confused by other books about Modigliani they had read, others dazzled by the glow of the past. The bohemian life he embraced offered rich opportunity for creating a legend. The Modigliani biographer is forced to weigh not only the stories themselves but also the truthfulness of the witnesses. Parts of Modigliani's life can never be known for certain.

When I became drawn into the Modigliani story over thirty years ago I was fortunate in meeting his daughter Jeanne, his brother Umberto and his wife, his old aunt Laure and his first patron Dr Paul Alexandre, as well as Brancusi, Cocteau and a number of others who knew him well. My biography is a quest for the man, an attempt to 'save the dream'.

— 1 —

Origins

MORE than seventy years after his death, the painter Amedeo Modigliani remains the idol of bohemian life. Hero of a movie, a play[1] and hundreds of books, Modigliani was singled out among all the artists who lived in Paris at a time of riotous creativity as the symbol of doomed and decadent youth. The myth of Modigliani intrigued Montparnasse just after the First World War; even in his lifetime dealers seized on it as a valuable commodity, so that it often seems difficult to disentangle the anecdotes about the 'mad' painter from his work. Yet as a human being and an artist Modigliani was an original, with a purity of vision he honoured to the end.

He was born in 1884 in the town of Livorno on the Mediterranean and retained all his life a profound attachment to his origins. Livorno (Leghorn in English) features in a poem he wrote and is inscribed on several drawings. To develop as an artist he had to cut loose from his home, but his emotional ties to it and his bond with his mother remained intense.

His parents were both Sephardic Jews from old families. Unlike Marc Chagall, Chaim Soutine and other Jewish artists he was to meet in Paris, who came from impoverished Eastern European villages, Modigliani knew nothing of ghetto life. His background was privileged and he had never met anti-semitism in Italy. The history of the Jews of Livorno, which Modigliani knew well, gave him a sense of freedom and a self-confidence which was rare at the time. Over 300 years before he was born the Jewish community of Livorno had enjoyed the special protection of the Medicis at a time when other communities all over the world suffered civil disabilities and social prejudice. In 1593 the Grand Duke of Tuscany, Ferdinand I, encouraged all refugees and specifically the Hebrews to settle and develop the fishing hamlet into a seaport. He also granted the Jews of Livorno equal political rights. The Jewish community flourished in a cosmopolitan society, and although by the

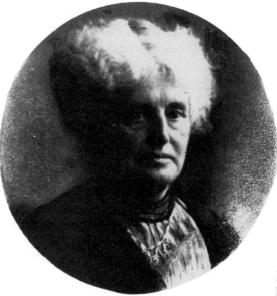

Modigliani's mother,
Eugenia Garsin Modigliani.

time Amedeo was born in the late nineteenth century the prosperity of both
the city and his own family was in decline, the Modiglianis remained highly
respected and, thanks to his mother, in the intellectual forefront of life in
Livorno.

Modigliani signed one of his drawings with his mother's maiden name,
'Garsin'.[2] She had the most profound influence on his development and holds
the key to Amedeo's complex and singular personality. Her own family were
business people with an intellectual background and a surprising disdain for
money, a trait which Modigliani was to inherit. Eugenia Garsin was born in
Marseilles in 1855 in an imposing four-story house with a large garden,
where three generations of her family lived, surrounded by Garsin history
and tradition. An ancestor, a Biblical scholar, had founded a school for
Talmudic studies in Tunisia in the eighteenth century and her father and
grandfather debated theological and philosophical questions with fervour.
Eugenia's great-grandfather had married a Regina Spinoza, and in Paris
Modigliani was to tell his friends that 'philosophy was in his blood'. The
family claimed to be descended from the great philosopher, although Spinoza
was a bachelor and not known to have any children, so the descent was
perhaps collateral.

Naturally Spinoza, who was a Bible critic excommunicated from the
Jewish community for his heretical beliefs, was a family hero; another was
Moses Mendelssohn, who believed fervently in assimilation. The Garsins

admired the freethinkers and iconoclasts who challenged the established order. The children were encouraged to think for themselves and read widely and the atmosphere at home was liberal and cosmopolitan. Eugenia scarcely ever had to attend synagogue; the family were deists in outlook, they believed in God but had little interest in the ritual of religion. Their business, a credit agency, had branches in London and Tunis, and for some time before settling in Marseilles they had lived in Livorno. They spoke French, English and Italian equally fluently, as well as a number of other languages, and were capable of existing comfortably in almost any city on the Mediterranean without completely identifying with the life of it. Fortunately, as it turned out for Amedeo, the girls as well as the boys were given a sound, liberal education. Eugenia's English governess, a Miss Whitfield, who seems to have been something of a martinet, instilled into her a dour puritanism and an utter abhorrence of falsehood. Later she attended a French convent: 'from eight in the morning to six in the evening . . . she was a pupil in a worldly, Catholic, French institution', she wrote of herself later. '. . . at home she was Italian, Jewish, patriarchal and serious-minded'.[3] The result of living in two worlds was that she felt an outsider in both and tended to become introspective and analytical. All the Garsins were highly strung as well as highly intelligent, and dangerously susceptible to ideas and ideals. As a girl Eugenia had little grasp of practical matters. Business was never discussed in her hearing and she gained the impression that financial transactions were a sort of intellectual game. At that time her grandfather was still head of the firm: her father put in a couple of hours at the Stock Exchange in the mornings and then escaped to his club to spend the afternoon playing an excellent game of chess. As to money, that was a taboo subject. If Eugenia wanted an expensive dress or a new hat, she was put off obliquely: '. . . your father does not want you to get used to such luxuries . . . it is too showy'.[4] And, surprisingly, since they were an extremely close family, the Garsins disapproved of any outward display of affection; the children were not kissed until they were safely asleep. Yet sexual adventures were freely discussed. As a girl Eugenia heard the story of her maternal grandfather, a great womanizer, who died of pneumonia after being chased into the street by a jealous husband, wearing only a shirt. She relished the bawdy story and told it to Amedeo and her other children in her turn. Yet at that time Eugenia accepted the restrictions placed upon the behaviour of the women in the family without question.

In 1870 the Modiglianis of Livorno sent their son, Flaminio, to stay with the Garsins for an extended visit with the request that he be introduced to eligible young women. The two families were old friends as well as business

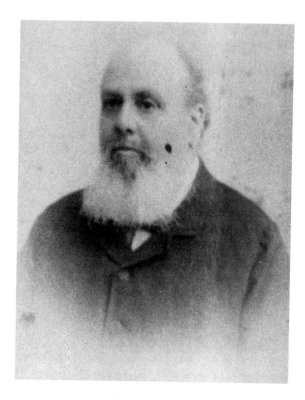

Modigliani's father,
Flaminio Modigliani.

colleagues. Flaminio spent most of his time supervising his family's mining interests in Sardinia and at 30 was still unmarried. He enjoyed the informal atmosphere of the Garsin family, listened to their heated debates and eyed Eugenia, who was a striking-looking girl with a proud carriage and fine, penetrating dark eyes. Before long he blurted out a declaration of love for her.

Although he was tall and well built, Flaminio had a weak, rather flaccid face and lacked the fire and wit of the Garsins. To Eugenia, an intellectual girl, interested in her studies, he must have seemed a disappointing suitor. When her mother told her of the match she merely shrugged: 'Already, mama . . .?' The engagement lasted the customary two years, which may have seemed like a reprieve for the bride-to-be. Her parents were sad to lose their daughter, but on the whole relieved. In two generations of their family, first cousins had married. They knew the reputation and standing of the Modiglianis, and for upper-middle-class Jews of their kind suitable partners were extremely difficult to find.

In January 1872, Eugenia Garsin and Flaminio Modigliani were married in the fine baroque synagogue in the centre of Livorno, and Eugenia moved into a part of the large villa on the Via Roma where all her children were

born. Eugenia found it almost impossible to settle in with her new family. Like the Garsins, the Modiglianis had a distinguished family history and for Eugenia's taste they were far too conscious of it. Her husband's grandfather had been a counsellor to Napoleon I. Her father-in-law, Emanuele Modigliani, was a man of substance who had lent a considerable sum of money to a cardinal when he was living in Rome. He bought a vineyard in the outskirts of the city, believing he would not be bound by a Vatican law which forbade Jews to own land, but within twenty-four hours he was forced to sell it. This precipitated the move to Livorno, where he settled in 1849. On Eugenia's marriage Emanuele, a man in his seventies, fat and bombastic, still ruled the household and the family wood and coal business. He insisted on formality in the family. His sons still kissed his hand and addressed him in the third person, and as his daughter-in-law Eugenia was expected to attend synagogue like the other Modigliani women, and to pay social calls at fixed times. The life did not suit the seventeen-year-old girl. She felt the Modiglianis were on show all the time. 'The house . . . huge and full of servants, the meals fit for a Pantagruel, the table always set for an endless number of relatives and friends, great receptions in a series of vast drawing-rooms . . .'⁵ Yet, despite the grand style, Eugenia found that her in-laws were petty about her own small expenses. However trifling the sums she laid out, there was always an inquest. To avoid the indignity she cut her expenditure to the minimum. Nor was Flaminio much support to his young wife. He was often away on business, and when he was at home he fully expected Eugenia to conform to his family's standards although he paid extravagant compliments to Garsin ways.

Eugenia missed the liberal atmosphere of her parents' home and kept in close touch. When her first son Emanuele was born, in October 1872, Eugenia's mother Regina travelled from Marseilles to see the first grandchild, although she was suffering from TB. Regina Garsin died soon after returning to Marseilles, and in 1873 the family suffered another severe blow with the failure of the London and Tunis branches. The disasters completely overwhelmed Isaac Garsin, who turned on his brothers and business colleagues with such venom that they questioned his sanity, particularly in the light of a history of instability in the family. Eugenia was still bound up with them all and agreed to have her disturbed and irascible father to stay, although she was nearing the end of her second pregnancy. After the baby, a girl named Margherita, was born in 1874, Eugenia took the infant, a nurse and her father to stay in a villa at the seaside. Isaac Garsin was still

distraught, insisting that the gardeners were persecuting him, but gradually Eugenia's tactful care restored him to health. Her own husband was away a great deal on business, which may explain why so many of her own family came to stay on extended visits. In 1878 she gave birth to a second son, Umberto, and eight years later her youngest son was born.

Amedeo Clemente Modigliani was born on 12 July 1884. The name Amedeo means 'beloved of God', but the baby could hardly have been born at a worse time. Two months earlier Eugenia's youngest sister Clementina had died in Marseilles, and the child was named in her memory. Eugenia was desperately worried about money. For some time the Modigliani business had been in decline and in 1884, when a slump throughout the country weakened the economy, the Modiglianis were made bankrupt. Flaminio tried to keep the extent of the disaster from Eugenia, but she had seen an inventory of the contents of the flat and guessed the truth. As she was going into labour, bailiffs entered the house and seized the furniture. Frantically the family piled up as many of their valuable possessions as they could on to her bed, taking advantage of an ancient Roman law which forbade the bed of a woman in childbirth from being disturbed. The baby was born into a chaotic and despairing household, and Eugenia was convinced that his birth at that time was an omen of ill-luck.

The name of old Emanuele now disappears from the family journals. He would have been almost 90 and had, presumably, died. The younger generation of Modiglianis could not afford to stay in the large villa. At first they moved into a cramped apartment, but soon they found a small house with a garden on a quiet street, Via delle Ville, close to their old home, where Amedeo grew up. 'The family did not lose its rank or position in losing money', wrote Margherita,[6] who was 10 at the time of the crash. Friends and neighbours still admired the elegance and style of the household in the face of straitened means. At times they were so poor that Eugenia had to feign pregnancy to stave off the bailiffs. Flaminio, now a disappointed middle-aged man, first opened an office on his own as a house agent. When that collapsed he began to work as a commission agent. After the crash Flaminio never completely recovered his confidence. The differences in character between the couple became clearer in their reaction to failure.

Despite her fastidiousness, Eugenia had enormous energy and courage. In Livorno she had already made friends of her own outside the Modigliani circle. In particular, Rodolfo Mondolfi, a leading intellectual in the city, a teacher at the High School and a convinced spiritualist, became a loving and loyal friend to Eugenia and visited her almost every day. There was certainly no more in it than that, as Eugenia had her house full of relatives and children

and had very little free time. Mondolfi admired Eugenia and helped all he could. With his support, and the encouragement of a Roman Catholic priest whom she had met on holiday, she began to give English and French lessons to local children, helped by her sister Laure. Before long she had organized a real school in her house. The conservative Modiglianis were shocked at her initiative but glad of the money. In defying local prejudice about the role of women and bringing in a useful income, she had become in practice the head of a large extended family. Besides her husband and four children, she had her maternal grandmother, known to all Livorno as Signora 'Nonnina', staying with her, her father Isaac had come back to live with her and her sisters Laure and Gabrielle were in the house. Laure helped with the school, Gabrielle kept house and 'spoiled' the children and Isaac began to take his little grandson Amedeo for walks. Their favourite route was by the harbour with the ships. Isaac found a joy in taking the beautiful little boy along the seashore and reciting poetry to him. As a young man Isaac had travelled widely and he talked to Amedeo as if he were an adult of the scientific wonders and the beautiful paintings and monuments he had seen. Amedeo listened gravely and asked for more stories. His boisterous elder brothers nicknamed him 'the Professor'. In 1886 Eugenia began to keep a diary. An adoring but clear-eyed mother, she noted in May of that year that 'Dedo', his pet name, was 'a little spoiled, a little capricious, but *joli comme un coeur*'.[7] Flaminio was often away on business and Amedeo saw little of him. Nor did he meet other children of his own age, since he was delicate and Eugenia had decided not to send him to school straight away. He grew up surrounded by adoring adults in a house full of books.

The family now lived on a stringent budget, with Eugenia fighting off her anxiety and depression at the situation. Occasionally her younger brother, Amedeo Garsin, would visit from Marseilles. A businessman with fluctuating fortunes, when he was in funds he would arrive bringing handsome presents for all the family and take them off on wonderful outings, leaving behind 'a breeze of fantasy, generosity and warm enthusiasm'. The little boy heard many stories of the days when the Modiglianis were 'bankers to the Pope', and came to feel that he was in some way responsible for their decline. From his mother he picked up a mood of troubled anxiety. The marriage was strained, and Eugenia looked to her youngest son for the tenderness and love that was missing in it. In 1891, when Eugenia was 36 and Amedeo was 8, she dashed off a curiously perverse poem. She wrote it in ten minutes, as an exercise in given rhymes, but nevertheless the bitterness and melancholy of the mood is striking:[8]

FIERCE WISH

I wish to proclaim the Kingdom of Force:
To hang a Jew on every tree,
To loose from prison every thug,
To flay every person of virtue.

To snatch from Aunt Eugenia the pious Amedeo
Who today soothes her every pain
And compels her to smile sometimes.

To drive all kindness from the earth,
To duck every abstainer in a wine-vat,
To put every clean person in a pigsty

And to annoy and upset my neighbour
And set light to his hayloft
So that his little son suffocates.

No doubt her wayward youngest son was a consolation to Eugenia. According to Margherita, who was ten years his senior and jealous of all the attention lavished on him, 'she never crossed him'. He was delicate, so Eugenia taught him herself, and when he was old enough he came to her classes. Despite all her efforts to be scrupulously fair, Amedeo sensed his difference from other pupils: even as a child he bore an air of luminous distinction.

When he was 10 his grandfather, Isaac Garsin, died. Perhaps to distract him from his grief, Eugenia decided to send Amedeo to the local secondary school, the Ginnasio Guerrazi. Even there he was protected. Eugenia's close friend Rodolfo Mondolfi, who was a teacher, helped Amedeo with his Latin homework. And he was set apart from his schoolfellows by his almost unworldly beauty and by the exquisitely cared-for clothes he wore. His mother had given him a good grounding and at first he gained excellent reports. According to his brother Umberto,[9] Amedeo had begun to chalk pictures on the walls at home and to draw in his school exercise books.

After only a year at school Amedeo's regular existence was interrupted. In 1895, during the summer that he turned 11, he fell ill with a bad case of pleurisy. 'I still have not recovered from the terrible fright that it gave me',[10] Eugenia noted in her diary. The long convalescence gave the boy time to read and dream and to develop in a way that puzzled yet intrigued Eugenia, who had considerable experience of child development. 'The child's character is still so unformed that I cannot say what I think of it. He behaves like a spoiled

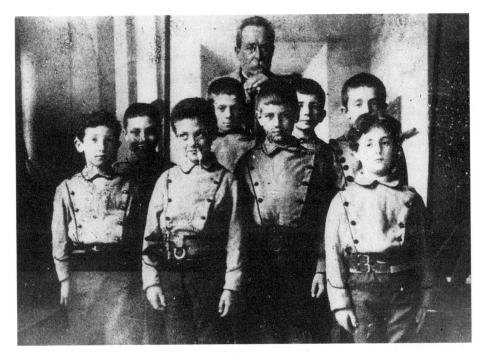

At school in Livorno. (Amedeo is in the front row, far right).

child, but he does not lack intelligence. We shall have to wait and see what is inside this chrysalis. Perhaps an artist?' The summer of 1896, when Amedeo was 12, was the first time since her marriage that Eugenia had none of the Garsin family living at home, which must have been something of a relief. Amedeo was back at school and life was relatively peaceful. As a schoolboy he only had one close friend, Uberto Mondolfi, the son of his mother's friend Rodolfo. There was a big gap in age; Uberto was seven years older, but no doubt both parents encouraged the friendship since Eugenia described Uberto as her 'extra son'. And Amedeo was precociously intelligent and used to the company of older people. One afternoon in 1896 the two boys decided to amuse themselves by decorating a shelf stand. On one side they painted a woman's head with a skull beneath it, to represent 'love and all its destructive power', and on the other a man's head with a flowing, divided beard, representing the male succubus 'which is what he too often is'.[11] The decoration in itself has no artistic merit, but it is an interesting pointer towards the morbid fascination that graveyards, skulls and the accoutrements of death were to have for Amedeo through the literary influence of poets such as Baudelaire and Gérard de Nerval. Approaching adolescence,

Amedeo was rebellious and so impatient of his father's authority that on one occasion Uberto's father Rodolfo was forced to reprove him, an indication of Flaminio's standing in his own household.

In July 1897 Amedeo turned 13, traditionally the age of maturity among Jews. Although Eugenia disliked orthodoxy, it was taken for granted that he would at least recite the benediction in Hebrew in synagogue, before and after the reading of the Law at his barmitzvah. Very possibly he learnt to read a chapter from the ancient scroll by heart, whilst Flaminio silently recited the rather strange prayer: 'Blessed be He who has taken the responsibility for this child's doing from me'. The occasion was a rite of passage and for once Amedeo was allowed to write in his mother's diary: 'I am taking my exams and have to take my barmitzvah. The exams are to pass from the fourth to the fifth class. This is for the accuracy of the Modigliani family annals'. On 31 July he added triumphantly: 'I wrote several days ago in the family diary that I was taking my exams. I now announce that I have passed them'. A few days later his mother noted, with relief: 'Not only has Dedo passed his exams, but he is just about to take his barmitzvah. Oof! there is another out in the world, or almost'.[12]

The school was doing well. At the end of term her pupils put on a theatrical show and Amedeo, looking well and happy, posed for the group photograph. The event was reported in the paper, which shocked some of the Modiglianis, but there was worse to come. Her eldest son Emanuele, a young lawyer, was completely absorbed in politics. He was elected to the Town Council, which was a source of pride to the family, but he was also an active member of the newly formed Socialist Party and in 1898 was secretly attending meetings to counter the bread tax the government had imposed. Wretchedly poor peasants rioted in the streets, and in the state of siege which followed, martial law was imposed and the police began to arrest anyone suspected of being connected with the disturbances. Eugenia knew that her son was taking a risk but sympathized wholeheartedly with his cause. Nevertheless his arrest on 10 May 1898 came as a great blow and the whole family, who had looked up to Emanuele, were stunned by the shock and the shame. In July the Military Tribunal of Florence sentenced Emanuele to six months' imprisonment and ordered him to pay 750 lire in fines and costs for two offences against public security laws. For the third and most serious charge of instigating rebellion, he was sentenced to another two years in prison. 'The most distressing day of my life',[13] Eugenia wrote in her diary, but added that she was proud of the way Emanuele had conducted himself at the trial. Despite her depression characteristically Eugenia looked for a way to help her son. The fine was paid, almost certainly by her brother, Amedeo, and after

eight months in prison the government granted political prisoners an amnesty and Emanuele was released.

For the Modigliani side of the family, staunch monarchists (all the children were named after the Royal House of Savoy), the disgrace to their name was unbearable. They had regarded Eugenia with some suspicion when she started her school and brought unwelcome notoriety to the family, but this was unpardonable. After Emanuele's imprisonment Eugenia gave up all pretence of acquiescing with the Modigliani standards to please her in-laws. She had a short story published under an assumed name, began to work on a novel about Emanuele and was translating D'Annunzio's poetry into French. She was writing because it 'amused' her. Soon afterwards she became a ghost writer for an American professor referred to discreetly in the family as 'Mr K.', and helped to keep her household going by her studies of Italian literature published under his name. Just after sentence was passed on 17 July Eugenia noted her disappointment at Amedeo's examination results in her diary. She was not surprised, as he had not settled down to work all that year. But, despite herself, and with the financial help of her brother, she had decided to indulge Dedo in a whim: 'At the beginning of August he [Amedeo] starts to take drawing lessons, which he has wanted to do for some time. He already sees himself as a painter. I do not want to give him too much encouragement for fear that he will neglect his studies to pursue a shadow. All the same, I wanted to do what he asked to get him out of this state of apathy and sadness in which we are all more or less wandering at this moment . . .'[14]

Amedeo, just turned 14, was delighted with his drawing lessons, but the family seemed dogged by bad luck. Barely started at Art School, he fell ill with a serious attack of typhoid, a disease regarded as fatal at the time. For weeks he was seriously ill and lapsed into delirium for a month. According to the legend, it was then that Amedeo revealed his ardent desire to be an artist. He babbled of the masterpieces in the museums and churches of Florence and pleaded with his mother to be allowed to see them before it was too late. In his illness Amedeo confessed the depths of his passion to become a painter, but from her diary it is clear that Eugenia had divined it for herself. Devoted nursing and care eventually saved Amedeo's life, but the experience had been shattering: 'Dedo's illness and his recovery have left their mark on the family's memory too strongly for me to have to go into details',[15] she commented.

Perhaps in one sense the illness had been the miracle claimed in myth. Eugenia now realized that the strongest attachment to life for Dedo was the chance to become an artist. Otherwise she would never have allowed him to give up his classical studies and attend art school as a full-time student. His

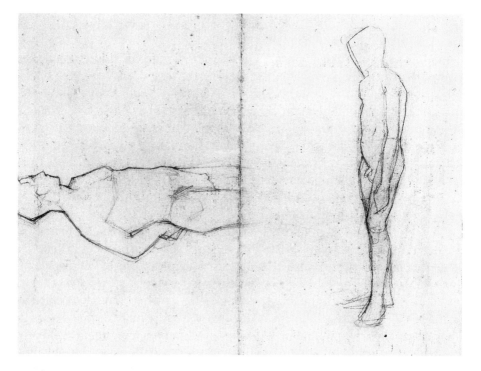

Nude study, *c.*1900.

brother Emanuele had come out of Livorno prison in December at the same time as Amedeo recovered from his illness and, with a sense of relief always tinged with anxiety, Eugenia and her family resumed everyday living.

The art academy, the only one in Livorno, was run by Guglielmo Micheli, a landscape painter and a pupil of Giovanni Fattori, the well-known Macchiaioli painter. The Macchiaioli, influenced by the Impressionists, were interested in painting rural landscapes and seascapes in a naturalistic manner with *macchie* or blobs of colour. They were known contemptuously as daubers, just as were the early Impressionists, but the Italians never attained international prominence. Micheli's school in Via della Siepi was only a five minute walk from Amedeo's home. Micheli had converted a large room on the ground floor of his house, the Villa Baciocchi, into a studio lit by three windows. There were only nine students in the class. Amedeo, at 14, was the youngest. Oscar Ghiglia, at 23 the oldest student, was to become his closest friend. The atmosphere in the studio was genial, informal and domestic. When Amedeo was well enough to go back to Micheli's after months of illness, Signora Micheli greeted him kindly, stroking his hair

which had been cropped because of his illness. 'How well your head turned out', she said kindly.[16] All the youths in the group were eager to learn, and Micheli gave them an introduction to all the techniques of painting, portraiture, still-life and painting from the nude, which even as a boy was Modigliani's strength. 'It was only in his nudes that he showed a certain independence, giving free expression to his interest in line,' a friend of those days remembered. A surviving example, the drawing of a nude youth Modigliani made when he was 16, is well observed but the kind of work that any promising art student might turn out. Fattori, who came from Livorno, used to visit the school occasionally; he praised Amedeo for a charcoal

A session at Gino Romiti's studio, Modigliani is seated on the right.

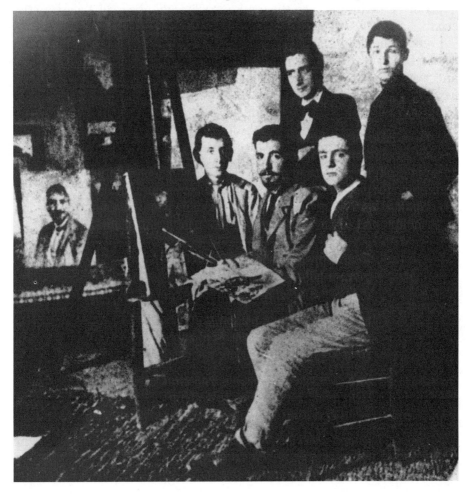

drawing he had made in a special technique Micheli had taught them, known as a *carta intelaiata*, a still-life with drapery behind it. First the artist had partly to burn the paper and use the smoked areas as half tints.[17]

Amedeo at that time was rather cheeky, pleased with himself, and on friendly terms with both Fattori and Micheli. If anything set him apart it was his knowledge of aesthetics, and his range and taste in literature.

Micheli lectured his pupils in art history and gave them a weekly essay to write. Amedeo chose to write about the English pre-Raphaelites, whom he much admired. The romanticism of the movement, in rebellion against the pomp and cant of academic painting, appealed to Amedeo's temperament. He felt in sympathy with the atmosphere of chivalry and the medieval inspiration of their work derived from the Italian primitives. Micheli was so impressed with his essay on the pre-Raphaelites that he read it aloud to the class.

Even in those days Modigliani was fond of quoting poetry: Baudelaire, Dante, D'Annunzio. He had been reading Nietzsche's *Thus Spake Zarathustra* and was excited by it. In his formative years the propaganda for the new aestheticism, the claim that artistic creation related to the contemplative life was the highest form of action, made him an eloquent advocate of the superiority of the artist in a materialistic world. The kindly Micheli called him 'Superman', and at home when Amedeo tried to convey to Umberto, a down-to-earth engineering student, the wonder of a primitive Madonna he had seen, his brother merely replied: 'I'd rather have her in the flesh!'[18] His father seems to have shown little understanding of the ardent student. He nicknamed Amedeo 'Botticelli'. It was as always his mother who made the effort to understand and appreciate his work: 'Dedo has completely given up his studies and does nothing but paint, but he does it all day and every day with an unflagging ardour that amazes and enchants me. If he does not succeed in this way there is nothing more to be done. His teacher is very pleased with him, and although I know nothing about it, it seems that for someone who has studied for only three or four months he does not paint too badly and draws very well indeed'.[19]

If they could not share his passion for fine art, both Eugenia and her sister Laure influenced his intellectual development. With his mother, who had translated D'Annunzio, he could at least discuss the works of that poet. Like most educated young Italians, Amedeo admired D'Annunzio's fire and extravagance, although Eugenia must certainly have disapproved of the emphasis on 'vice' and decadence in his poetry. With his aunt Laure he discussed the writings of Nietzsche and Bergson: she pressed the memoirs of the anarchist Kropotkin on to her nephew and also gave him Kropotkin's

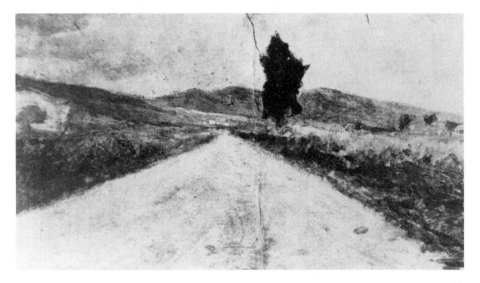

Road in Tuscany, *c.*1899.

tracts on *Bread* and *The Unwed Mother*. Amedeo confided in Laure, who was now writing articles on sociology and philosophy. A generous and cultivated woman, she was unstable in temperament and like her father was to suffer from delusions of persecution.

When his classmates came to tea they were impressed and somewhat discomfited by the upper-class gentility of the family. Aristide Sommati, a painter who in later years became a baker, remembered tasting 'English' tea for the first time in the Modigliani house. More relaxed were the Sunday meetings at Gino Romiti's place. Gino, a student of 18, had his own studio and invited the other students to draw from the nude there. Gradually the boys tired of working with Micheli in the studio and began to go off on their own painting expeditions. The band of youths with paint-boxes slung over their shoulders were an unfamiliar sight in the countryside. A farmer's wife mistook them for pedlars and asked if they had any combs for sale, and a small boy threw stones at them while they were painting a river scene and made them scatter for cover. With the others, Amedeo painted country roads at sunset and rural scenes. He worked diligently, but it was his personality rather than his work that was remarkable at the time. His comrades sensed the complexity of his nature. At one moment he seemed so sure of himself, so cocky, with his good looks and fine clothes and the way the women eyed him. He boasted to Manlio Martinella, a fellow student, that he was going to seduce Micheli's housemaid. At other times he seemed docile, almost child-

like, blushing for the least thing. All his friends agreed that Dedo was kind-hearted, absolutely truthful and very polite. Nevertheless he was experimenting, haunting the sleazier canals in the old part of Livorno, smoking and staying out late. Margherita, his disapproving elder sister, snobbishly blamed 'boys who were less well brought up' for Dedo's bad habits: 'too many cigarettes and too early an initiation from chambermaids'.[20] She grumbled that his brothers saw him drifting into laziness.

Oscar Ghiglia, now 24, confided in Dedo that he was planning a self-portrait which he hoped to submit for exhibition at the Biennale. Ghiglia had tried his hand as a tinker, a blacksmith's apprentice, a butcher and a paint grinder before he came to art school. Amedeo admired his courage and his experience of life, and to Oscar he confided his own plans and hopes. In July 1900 Amedeo turned 16. He had been barely two years in art school and was already growing impatient with Micheli's teaching, feeling that he had learnt all he could from his teacher. Then he fell ill again with pleurisy. His attack of typhoid in 1898 had probably left him with a lesion on his lung, and the relapse was serious. According to his sister, he suffered a violent haemorrhage followed by a fever.[21] The doctors pronounced his case hopeless and warned Eugenia to resign herself to the worst. But that was not in her nature. She appealed for help to her brother, Amedeo's namesake in Marseilles. 'Consider your son as mine and I shall take care of your necessary expenses' he wired back. Against the doctors' advice Eugenia decided to take Amedeo south for the winter to escape the winds and cold of Livorno.

—2—

The artist's creed

A MEDEO'S illness again helped to liberate him, this time from the narrowness of Livorno. He used his convalescence to deepen his knowledge of the Italian masters of the past and to discover his own artistic direction. Eugenia indulged him, encouraging him towards a future which appeared to her extremely precarious. All she wanted was to restore him to health.

Their first stop was Naples, where Amedeo had planned to visit the National Museum. Usually he was restless and volatile, but to Eugenia's surprise he would stand immobile for hours marvelling at the fine Greek and Roman bronzes. He returned again and again to study his favourites in the collection: the Roman god Silenus, the boy taking a thorn from his foot, and a Hermes with numerous breasts. Mother and son were diligent tourists with a carefully thought-out itinerary. Sometimes with his mother, sometimes alone, Amedeo visited the most important churches in Naples: Santa Chiara, San Lorenzo, San Domenico and Santa Maria Donna Regina. In those churches he saw the work of Tino di Camaino, the Sienese sculptor thought by critics to have influenced him. Tino had 'inspired him to use sculpture as a means of resolving the contradictions between line and volume'.[1] Modigliani grappled with that problem all his artistic life.

The stimulus of the art works, the scenery and the town life fanned his imagination and left him in a state of exaltation. Outwardly he appeared a modest, well-behaved, attractive young man. At the time he affected a slight beard and had '. . . a rather condescending air, a cool manner and a way of talking on every subject with intelligence'.[2] Strangers, especially those who met him without his mother, took him for more than his sixteen years. Eugenia insisted that Dedo should share a bedroom with her, not only to economize but so that she could be there to nurse him if he grew feverish in the night. With her he was, to quote his sister Margherita, 'far from evil influences'.[3]

From Naples they moved to Torre del Greco, a small town a few kilometres south on the sea, with Vesuvius dominating the landscape. For two months they stayed in a large, almost empty hotel. Margherita insisted that he had had a studio there and painted an old beggar for his mother, but destroyed the work later. If he really did make the painting (and he never discussed his work with his sister) he did not mention it to his friends. An English visitor at the hotel who had heard of his ambition advised him 'to paint with intuition, imagination and concentration'. 'That is quite a programme. I shall apply myself to it,' Amedeo replied, so politely that it was possible to miss the underlying irony in his voice. After two months mother and son travelled by vaporetto to Capri. Amedeo was stronger now, no longer feverish by night, and he wanted to forget about his illness. Despite his close bond with his mother, the strain of being tied to her was becoming oppressive. He was missing his friends from art school with whom he could talk about the things that mattered, particularly Oscar Ghiglia. When he read in the paper that a work by Ghiglia, a self-portrait, had been accepted for exhibition at the Venice Biennale, Amedeo wrote to him for the second time, excited and impatient:

Dear Ghiglia,
. . . and this time answer, unless your honours have weighed down your pen. I have just read the announcement of your acceptance in *The Tribune*: Oscar Ghiglia, self-portrait. I suppose that it is the self-portrait you spoke to me about, the one you were planning in Livorno. I rejoice for you greatly and most sincerely. Believe me, this news has really excited me.

I am here in Capri (a delightful place, by the way) for the sake of my health. For four months now I have done nothing, just accumulated material. I shall soon be going to Rome, then to Venice for the exhibition . . . just like an English tourist. But the time will soon come when I shall have to settle down, at Florence probably, and work. Work I mean in the full sense of the word, that is, to dedicate myself with faith (brain and body) to the organization and development of all the impressions and germinal ideas that I have stored up in this peaceful place as in a mystic garden. But let's talk about you: we left each other at the most critical point of our intellectual development and we have gone our separate ways. I should like to meet you and talk to you now.

Do not take this letter as one of vulgar congratulations but as a testimony to the sincere interest in you from your friend

Modigliani[4]

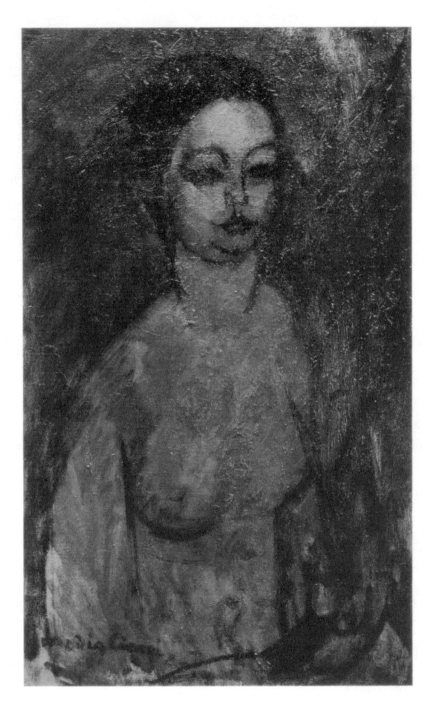

Little Jeanne, 1908

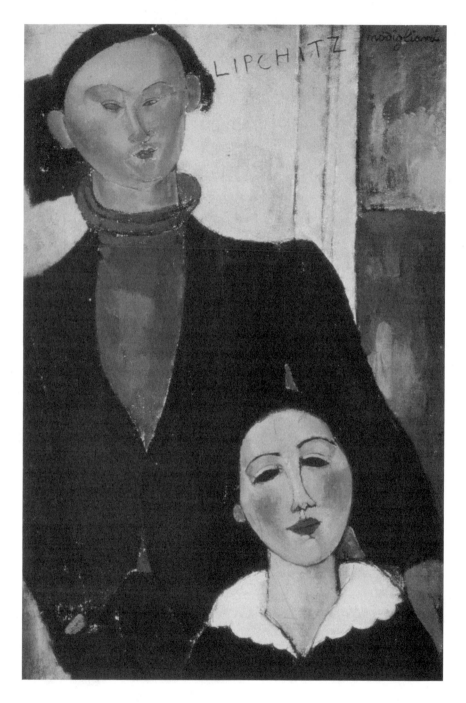

Jacques and Berthe Lipchitz, 1917

It is worth keeping in mind that this was a sixteen-year-old boy writing to a man of 25. He was getting bored with Capri, impatient with the tourists and amateur painters, and wanted to move on to Rome. Eugenia persuaded him to stay on the island for a few days, since the sea air was doing him so much good, but they did move from their hotel, the Hotel Pagano, to stay in a small villa in the quieter village of Anacapri:

Dear Oscar,
Still in Capri. I wanted to wait to write to you from Rome. I shall go there in two or three days, but the desire to talk to you a little has made me take up my pen. I do believe that you have changed under the influence of Florence. Will you believe me when I tell you that I too have changed visiting these places? Capri, whose name alone was enough to evoke in my mind a welter of images of beauty and antique sensuality, appears to me essentially a symbol of springtime. In the classical beauty of the landscape there is, for me at any rate, an omnipresent and indefinable feeling of voluptuousness. And even, despite the invading English tourists with their Baedekers, of a dazzling and poisonous flower emerging from the sea.
Enough of poetry. Besides, imagine that just yesterday (these things only happen in Capri) I went for a walk in the countryside by moonlight with a Norwegian girl, alone . . . really a very erotic type but also very sweet. I don't exactly know when I shall be in Venice, I'll let you know. I'd like to visit the city with you.
How's Vinzio? He made a good start with that little picture of his. Is he progressing or standing still? Answer me! That is really why I write, to know what is going on with you and the others.
Greetings to Vinzio. Ciao –

Dedo
April 1st. Write Rome Poste Restante.[5]

That is the only letter he dated. By now it was Eugenia who was anxious to move from Capri, concerned that Dedo might become tainted by 'the atmosphere of vice' on the island.
In spite of the overlay of literary verbiage in these letters, the gathering force of Modigliani's inspiration breaks through as he describes his voyage of self-discovery to his friend.

Dear Friend,
I am writing this to open my heart to you to make a sort of stand in front of myself.

[handwritten: A feast of natural glory —]

I am the prey of great forces that surge up and then dissolve. But I wish instead that my life were like a fertile river, joyfully flowing over the earth. You are by now the only one to whom I can say everything: well, I am now rich in fruitful ideas and I must produce my *work*. I am in a sort of orgasm, the orgasm which precedes joy and that will be followed by the dizzy, uninterrupted activity of the brain. Already after writing this, I think that such a state of excitation is a good thing. And I shall free myself from it by throwing myself again into the great battle, facing the risks, carrying on the war with great energy and lucidity hitherto unknown. I would like to tell what the new weapons are which I'll take up in the joy of battle again.

A bourgeois told me today – insulted me – by saying that I, that is my brain, was idle. He did me a lot of good. I should like such a warning every morning on wakening; but they cannot understand us, nor can they understand life.

[handwritten margin: seaside]

I shall not speak of Rome. As I speak to you, Rome is not outside but inside me, like a terrible jewel set upon its seven hills, as upon seven imperious ideas. Rome is the orchestration which girds me, the circumscribed arena in which I isolate myself and concentrate my thoughts. Her feverish sweetness, her tragic countryside, her own beauty and harmony, all these are mine, for my thought and my work. I cannot tell you of all the impressions I have found in her, nor all the truths.

I am going to start on a new work, but already after defining it and formulating it, a thousand new ideas spring out of my everyday life. You can see the necessity of method and application.

I am also trying to formulate with the greatest lucidity the truths of art and life I have discovered scattered among the beauties of Rome, and as their inner meaning becomes clear to me, I will seek to reveal and to rearrange their composition, I could almost say their metaphysical architecture, in order to create out of it my truth of life, beauty and art.

Goodbye. Speak to me about yourself as I have spoken of myself. Isn't this the aim of friendship: to shape and exalt the will according to its bent, to reveal each to the other and to ourselves? Goodbye.

Your Dedo[6]

Amedeo and his mother were together in Rome for Holy Week. From there they travelled to Florence, and then home, according to Margherita. But Modigliani's next letter to Ghiglia suggests that he had persuaded his mother to let him travel on alone to Misurina, in the Dolomites.

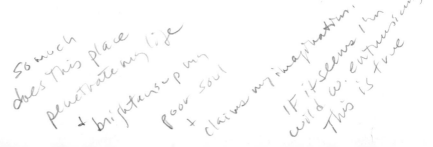

[handwritten: So much does this place penetrate my life + brightens up my poor soul + claims my imagination. If it seems wild w. entire This is true]

Dear Oscar,

You had promised me an account of your life from the time we separated until now . . . I wait impatiently.

As for me, I cannot keep my promise because I am incapable of keeping a diary. Not only because no exterior event has penetrated my life, but also because those that take place in one's innermost soul cannot be expressed whilst we are still in their power.

Why write when one feels? All these are steps in the process of evolution through which we must all pass, and they have no importance save in the goal to which they lead us. Believe me, it is only the work of art that has reached its full term of gestation and fully matured, freed from all the hindrances of the particular incidents which have contributed to fertilize and produce it, that deserves to be expressed and translated in terms of style. The value and necessity of a style become clear in that style is the unique vocabulary of expressing an idea, the way of distancing it from the individual who conceived it, leaving the way open to that which cannot and must not be said.

Every great work of art should be considered like any work of nature. First of all from the viewpoint of its aesthetic reality, and then not just from its development and the mastery of its creation, but from the standpoint of what has stirred and moved its creator. But this is pure dogmatism, after all.

Why haven't you written to me? And what about your paintings? I have read a description of one of them in the *Corriere*. I cannot produce a picture yet. I have to stay in a local hotel, so you understand the impossibility of dedicating myself to painting; however, mentally, and in the study of nature, I am working very hard. I think I shall end up by moving away from here: the barbarism of tourists and holiday-makers renders it completely impossible to concentrate when I most need to. I'll finish by going to the Austrian Tyrol. Don't mention it at home yet. Carry on writing to Hotel Misurina, Misurina. Goodbye. Write, send me what you promised. The habit of contemplating the countryside and the landscape of the Alps will mark one of the greatest changes in my spirit, I think. I should like to discuss with you the difference between the artists who have lived and communed with nature and the artists of today who seek their inspiration in their studies and want to educate themselves in the art cities.

Does one amuse oneself in Livorno?[7]

(unsigned)

Modigliani never managed to visit the Austrian mountains; all his life, it was the tumult of a city that inspired his best work. As he gained in health and confidence, the conflict between his sense of himself as an artist, the constraints imposed upon him by his convalescence and the smothering effect of Eugenia's sacrifice became even clearer. Apparently Oscar had hinted at a personal crisis, and Amedeo wrote with empathy and authority:

Dear Oscar,

I received your letter, and regret tremendously the loss of the first one you say you sent to me. I understand your pain and your discouragement – alas, more from the tone of the letter than from its contents. I can guess the reason and, believe me, I too have suffered and suffer real pain and I feel for you sincerely. I don't exactly know yet the precise cause, but knowing that you are a noble spirit I realize that this situation must have produced a severe reduction of yourself, of the right you have to joy and life, as well as bringing you to this dispirited state. I repeat that I do not know what the reasons are, but I think the best remedy would be to send you a breath from my sturdy heart, because you are created, believe me, for intense life and joy. We (forgive me if I say we) have rights that others have not, because we have different needs that place us above – one has to say it and believe it – their moral code. Your real duty is to save your dream. Your duty is never to waste yourself in sacrifice. Beauty demands some painful duties, yet they bring about the most beautiful exertions of the soul. Every obstacle overcome marks an increase in our willpower and produces the necessary and progressive renovation of our inspiration. You must hold sacred – I say this both for you and for me – all that which may exalt and excite your intelligence. Seek to provoke and to multiply all such stimulating forces which alone can drive the intelligence to its utmost creative power. For this we must fight. Can we confine this research within the narrow limits of their morality? Assert yourself always and surpass yourself. The man who is not able to release from his energy ever new desires, almost, so to speak, like new individuals destined to overcome all that remains putrid and rotten in him, so as to assert themselves, is not a man but a bourgeois, a churl, call him what you will. You are suffering, you are right, but couldn't your suffering goad you on to further renewal and elevate your dream higher, even stronger than desire? You could have come to Venice this month, but take your time to decide, don't exhaust yourself, get used to putting your own aesthetic needs above your obligations to your fellow-men. If you want to escape from Livorno, I can help you in so far as I can, but I don't know if it is necessary. It would be a joy for me. Answer me in

any case. From Venice I have received the most precious teachings of my life: from Venice I seem now to go forth with a feeling of fulfilment, just like after the finishing of a work. Venice, head of Medusa with countless blue serpents, sea-green immense eye in which the spirit is lost and exalted to the infini . . .[8]

The word, obviously infinite, is unfinished, the letter unsigned. This is the last of the letters to Oscar in existence, the most complete statement of the young artist's creed. The notion of the artist as superman had claimed Modigliani's imagination. And not only Nietzsche but D'Annunzio were potent influences. 'Man must either renew himself or die', D'Annunzio told reporters on leaving Florence ten years after these letters were written. And in his play, *La Gioconda*, the sculptor cries in fury: 'I was born to carve statues. When a form comes from my hands with the imprint of beauty on it . . . I am no longer under law. I am beyond Good and Evil'.[9]

In writing, and meditating, on his 'work' in those months of idleness Modigliani had charted out his own future. Clearly the young man who wrote those exalted letters was in no mood to settle to family life in Livorno, and Eugenia was wise enough to realize it. 'He could never stand Livorno again',[10] according to his sister, but her account was not unbiased. What he could not stand was to be treated like a spoilt boy and an invalid when he felt himself a young god.

After only a few days at home, Amedeo went to Florence where Oscar Ghiglia and another friend from his art-school days were now studying. But he did not settle down to further study straight away. In Florence he saturated himself with the sights of the city, visiting the great galleries, churches and palaces, and then moved to Rome for the winter. No records or letters exist of that time and the dates are uncertain. It is safe to assume that Modigliani spent his time partly in absorbing and copying the great works of the past, and partly in enchanted idleness; in the cafés, or attending concerts (he was fond of Boccherini), always with a beautiful girl by his side. If there was a first love no trace of the affair exists. For him the conquest was almost too easy. Women pursued him and so many loved him that he must have been a marvellous lover, sensual, tender and gravely courteous, but a dreamer, so obsessed by his artistic vision that he could not be deflected.

On his first visit the city of Venice had cast its spell. In the spring of 1902, not yet 18, he went back to the fascinating city, which since the introduction of the Biennale had become even more cosmopolitan, attracting artists and writers from all over the world. Even then Modigliani was something of a man of the world. He found himself a comfortable hotel in a fashionable

quarter and took his coffee at the famous Café Florian in the Piazza San Marco. It was probably there that he met the Chilean painter, Ortiz de Zarate, who was to become a lifelong friend. They felt an instant sympathy for each other and Ortiz remembered every detail of their first encounter.[11] The two found they shared a wild enthusiasm for the Italy of the Renaissance and loved to quote poetry, and both took inordinate pride in their ancestry. Ortiz was as exotic as Amedeo. A tall, awkward-looking young man, about the same age as Modigliani, he was born in Como, the son of a musician; his family returned to Santiago and his parents wanted Ortiz to study engineering, but he rebelled and ran away to Paris to become an artist. Late in the evening Ortiz would announce that he was 'the last offspring of a mythology of heroes and princesses', of ancestors who had 'conquered Peru and Chile, those countries loaded with gold, nuggets and diamonds'. That would set Amedeo off to speak of his background, the great philosopher Spinoza who was an ancestor, and the Modiglianis who had been 'bankers to the Pope'. Ortiz had just come from Paris and Modigliani pressed him for news of Montmartre, of the painters, the new work, the avant-garde galleries. His sloe eyes would glow with excitement as he fired questions at his new friend. At the café he decided he must go to Paris immediately. His uncle, who was funding his studies, would understand the necessity, he told Ortiz. After a second's thought he realized his mother would never agree. But he did promise Ortiz – and himself – that one day he would get to Paris. In the meantime he invited Ortiz to his hotel to look at his paintings. The Chilean found the work academic and unexceptional, very much the kind of painting all the students were doing at the time. What impressed him, even years later, was the magnificence of Modigliani's pyjamas laid out on the bed. He was quite the dandy and, as Ortiz recalled wryly, always popular with the ladies. De Zarate was the first to hear of Amedeo's growing desire to become a sculptor. His tour of the great works of art in Italy had slowly awakened in him a desire to work in stone, to sculpt on a monumental scale, he confessed. He was only painting as a second best as he could not afford the cost of the materials.

They parted and promised to keep in touch. Modigliani travelled to Florence tired from his journeys and succumbed to an attack of scarlet fever. Eugenia left her household in Livorno and hurried over to nurse him back to health. Perhaps under her influence, he enrolled at the Scuola di Nudo, the School for Nude Studies in Florence in May 1902. To his delight he was able to arrange to share a studio with Oscar Ghiglia.

He went home to Livorno for the hot summer and made a bold effort to realize his ambition to become a sculptor. To the rest of the family,

hardworking and thrifty, even to his mother, this notion of sculpture must have seemed another of Dedo's wild schemes. His uncle was paying out all that money for him to learn to become a painter, now Botticelli wanted to become Michelangelo. But Amedeo was so sincere, so convincing, that as always he got his own way. He found himself lodgings in the beautiful little town of Pietrasanta, five miles below the great marble quarries of Carrara, and produced three primitive sculptures, two heads and a torso. In a letter to Gino Romiti, his friend from Micheli's, he asked for enlargements of photographs he had taken of his work:

Dear Romiti,
The enlargements should be 18 × 14, exclusive of the head. Do them properly. I would like to have three or four copies of each soon. (For you as many as you like.) Address them to me here at Pietrasanta, Via Vittorio Emanuele, in care of Emilio Puliti. I hope to work and finish up and see you soon.
Greetings.

Modigliani[12]

The letter, brisk and confident, contains the only factual evidence of Modigliani's early attempts at sculpture. He had, it seems clear, chosen to live in Pietrasanta, known for its marble-working, so that he could pick up material cheaply and find a local craftsman, possibly his landlord Emilio Puliti, to give his some basic instruction. The stone dust irritated his throat and made him cough, and the work was hard and tiring, but in those first attempts with hammer and chisel Modigliani gained a respect for his material and an admiration for the craftsmen as well as the artists who worked in stone.

But he was committed to study painting, and for some years his ardent ambition to become a sculptor had to take second place. He returned to Florence to the Scuola di Nudo, where old Fattori, now 77, taught life drawing in a squalid and badly heated attic. The atmosphere was friendly and informal; three of the group, Amedeo, Oscar Ghiglia and Llewellyn Lloyd, had studied together in Livorno. Both Llewellyn Lloyd and Ghiglia found Fattori an inspiring teacher and remained devoted to him. Only Modigliani, with his head full of the role of the artist as superman, grew impatient at the limitations of the class. He took to playing truant, spending his time at the museums and artists' cafés, engaging in debate with other young intellectuals about the renewal of Italian culture which prefigured Futurism. Evidently he respected old Fattori, since he persuaded his mother to buy a

series of the master's etchings, knowing that, despite his fame, Fattori rarely sold a painting.

In the studio he shared with Ghiglia in the Piazza Donatello, he covered the walls with photographs of the paintings of English pre-Raphaelites whom he adored, and of the Sienese school, tastes considered exotic and extravagant by his companions. Sadly the idealistic friendship with Oscar suffered a strain by their rooming together. Ghiglia, who had struggled out of poverty to afford an art education, accused Amedeo of wasting his family's money by loafing in cafés. He was understandably irritated by his friend's habit of getting up late, staying out all night and bringing girls home to pose. 'He was a handsome young man with . . . a rather feminine manner and . . . an inexhaustible amount of kindness and generosity. His more mature friends, Andreotti, Sacchetti, Ghiglia, considered him, quite rightly, a dilettante with a fine cultural background who . . . didn't know the first thing about drawing. He appeared to be well off and solidly supported by his family . . .'[13] Not difficult to read into that account envy at the handsome, arrogant playboy who could afford, apparently, to flirt and dally in the cafés instead of working at his easel.

Ghiglia entered his work again for the Biennale of 1903. In Amedeo's terms he was becoming almost bourgeois, working hard to get together enough money to marry. Perhaps because of his friend's marriage Amedeo decided to move to the art school in Venice early in 1903. From Florence not a single work of his survives, either because he destroyed everything dissatisfied, or, as his daughter believes,[14] because art critics and dealers did not recognize his value in Italy until some years after his death.

Modigliani liked to live well, and his first lodgings were at an elegant address, 22 Via Marzo, within a stroll of the Piazza San Marco.

Almost all our knowledge of Modigliani's student days stems from anecdotes told by the friends who met him in the cafés. In July 1903, Umberto Brunelleschi, a painter Modigliani knew from Florence, introduced him to Ardengo Soffici. A painter and writer, founder of a small literary magazine, Soffici had lived in Paris for three years; that in itself was enough to recommend him to Modigliani. He enjoyed showing his new friend round the city Ruskin described as a 'treasure heap'. No doubt Amedeo invited Soffici and Brunelleschi to dine, for he loved to play host. Soffici remembers that he talked to them of his passionate interest in the painting techniques of the Old Masters. At the time he was studying the fourteenth-century Sienese painters and was also particularly enthusiastic about Carparccio, the Venetian painter. Modigliani's 'graceful countenance and gracious features' impressed Soffici, who remembered the painter as a gentle, well-mannered boy who ate

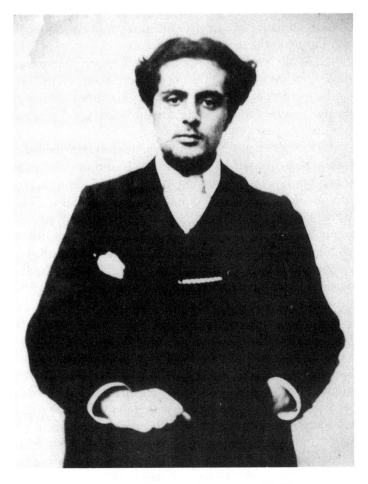

Modigliani, aged
about twenty.

sparingly, watered his wine and possessed 'great serenity of mind'.[15] Since in
later life Modigliani is always portrayed as a tormented, distracted creature,
that early portrait of the calm, untroubled young man makes a haunting
contrast. Not that all his friends saw him like that. Students at the Academy,
who included Umberto Boccioni, one of the leaders of the Futurist movement,
remember that he attended the life class at irregular intervals, preferring to
draw in the cafés and brothels. Towards evening he would disappear, to
return at dawn. 'I learn far more in a night in a brothel than I do in any
Academy', he would say.

From his days in Venice until the end of his life, friends who had known
him, writers and journalists, even his own sister, colluded in ascribing to
Modigliani an aura of wickedness and a highly coloured decadence quite out
of proportion to his accomplishments in that direction. He did not commit

suicide, contract VD, or dry out in a clinic for alcoholics. He did not even womanize on the scale of other artists and writers of his period. Certainly he experimented with drugs and occult experiences, reaching out for new sensations, new stimuli that would 'exalt and excite' his intelligence, as did spirited young artists the world over. Perhaps the Modigliani myth grew up partly because Modigliani himself needed it so badly; the well-brought-up mother's boy had to break away.

At the Academy in Venice, Amedeo befriended Guido Cadorin, a precocious youth of 13, and showed him round the churches. Not only the magnificent art treasures and the canals (it is tempting to picture Modigliani in a gondola) but the colour, pageantry and atmosphere of shrouded vice were alluring to young artists. A certain Baron Croquli or Cuccoli, a Neapolitan of the minor aristocracy, enjoyed the titillation of introducing young students to the seamier attractions of the city. The plump little man, dressed all in grey, would pick up Modigliani and Cadorin and take them across the Giudecca Canal where, with two local girls, they were offered hashish and taken to spiritualist seances.

If Modigliani cared to, he could find family friends who would offer him a very different kind of hospitality. The Olper family from Livorno had moved to Venice some years earlier. Their daughter Albertina was a school-friend of Margherita's and Amedeo was treated as a son and made welcome in their home at any hour of the day. He befriended Albertina Olper, a lonely, sensitive girl with the pale, elongated oval face that was to become characteristic of his work, and also painted a portrait of her father.

As funds dwindled he moved to the cheaper artists' quarter, San Barnabas, across the bridge from the Accademia, and lived at some point at the Rialto, a working-class area. He never stayed very long at one address, but would put up at friends' or stay unexpectedly with casual acquaintances.

Fabio Mauroner, a fellow student at the Accademia, shared a studio with Modigliani for a time. Mauroner recalls Modigliani playing a regular part in student life, enjoying the parties and outings with a regular girl-friend. He drew Mauroner's portrait in pastel (now in the Galleria Naviglio, Milan) and a portrait of Franco Montini, a lawyer, which subsequently disappeared. Mauroner taught Modigliani the art of etching and enjoyed his distinctive company. Like all the other young men he noticed that 'women, young and old, adored him'.[16]

In Venice, thanks to the Biennale, Modigliani was exposed to European art and had seen the works of the Impressionists, Monet, Pissarro and Renoir as well as Rodin's sculpture. Through the European art journals he had admired the works of the Art Nouveau painters, Toulouse-Lautrec, Van Gogh and

Munch. 'Venice', he had written in his last letter to Ghiglia, 'has given me the greatest lessons in my life'. 'In Venice Dedo has finished Olper's portrait and speaks of doing others', Eugenia wrote in her diary. 'I still do not know how he will turn out, but since up to now I have thought only of his health I cannot yet attach much importance to his future work, in spite of our financial situation'.[17] Eugenia was deeply distressed at the time. Her bachelor brother Amedeo, the uncle who had paid for Dedo's tuition, had just died at the age of 45. She had been very close to him and he had helped Eugenia generously with money for her children. The tone of Eugenia's entry suggests that he may have committed suicide.

Amedeo was now desperately keen to go to Paris. All the knowledge he had gleaned drew him towards the artistic capital of the world. It was, he believed, the one place where he could develop his talent. Eugenia knew, of course, of his longing and one cannot but admire her response. After her brother's death the family was worried about money. Amedeo's health was always precarious, his prospects were uncertain, and above all her other children she adored him. But freedom had always been her own goal, and she sensed that Dedo would never be fulfilled until she let him go. Towards the end of 1905 she travelled by train to Venice, bringing Dedo several hundred francs as travelling expenses and, as a farewell present, a copy of Oscar Wilde's *Ballad of Reading Gaol* bound in red leather. Could it have been a warning? When she went back to Livorno, Amedeo spoke to Mauroner with emotion of his mother's visit. Early in 1906 he took the train to Paris.

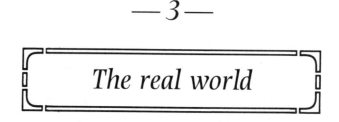

The real world

A MEDEO was still a boy when he went to Paris, financially and emotionally dependent on his mother despite his twenty-one years. Although his work showed great promise and his philosophy of aesthetics was both profound and poetic, he had not yet produced substantial evidence of his talent. His mother, who had done so much for him, was partly responsible for his immaturity. Preoccupied by his health, she could not bring herself to consider Amedeo's artistic ambitions seriously but took a great pride in his appearance. She herself was under the spell of her son's dangerous charm, and almost unwittingly he used it with women wherever he went.

On the journey to Paris, a wealthy German matron with a very pretty adolescent daughter boarded the train at Geneva. The older woman immediately noticed the young man sitting opposite and, on impulse, asked him to join them. Amedeo thanked her gravely and charmed her with his courtesy, but contrived to flirt outrageously with the young girl when her mother's back was turned. The railway romance was of no importance and almost certainly innocent, but with a young man's vanity Modigliani boasted of his conquest to an acquaintance in Paris, Ludwig Meidner, a German painter of about his own age ardently following the Impressionists. Other artists were only too aware of the attention Modigliani attracted among women and the story soon spread. At a time when Modigliani had misgivings about his work and would not let it be seen, the talented painters of Paris dismissed him as a dilettante: he was known simply as 'the beautiful boy'.

He arrived in Paris at the beginning of 1906 at a period of unprecedented artistic excitement. Young painters from all over the world, men of the calibre of Picasso, Matisse and Braque, were concentrated in the city, attracted by and in reaction to the dazzling achievements of the Impressionists and Post-

Impressionists. Painters, writers and musicians worked together in an atmosphere of collaboration perpetuated by literary cabarets where they clowned, theorized and experimented. The Eiffel Tower, the new landmark of Paris, often featured in the poetry and painting of the period, for the revolutionary arts reflected the achievements in technology, in the new age of speed. Young moderns enjoyed the reputation of being 'mad'. They played the fool to keep up their courage to change the face of art. Painters began to reject the long tradition of representing the 'real' world in a recognizable way. In an age threatened by mechanization and penetrated by psychoanalysis, the natures of reality and illusion were examined and inverted.

In 1905, the year before Modigliani arrived, a group centred around Matisse was labelled *fauves*, wild beasts, by critics because of the violence of their colours, designed to give intense rather than literal expression to their perception of the world. 'Exactitude is not truth', Matisse's expression, was the watchword of the modern movement in art. By 1906 the power of African sculpture was exciting modern painters and Picasso was soon to paint pictures of fragmented objects in the first stage of Cubism.

At the age of 16 Modigliani had theorized to a friend on the importance of finding fresh sources of inspiration. But here in Paris his theories, his artistic idols, which had seemed so exciting and advanced in Italy, were regarded as outdated. The avant-garde, led by Picasso and his followers, ridiculed Art Nouveau and the Post-Impressionists so much admired by Modigliani. They were breaking with the past completely and Modigliani found it very unsettling, despite joining a Life class at the Académie Colarossi.

Modigliani rushed about Paris looking at the new work when he arrived. His comfortable central hotel, in the Place de la Madeleine, was a short walk away from the Rue Laffitte which was the heart of the modern art market. Impressionist paintings by Monet and Pissarro hung in the window of the Durand Ruel Gallery in the narrow street. Next door, at Ambrose Vollard's, said to be the untidiest shop in Paris, Gauguin and Van Gogh were on display, but it is doubtful whether Modigliani was allowed to see the magnificent stack of Cézannes that Vollard kept stuffed behind the furniture for special customers. At the Bernheim-Jeune the paintings of Matisse were on exhibition, and at Clovis Sagot's, the genial print dealer who had taken over a chemist's shop, gouaches and water-colours from Picasso's blue period hung on a nail, among the clutter of bottles, jars and patent medicines. Most of the dealers in the Rue Laffitte were eccentrics like Sagot, friends of the artists, who came in with their portfolios. In his well-cut Italian suit, starched shirt and bow-tie, topped by a flowing cape, Modigliani looked more the prospective buyer than the artist. Modigliani immediately recognized Picasso

Modigliani in Paris with Picasso and André Salmon.

and Matisse as outstanding among the moderns, and some of his early paintings reflect his admiration for Picasso's blue period. One afternoon soon after he arrived he overheard passers-by point out Picasso, who was standing nearby, and surprised himself by inviting the Spaniard for a drink. He explained that he was an Italian, just arrived from Livorno. 'I have been wanting to know you ever since I saw a pastel and a gouache of yours at Sagot's where I went again this morning. The pastel was signed "Pablo Ruiz" and the gouache "Picasso", but they were clearly by the same hand'. Picasso grunted, muttered that those were old hat, and accepted one drink and then another from the well-dressed young Italian who insisted on lending him a few francs. He advised Modigliani to leave his smart hotel and find lodgings in the artists' quarter of Montmartre. Living near the Madeleine was all right for flower painters, but a real painter 'has no damned business knocking around the Madeleine. Even Degas never lived near the Opera, although he did get some models from its dressings rooms . . .'[1] In another version of their

meeting, Ortiz de Zarate recalled that he and Modigliani were sitting in the Café de la Rotonde when Picasso walked by, wearing faded and patched blue overalls. One thick lock of black hair hung down from his workman's cap and his toe protruded from a hole in his canvas shoes. Modigliani looked at him disdainfully. 'He may have talent,' he remarked, 'but that's no reason why he shouldn't dress decently'.[2] Since the Rotonde was not in existence until 1911 that story may have suffered more than one change in the telling.

Modigliani could not afford to stay in a smart hotel for long. Even without Picasso's advice he would have found his way to the Montmartre night spots, haunted by Toulouse-Lautrec so recently, and visited the circuses on the fringe of the boulevards. Although the 'village' five hundred feet above the city was no longer rural, and mills like the famous Moulin de la Galette had been converted into bohemian dance halls, the air was fresher up on Montmartre, gardens and woodland softened the buildings and in the Place du Tertre artists and shopkeepers sat about on café terraces shaded by red-striped awnings looking on to a village green. Before the tourists invaded, artists could still find cheap lodgings alongside the petty crooks, acrobats and street girls of Montmartre. Talented foreigners, failed students and hangers-on learnt the slang and survival of the streets and caroused in the cafés.

Montmartre's attractions included music halls, cabarets, circuses and dance halls, and the sideshows extended to the streets: '. . . people never troubled to change their clothes. The can-can girls would stand about in their befrilled and bepetticoated dresses, though the gamin was the fashion, with tight skirts, bobbed hair, long black stockings and no underclothes, a fact which was often displayed. The Tyrolean band, when off duty, would walk about Clichy in their strange get-up: the tango orchestra would be dressed à la Sud-Américaine: and the Hungarian tziganes would stroll in their be-frogged uniforms of brilliant blue with shakos and top boots . . . and all this at half-past five in the afternoon'.[3]

The reality of the artist's life in Paris, cut-throat and miserably poor, came as a great shock to Modigliani. He admired the three dandies, Oscar Wilde, Whistler and D'Annunzio, and would have liked to lead a life of style, entertaining literary friends at the best restaurants, dressing elegantly, living in fashionable surroundings like his fin-de-siècle heroes. The only accommodation he could afford was a shack in a shanty town. He badly needed to find a studio for his work, and friends pointed him to the maquis of Montmartre, a wasteland which stretched from the Rue Caulaincourt to the back of the Moulin de la Galette. The area had been razed in preparation for redevelopment after the Paris Exhibition of 1900, and while new building was delayed squatters took it over. Tramps, beggars and a few artists put up

hovels and shacks on the maquis and it was here that Modigliani, so recently an elegant man about town, found an empty wooden shed with a corrugated iron roof, scrubbed and repaired it and set up his first Paris home. The area had two advantages: rent was dirt cheap and, across the street, building was beginning and Modigliani managed to scrounge stone for his sculpture.

His work, at the time, was regarded as 'of very little importance', but people were curious about the man. André Salmon, principal architect of the myth of Modigliani, described his first home in some detail: '. . . a couch which could serve as a bed, as well as a bed with good cotton sheets, several chairs, an armchair of uncertain style, and . . . a broken-down piano covered with a large cashmere shawl.' The piano, 'the last remaining sign of Modigliani's loyalty to his background', never existed.[4] But Salmon was eager to demonstrate the difference between Modigliani the bourgeois who was a mediocre painter and the bohemian genius he became after the fall.

He did change his clothes, which were hardly suitable for a squatter, and dressed in a similar fashion for the rest of his life: '. . . in brown corduroys with a coloured neckerchief and a broad-brimmed hat, he looked exactly like the conventional idea of a painter, but was so original that one noticed his looks – both Jewish and Venetian – at once . . . his eyes shone, at once ingenuous and ironical; his smile was so very young'.[5] He walked with a hop, very erect, which made him look taller than his five foot six inches, hands in his pockets in which he always had Dante's *Divine Comedy* and a copy of the Bible in Italian.

He made a vivid impression on Louis Latourettes, a financial journalist and poet who was a neighbour. They met through a mutual friend, a musician from Florence, and as the three men were drinking a glass of red wine before lunch at a good, modest local restaurant, Chez Placier, Modigliani pulled out a letter from his mother he had received that morning and started to read it. He got as far as 'My dearest Dedo' and broke down. Tears streaming down his face, he passed the letter to his Italian friend to read. Later Modigliani regained his self-control and apologized, explaining that he was new to Paris. Latourettes was intrigued by the young provincial who looked so self-possessed on the surface, but was obviously horribly homesick. The artists he knew in Montmartre would never admit to feelings of affection for their parents; in public, at least, they sneered at their relatives. Latourettes also noticed that Modigliani was carrying a book on philosophy, which struck him as incongruous. After that, they often met for a meal locally. Modigliani hankered for Italian food and favoured À la Maison Vincent, where the cook was a compatriot. On fine evenings they strolled on the terrace of Sacré Coeur, the glistening white cathedral which dominated Montmartre, and

spoke of poetry. Like the young Tchaikovsky, who quoted Dante to his friends, Modigliani would recite long passages from Dante and modern Italian poets, Leopardi, Carducci and most frequently D'Annunzio. They both admired Shelley and Wilde, and Latourettes described his meeting with Oscar Wilde after the trial when he was taking refuge in Paris. Modigliani's French was both fluent and cultivated and Latourettes enjoyed his civilized company. But although the painter would talk about books and girls all night, Latourettes could never persuade him to discuss his work.

A sympathetic witness, Latourettes recalled that well-bred virgins as well as the washerwomen and 'girls' of Montmartre 'queued' to pose for the painter, who was quick to take advantage of them. But his liaisons were casual and light-hearted. Modigliani was not yet ready for a love affair. His latest girl, Mado, was special, a svelte and luscious blonde who had been Picasso's former mistress, and she inspired many of Modigliani's drawings. Years before Picasso won world-wide fame Modigliani recognized his genius, admired the artist and came to dislike the man who could change his coat like a chameleon. Modigliani may have felt superstitiously that through Mado he could acquire some of Picasso's power.

His work in the early years in Paris was hesitant and uncertain: the explosion of the moderns had unsettled him as did the tough-minded band of poets and painters clustered around Picasso. Modigliani experimented on his own, working as a sculptor directly in the stone, with the dust irritating his throat, drawing and painting, dissatisfied with almost everything he produced.

On the maquis he met Deleschamps, an eccentric coachman who wrote doggerel and proudly hung his verses on a slate outside his shack. An ardent patriot, Deleschamps refused to move furniture for anyone who was a pacifist. He admired Modigliani for his scholarly knowledge of poetry and philosophy, and Amedeo was amused by his neighbour's antics and by the pigeons he kept, which flew in military formations. One night when Deleschamps was out, Modigliani sneaked over and erased the verses on the slate; perhaps they were too chauvinistic for his taste. When the coachman came home he was furious and threatened murder and horrible vengeance on all his suspects, almost everyone in Montmartre except Modigliani, who enjoyed a rather mean joke. The curious shanty-town life did not last for long. As new buildings went up Modigliani was forced to leave his studio in the maquis. He was on the move for years, staying in seedy hotel rooms, putting up at friends', not certain himself where he lived. He hated the developers changing the face of the city, and his restless nomad existence in Paris seems to date from that first uprooting. Early one morning Louis

Latourettes found him asleep under the wooden table at the entrance to the Lapin Agile tavern.

For a time after he left the Rue Caulaincourt he lodged at No. 13 Rue Norvins, and after months of refusing even to discuss his work with Latourettes he rather shyly invited his friend to the studio. Despite the simplicity of the furniture, a bed, two chairs, a table and a trunk, the effect of the room was arresting. The walls were covered with canvases, portfolios overflowing with drawings were scattered all around and one or two sculptured figures stood on the floor. Latourettes was impressed immediately with Modigliani's remarkable draughtsmanship but felt that the artist had not yet found his way, his colours were disconcerting. 'It's my damned Italian eyes', the painter agreed, 'I can't get used to the light in Paris. Such an all-embracing light . . . You can't imagine what new themes I have dreamt of in violet, deep orange and ochre. But I can't make them sing yet.' Modigliani dismissed his 'fantasies' impatiently but Latourettes protested, admiring a splendid head of a young actress who often recited poetry at the Lapin Agile. Modigliani would not have it. 'No. It's not right yet. It's imitation Picasso . . . Picasso would give this monstrosity a kick in the pants!'[6]

For the first time Modigliani spoke seriously to Latourettes of his own work and ideals, and of his view of the other artists working in Paris. Picasso and Rousseau were the only two he wholeheartedly admired.

He evidently valued Latourettes' opinion, and a few days later he told the journalist with a certain bravado that he had made a bonfire of all the work that Latourettes had seen, except for two or three drawings and the head of the actress. 'One must know how to judge one's work without sentimental indulgence. After all, that's only to begin again in a new way. I've a good mind to chuck painting and work as a sculptor, which I prefer.' True to his creed, Modigliani was resolved to renew himself and his work.

All trace of Modigliani's work in his first year in Paris has almost disappeared. Little remains of his bundles of drawings, his paintings or the sculpture he worked at in the rubble behind his shed. Fortunately contemporaries witnessed some of the results. Anselmo Bucci, an art student, noticed 'three women's heads, bloodless, haunting, almost monochrome, thinly painted on green backgrounds', on sale for fifteen francs each early in 1906. They hung in the rather grubby window of 'The Art Gallery', a little shop on the Rue des Saint-Pères close to the Boulevard Saint-Germain. The proprietor, Laura Wylda, an English poet who liked to encourage young artists, gave Bucci Modigliani's address in Montmartre and Bucci and two friends went to visit him. Modigliani, in a turtle-necked red sweater, was charmed to find someone enthusiastic about his work and went out with

them towards the boulevards, lecturing the Italians on modern art. In Italy he insisted there was only one artist, Ghiglia, his old friend, who was worth while, important: 'I've been to Venice and seen all the studios.' Startled by his attitude, Bucci and his friends persisted, 'What about France, there must be *someone?*' They mentioned all the painters they admired: Fantin-Latour, Puvis de Chavannes, Manet, Monet, Sisley. 'Competent,' is all Modigliani would say of them. 'Wait a minute. Do you mean to say there isn't one real artist in the whole of France?' 'Well, there's Matisse . . . There's Picasso . . .';[7] Bucci thought that Modigliani was about to add 'and me' but held back.

Gino Severini, another Italian painter who came to Paris in the same year as Modigliani, remembered his paintings: 'Small figures or still-lives on pieces of cardboard with very delicate colours and a refinement of taste that surprised me.'[8] No other record seems to exist of a Modigliani still-life. From the beginning, he concentrated on painting portraits or nudes, and a very few landscapes. His portraits reflect his involvement with his fellow human beings, an involvement removed from the distractions of daily life.

Daily life, routine in the sense other people understood it, was almost incomprehensible to Modigliani. There were days when he did not work at all, simply drifted from café to café or visited friends. Others when he worked so hard that he forgot to eat, and eventually fell asleep whilst working. Two hundred francs a month, all he had to live on, came regularly and it was a sacrifice for the family, but at that time a meal at the most modest restaurant cost 1.50 or 2 francs and most of his money went on materials for his work. Many artists learnt to scavenge, slipping into blocks of flats where the concierge delivered a tray of croissants and coffee and whipping it away, but for Modigliani that came hard.

At first he tried to hide his poverty from certain friends: 'Although my own life was tolerably comfortable, Modi never came to me . . . between us there was no mention of money. I don't know why. He was proud in those matters.' When Meidner met him in the autumn of 1906, he made a delightful companion, lively, given to contradictory moods and full of imagination. 'I never met a painter with such fire!' Modigliani showed Meidner photographs of the early Florentine masters and spoke with marvellous enthusiasm of the later painters he admired: Gauguin (there had been a large Gauguin exhibit at the Salon d'Automne in 1906); Toulouse-Lautrec; Whistler. Modigliani also praised the work of Picasso, Matisse and Rouault, who had outraged popular taste by his great series of paintings of the street women of Montmartre.[9]

One autumn evening Meidner and Modigliani drank strong coffee through the night at the café that catered for artists, Le Lapin Agile. Painters and poets

from Montparnasse as well as Montmartre trooped nightly into the dimly lit, noisy little haunt to eat something and knock back as much as they could drink. Paintings, drawings, poems and posters plastered the walls as well as a sculpture of Christ used as a hat-stand, a Buddha and a painting of two harlequins, donated by Picasso and later sold for a handsome price. Poets recited classical verse, singers performed and one or two of the clients inevitably passed out. Late in the evening Frédé, the bearded proprietor, would pick up his old guitar and accompany himself in bawdy songs, with the audience roaring out the chorus. Gangs from the underworld sidled in to drink in the semi-darkness and Frédé kept his ancient pistol loaded, as clients were occasionally attacked. Modigliani, who liked to declaim to friends in private, remained aloof from the uproar and there were those who said he was appalled by the 'bohemian life'.[10]

At first he paid all his bills at the cafés but now he would disappear when the chalked-up debts grew too large. Visitors to his room were forced to talk in whispers and often Modigliani would peer through the keyhole at the sound of footsteps, for fear of creditors. Worst of all, he wasted days trying to sell his drawings to dealers or borrow money until his allowance arrived. When he was in funds he still insisted on inviting his friends to a glass of Pernod. His expansive nature could not resist the grand gesture. 'I am the son and grandson of bankers,' he told Louis Latourettes one evening, adding with a smile, 'Jewish bankers. If your proprietor [the financial newspaper] takes heed of certain theories and methods that I have we'll make millions.'[11]

To his disgust he was reduced to retouching photographs (although he would never make enlargements), making copies, even painting shop-signs, fiercely guarding his anonymity. One day he was delivering a Japanese print by Utamaro to a well-known collector living in a luxury block of flats. The doorman looked at the dishevelled man in a corduroy suit, covered with paint and food stains, and refused to admit him to the building. A new suit was completely beyond Modigliani's means, but he was humiliated. When, in 1907, he met the Russian Jewish painter M. Chwat, a man who saw him when he first came to Paris in his good Italian clothes, he looked down at his soiled cords and said ruefully 'My family would be appalled . . .'[12]

For a time he stayed at the Bateau Lavoir, the wooden tenement building at No. 13 Place Ravignan, nicknamed the 'floating laundry' because it creaked in the wind like the washerwomen's barges on the Seine. Since Gauguin's day artists had rented the cubicled basement studios. The decrepit building lacked heat, water and lighting and they had to work by lamp or candlelight. Most of the visitors came to see Picasso, who lived in one large room: '. . . dirty, curtainless and in disorder. Unfinished canvases are propped against

the walls. A small, rusty stove on which is a yellow earthen basin serves as a washstand. A towel and a bit of yellow soap lie on a table among tubes of paints, brushes and a dirty plate containing remnants of a hasty meal . . .'[13] In these unpromising surroundings almost everyone of importance in the world of modern art, painters, poets and critics and one or two major collectors, turned up to play cards, drink and discuss aesthetics and the aims of the avant-garde. Picasso's 'gang' included the writers Max Jacob, Apollinaire, Alfred Jarry and André Salmon and the painters Derain, Vlaminck and Van Dongen, later to be joined by Braque and Juan Gris. Members of the gang promoted each other's work and by 1906 Apollinaire, who became the chief spokesman for the Cubists, had already written appreciatively of Picasso's art. Although Modigliani lodged briefly at the Bateau Lavoir, he was one of the few gifted modern artists who remained outside Picasso's orbit, outside the revolutionary movement in art. Ironically he understood the new development and longed to be among the revolutionaries in the fight against the bourgeois, but he sensed that he could not endorse the break with the tradition of European art. As an artist and a man he was essentially solitary, at his best with one or two intimate friends. Pride and a deep inner shyness prevented him from seeking to ingratiate himself and it would not occur to him to flatter or bribe a critic. Among the brilliant and calculatedly audacious gathering in Picasso's studio, he felt ill at ease, and it was remarked that he did not pay homage.[14] The constant swarm of beautiful girls who enjoyed Modigliani's company, and his elegance even in poverty, also did not go unnoticed; nor did his aloof attitude. In Picasso's circle, where 'mockery or malicious and wounding remarks' were honoured, one of the wits must have thought up a nickname for Modigliani. 'Modi' is not only a useful abbreviation but an ill-natured pun, since in French the similar sounding word *maudit* means accursed or damned.

The Modi of the legend, wild-eyed and debauched, began to obscure the picture of the courteous, scholarly artist, as the stories of Modi's rare outbreaks flew round the cafés of Montmartre. And Amedeo himself had an instinct for the dramatic. All the rebels of Montmartre experimented with drugs, but Modigliani, with his head full of poetry, imbued the habit with a dark glamour. 'Epicurean in his search for sensation and refinement, he loved to hear of the experience of taking hashish, morphine and opium'.[15] Even his evictions were sensational. One night whilst sleeping in a poky little hotel room, the ceiling collapsed on him. The unsympathetic landlord burst into the room and ordered Modi to pay his back rent and get out. 'My eyes are blinded and my head is broken,' Modi yelled, 'and since I am a great artist, I will sue you for hundreds of thousands of francs . . .'

His eye for talent was extraordinary. When Utrillo was dismissed as a drunken idiot and his paintings sold for a few francs or the price of a drink, Modigliani recognized his genius. The 'moderns' patronized or despised the alcoholic who was in and out of hospital for years. But Modigliani admired his haunting scenes of empty streets in Montmartre and befriended their creator. The sight of the two of them weaving through the streets, Modi still erect and guiding the tall, gaunt man out of the gutter, was familiar late at night. Then, just sober enough to see Utrillo home, Modi would deliver the artist to his mother, Suzanne Valadon, a former model and a painter herself. 'Modigliani only had to touch Utrillo to get drunk,' Picasso remarked sardonically. The tales that the two were often found brawling and hurling insults at each other were denied in Modi's lifetime as 'pure imagination, because Mau-Mau [Utrillo's nickname] was closely watched and only rarely escaped at night. They were sensitives, far from insulting each other, they admired each other . . . Utrillo with his red wine and Modigliani with his absinthe'.[16] Fellow-feeling for an outsider, as well as recognition of Utrillo's gifts, made Modigliani champion the drunk of Montmartre.

The year Modigliani arrived in Paris, 1906, the long-drawn-out Dreyfus affair was finally resolved and Captain Alfred Dreyfus, the Jewish army officer falsely convicted of treason, was reinstated. 'I felt at every step that I was a Jew. People made me feel it . . .', wrote Chagall, who came to Paris in 1910.[17] Modigliani too was acutely conscious of being an alien, an outsider.

In military circles and among royalist Catholics, anti-semitism still festered. One day when lunching with Louis Latourettes at Spiehlmann's restaurant on the Place du Tertre, Modigliani overheard a group of noisy young men at the next table shouting anti-semitic slogans and pounding the table. The group of artists who had joined Latourettes' table merely shrugged and tried to continue their conversation but he sat silently, fidgeting in his chair and looking murderous. Suddenly he had heard enough. He got to his feet, strode to their table and stood over the party, a small man shaking with passion: 'Je suis Juif et je vous emmerde.' Stunned by his furious anger, the royalists were subdued that time, but anti-semitism was not always so crude or so open.[18]

Despite the lack of recognition, money worries and his difficult status as a Jew and a foreigner, his work kept him sane. The painter, Meidner, sat for Modigliani several times and fortunately described his methods. When he was making a drawing he used thin paper, and before the drawing was finished he placed carbon paper on a second sheet underneath the drawing and made a simplified tracing on it. He painted small portraits in thin colour, using coarse canvas when he could afford it or more often smooth cardboard.

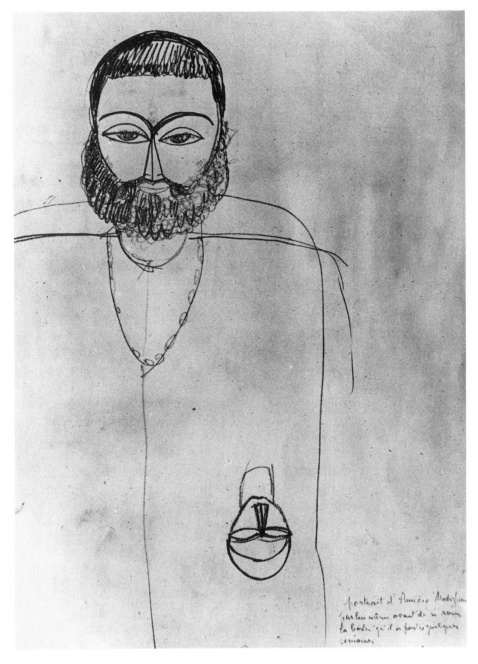

Self-portrait, before and after Modigliani had grown a beard.

The greyish-green tones were reminiscent of painters he admired, Toulouse-Lautrec and Whistler. To give the paintings the glow and transparency of old masters, Modigliani would cover them with coloured varnish when they were dry, sometimes using as many as ten layers.

Early in 1907 Modigliani had moved yet again. He was now living in a carpenter's shed, a makeshift building of wood and crumbling brick. But from his window Modigliani looked out on a small garden with a single cherry tree on the Rue Norvins, and beyond down the Rue Ravignan across Paris to the Meudon hills. He grew fond of the view with the graceful cherry tree and made a painting of it which was lost in one of his many moves. In his new home the rent was low, he was at least independent and could keep his work together. He decided to submit seven of his works, including the portrait of Meidner, to the Salon d'Automne.

The new Salon was formed by a group of young avant-garde artists. Matisse and Rouault were among the founder members. In 1905 they exhibited their work with Derain, Braque, Dufy and other colourists in a large central room where Rousseau's 'The Hungry Lion' was a focal point. The critics sneered; it was then that they labelled the room the 'wild beasts' cage', and the group of painters became known as the *Fauves*. Modigliani admired the *fauve* painters and was excited when he heard that the jury had selected all seven of his works. From 1 to 22 October 1907 seven Modigliani paintings were on show at the Grand Palais. His entries were two portraits in oils, one of 'L.M.' (Meidner), the other of his current mistress, and five water-colours: a head, a profile, and three studies.[19] Modigliani went to the Private View and wrote to Meidner, now back in Germany: 'They've accepted everything at the Salon . . . I went to the Opening yesterday and they've placed me very well.' Meidner had taken a batch of Modigliani's oil-paintings to Germany with him, hoping to sell them, but not one buyer could be found for the 'exquisite little pieces'. However, from his brother Umberto, now a qualified engineer, Modigliani had received a gift of money and wrote back to thank him:

Dearest Umberto,

Thank you first of all for the unexpected help. You ask me what I intend to do: to work and exhibit. As time goes on I hope to manage to get straight: the main thing is not to lose one's head. I feel in my heart that in this way I shall find my path one of these days. The Autumn Salon has been a comparative success and acceptance en bloc, practically speaking, was a rare occurrence since these people form a closed clique. If I give a good account of myself at the Independents [he intended to exhibit at the

Salon des Indépendants in the spring of 1908] I shall certainly have taken a first step forward.

And what is happening to you?

Greetings to Aunt Laure. Write when you can.

Your Dedo[20]

In this, as in all his letters home, the tone is simple and direct, neither over-confident nor pessimistic. That Dedo, who for all his bravado was so timid, should have had the quiet confidence to tell his elder brother that if he kept on working he would find his way is astonishing. The Salon d'Automne that year held a Memorial Exhibition to Cézanne, who had died in 1906. One room was devoted to forty-eight of his paintings and Modigliani was immensely excited by them. At the same time, the Bernheim-Jeune Gallery in the Rue Laffitte displayed seventy-nine Cézanne water-colours. Cézanne's last letters, recording his struggle and his determination in direct and moving terms, were published at the time and undoubtedly Modigliani read them. One painting in particular, Cézanne's 'Boy in a Red Waistcoat', moved him. He bought the best reproduction he could find and kept it in his pocket. Whenever Cézanne's name was mentioned he would secretively take out the postcard, hold it to his lips and kiss it. Herbert Read sees Modigliani at this stage as 'still torn between the contrary influences of Gauguin and Cézanne . . .'[21] It was Cézanne's influence that was to triumph.

His first showing in Paris at the Salon d'Automne brought neither fame nor money to Modigliani, but it did allow his work to be seen by art-lovers and fellow artists. Paul Alexandre met him in the autumn of 1907, almost certainly as a result of the Exhibition. An outstanding man himself, Paul Alexandre was just finishing his medical training. He had a great love and understanding of modern art and made it his business to get to know the young artists. He and his brother Jean, a dental student, helped them adventurously by taking over a condemned house, set in the wasteland in Montmartre, and setting up an artists' commune, run by Henri Doucet (the only painter living there to have a contract with a gallery) and Maurice Drouard, a sculptor.

Evidently Modigliani had been 'screened' by the two artists as a possible member after the Exhibition, for one afternoon in late autumn he stacked up a wheelbarrow with his pictures and books and took them over to the Rue du Delta commune. Among the pictures was 'The Jewess', an almost sculptural painting he had just finished, clearly influenced by Cézanne, the head and shoulders modelled in light and shade. Modigliani attached great importance

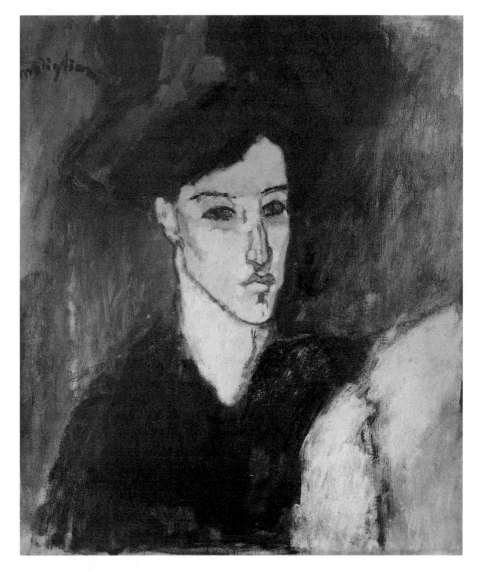

The Jewess, 1908.

to this painting and Paul Alexandre was immensely impressed. He bought it for a few hundred francs and begged Modigliani not to destroy any of the work in his portfolio. 'I will buy your work whenever I can', he promised. The importance to Modigliani of finding a cultured and sympathetic supporter cannot be overstressed. It is true that no professional art dealer or millionaire had expressed an interest in his work, but it is hard to see Modigliani finding a

common language with people of that kind. What he needed most was an understanding friend to back him. Modi was elated at his luck and gave all the artists working in the commune a gift of a small painting. Although he preferred to live in his shed, he began to work at the Rue du Delta, where the building was at least heated, and he often stayed on in the evenings to join in the conversation on art or the amateur theatricals.

Like other discerning friends, Paul Alexandre found Modigliani a remarkable man and appreciated his quality. Together the two scoured the antique and souvenir shops looking for masks and statues. They visited the Ethnographic Museum in the Louvre and the ethnographic section of the Trocadero Museum at the weekends; at that time avant-garde artists had begun to discover an interest and inspiration in the works of primitive man. As soon as Dr Alexandre was launched in his career, they would meet when the consulting room was closed. On the takings of the day, they would visit night-clubs, the Circus Medrano, where they sometimes met Picasso and his friends in the café by the stables, and classical concerts. The occult still fascinated Modi and he made a drawing at a seance he attended. Wherever he went he took his sketchbook with him and, although he drew quickly and spontaneously, he would often make seven or eight studies of the same drawing before he was satisfied. The influence of Toulouse-Lautrec, Beardsley, Gauguin and the *fauves* is apparent in his early work. But he was never merely imitative. He absorbed all the rich and diverse impressions of Paris and made them his own.

1908 was a year of devastating experiment and excitement in the art world. Despite his 'backer', Modigliani was an outsider, in art as well as in social life. The launch of Cubism, the stirrings of Dadaism were an obvious challenge and anxiety to him. When in 1907 Picasso painted his great picture 'Les Demoiselles d'Avignon', now regarded as the key to the development of modern painting, with one figure seen from both back and front and astonishing distortions in the faces of the women, he hid it in his studio for years and only showed it to his friends. If Modigliani did not see it, he certainly heard about it. At the Salon des Indépendants in 1908 Apollinaire gave a public lecture praising the work of Derain, Braque, Vlaminck, all the revolutionaries. Henri Rousseau exhibited two paintings, 'Combat Between a Tiger and a Buffalo' and 'The Football Player'. Derided for years, Rousseau was now taken up by Picasso's group. Modigliani, encouraged by Paul Alexandre, entered five works: 'The Jewess'; two paintings of nudes; a study for work in progress, 'The Idol', and a drawing. He had hoped that he would make his name, or at least gain some recognition, but Modigliani was ignored: he was not in fashion.

Unlike other young artists, he insisted on the value of keeping a line of communication with the past and wanted no label. 'How chic', he used to say ironically, 'to be in the swim'.

All that year new ideas, new directions were debated and celebrated in an eruption of high spirits. In 1908 Picasso bought a masterly full-length painting of Rousseau's, a portrait of Madame M., for five francs and, to celebrate his discovery, gave a banquet in honour of the venerable painter. Picasso's studio in the Bateau Lavoir with its solid beams and African masks on the walls was transformed by strings of Chinese lanterns, with the newly acquired portrait festooned with banners. One of them read 'Honneur à Rousseau'. The rowdy, disorganized gathering was a brilliant success, the disasters only encouraging the guests to drink more wine. Trestle tables were set for thirty guests, but the caterers forgot to send the food, Marie Laurencin toppled on to a tray full of jam tarts on the sofa, and the lanterns dripped hot wax. In the course of the evening, André Salmon and Cremnitz brawled – in a faked fight, they declared later – whilst Gertrude and Leo Stein in full evening dress looked on. One of the women guests rolled down into the gutter outside and later in the evening local friends dropped in, including Frédé from the Lapin Agile and Lolo his donkey. No one could remember later exactly how the party ended.[22] Modigliani was not present, even among the visitors who arrived after dinner.

The idealistic quest for beauty in his art was now unacceptable to the revolutionaries. His interest in the casualties of society is reflected in the subjects of his paintings, beggars, negroes, prisoners and outcasts. He painted a 'Sorrowful Nude' in 1908, influenced by the Picasso of the pathetic 'blue' period. Another nude was of little Jeanne, a young prostitute, a patient of Paul Alexandre's being treated for venereal disease, whom he painted standing against a bed, self-contained and dignified. Modigliani needed a rapport, however brief, with his sitters, and with commissioned portraits that was not always possible.

Through Alexandre he obtained his first order to paint a baroness who prided herself on her horsemanship. The sitter chose to be painted in her red riding-jacket, but Modigliani, clearly out of sympathy with his subject, offended his client's vanity by changing the colour of the jacket from red to yellow, to harmonize with the bluish-green background. The aristocratic model gazes coolly out of the canvas, hand on hip, one eyebrow raised. She may have tried to patronize the artist and clearly he was unimpressed. In the end it was the faithful Alexandre who bought 'The Amazon'. When he visited Modigliani, the painter Gino Severini found him discontented at that time, feeling that he had done too little work. But his compatriot tried to encourage

The Acrobat, 1910.

him, as he could see great progress. Modigliani had abandoned his naturalism and was seeking a more lyrical and expressionist style, influenced indirectly by the *fauves*, but adapted to suit his own sensibility.[23]

Paul Alexandre bought his drawings, portfolios of them, for a few francs as well as his paintings and kept them intact and in order. The canvases, often painted on both sides, record the evolution of his style. According to the legend Modigliani leapt to his feet at a party where they were all high on drugs, grabbed pencil and paper and began to draw feverishly, shouting that at last he had found the right road. When he had finished he triumphantly flourished the sketch of the head of a woman with a long swan-like neck. Severini and other Italian friends recall Modigliani carrying a little box of hashish and offering it to everyone he met. Severini, however, firmly denied that Modi worked under the influence of drugs or drink.

Paul Alexandre saw Modigliani almost every day until the First World War. Despite everything that was written about him, he insisted that Modigliani was 'an extremely well-brought-up young man'. Alexandre, who became a well-known surgeon, had experimented with hashish himself. It was rare to find anyone who mixed in artistic circles who did not. But Paul Alexandre never saw Modigliani work under the influence of stimulants.[24]

His life was lonely, enclosed in the studio. Modigliani made sketches and drawings of harlequins and acrobats in 1909, and for a time lived with a slim young acrobat who had posed for some of Modi's friends. When sitting for André Warnod she apparently told him that she did not like Modigliani's work. Soon after that she decided to leave Modi and, when Warnod asked her why, replied scornfully: 'I've had enough of painters. Now I want to be with artists.' 'But I don't understand. After all, Modi is . . .' 'No, Modigliani is a painter. He's not an artist.' Some time later Warnod met her in the street looking very happy. In reply to his question she smiled and said that at last she was living with a real artist – a clown at the Medrano circus.[25] Montmartre loved those stories.

On Christmas Eve 1908 Paul Alexandre threw a party for the colony at the Rue du Delta, with a midnight supper. The artists painted decorations, a barrel of wine stood in the centre and Modigliani acted as exuberant Master of Ceremonies. A week later, at a New Year's Eve party at a friend's studio, he again stood at the door giving hashish pills to all the guests. When midnight approached the well-stoked guests decided to set fire to an enormous bowl of punch in the centre of the room. When the brew would not burn, they dumped kerosene over it; this time it caught alight, the flames rising to the ceiling and burning the paper decorations until the whole room seemed ablaze. The dancing, the laughter and the drinking carried on and since

damage to the studio was slight and no one was hurt, it seems that this, like so many good Montmartre stories, swelled in the imagination. Modi, said to have burst into a D'Annunzian invocation to fire, was blamed.

Again, it was his troublesome good looks that made his exploits so memorable. Years after the event, a certain Madame Gabrielle D. recalled Modigliani's love affair with Elvira, known as La Quique, a ravishing courtesan: 'I was coming home one night with friends – oh! it was quite early, about one, and there was a lovely full moon. As we came into the Place Jean-Baptiste-Clément . . . we heard a piano going full blast, playing a Spanish scherzo, and a woman's voice wild and hoarse. We stopped to look. Outside the shed Modigliani had, to one side there was a bit of garden about the size of a handkerchief. Well, a woman in a kimono, nude to the waist, with her hair down, was dancing madly, and opposite to her was Modigliani, in trousers only, capering about like a lunatic and yelling like a demon. Every moment he would turn his head and scream: "You pig-headed calf, you pig son of a Madonna", at a lighted window in the big house in the Rue Norvins where some kind of Treasury fellow lived. As we stood laughing, he dropped his trousers and started to caper about her. Oh!', Madame Gabrielle interrupted herself, evidently affected by the memory, 'but he was beautiful there in the moonlight like a faun, and we all said what a shame it was that he drank like that. Then the woman dropped her kimono and the two danced nude. And then a gang of brutes who were passing started shouting and yelling and he picked her up. She threw her head back at that moment and I recognized her. As they disappeared into the shed I screamed "Vira, Elvira" . . . Oh! but they were beautiful, those two, but quite mad with it of course.'[26]

One night, in a drunken bout, he destroyed not only his own work but all the other artists' as well. The next morning he was appalled at what he had done, apologized and left the building. Here is the Modigliani myth in full flow. From then on the stories about him focus on his moments of wild abandon, and the gentle, thoughtful side of his personality, known to his intimates, is obscured.

In April 1909 Paul Alexandre invited Modigliani to his home for the first time, to introduce him to his family. They lived on the Rue Malakoff in decent bourgeois style. Other people remarked that Modigliani was glad to escape from the 'bohemianism' of Montmartre, and he struck up a friendship with the whole family. Paul's father was sufficiently impressed with the artist and his work to commission portraits of himself and his sons and soon afterwards recommended Modigliani to another sitter, a Monsieur Lévy.

In his painting of Paul Alexandre that year, Modigliani portrayed his patron as distinguished and austere, his hand in his pocket and the portrait of

'The Jewess' painted in behind him. This is the only time that Modigliani used such a device; his backgrounds were usually uncluttered, decorated only with broadly brushed bands of colour which heighten the impact. Perhaps 'The Jewess' is painted in recognition that it was his patron's first major purchase and a picture Modigliani valued highly.

'The Jewess', now in a private collection, has never been widely exhibited. Overcast by the influence of Picasso's blue period, perhaps it is too intensely introspective a painting to enjoy popular success. But the elegance and sophistication of much of Modigliani's work could have assured him of a brilliant career as a portrait painter. Had he chosen, he could have lived a life of ease as a fashionable society artist. He was, however, haunted by his vision of the ideal, still hankering to become a sculptor of great monuments. Since the cost of stone was so high and the effect of working in it so injurious to his health, Modigliani made an attempt to carve in wood. The Paris Métro was branching out, the Barbes-Rouchechouart section was under construction, and Modi discovered that there were cross-ties of oak stored in open sheds. Henri Doucet, the painter, and Modigliani climbed the fence surrounding the Métro station late at night and stole several oak ties. One wood carving of Modigliani's survives, twenty-two inches high, exactly the length of the wooden tie designed for the Métro. The work represents a woman's head with hair waved and in braids, wide forehead, deep-set eyes and a long nose, a description that might fit any of Modigliani's later paintings.

In his heart he was still determined to become a sculptor, and he asked Paul Alexandre to introduce him to the Rumanian sculptor Constantin Brancusi. Brancusi was an artist who had achieved an integrity and a sophisticated simplicity in his art and his life which was enormously attractive to Modigliani. He pared down his forms, nudes, a bird in flight, a couple kissing, to their essences. Rodin heard of his work and offered to take him on as an assistant but Brancusi refused, saying 'nothing grows under big trees'. A burly, bearded man who wore a blue smock and clogs, he created a world of self-sufficiency in his studio. He built his own furniture – guests sat on hollowed logs – and cooked his own meals on a stone oven he had made, and remained firmly outside the intrigues and cliques of the artistic scene, although his work had been exhibited at the Salon d'Automne. Honest, hospitable, with a philosophical and mystical turn of mind, Brancusi was a solid and reassuring figure after the poseurs and pranksters of Montmartre, and Modigliani was very taken with him. Brancusi undoubtedly helped and encouraged him for Modigliani had had no formal education in sculpture. But as critics have remarked, Brancusi's work was influenced by Modigliani. Modi moved to Montparnasse to be near the older man, dreaming of going

Constantin Brancusi.

home that summer for the first time for two and a half years, to escape from the stuffy city and stay by the sea. He invited Brancusi to come with him, but the sculptor was turned back at the frontier.

Before he left for Paris, Modigliani spent many hours in Brancusi's courtyard watching him at work on the simplified head of a woman, with the intensity of concentration he had had as a youth. After looking intently on while Brancusi carved into the limestone, he turned to the sculptor and said softly 'Ah, now I understand what you're getting at'.[27]

Modi left Paris at the end of June, undernourished and shabbily dressed. Eugenia was overcome with delight. On 3 July 1909 she wrote to her daughter-in-law, Vera Modigliani:

My dearest,
 Dedo has arrived. He is fine. I am very happy about it and felt that I had to tell you and send you a great big kiss.[28]

—4—

Transition

A MEDEO celebrated his twenty-fifth birthday a few days after he arrived in Livorno. Eugenia was so delighted to have him home that nothing else mattered. She had been warned by Laure, who had visited Amedeo in his little cell of a studio in Paris, that Dedo was exhausted, undernourished and poorly clothed. None of the three letters she wrote to Margherita that summer conveys even a hint that she was coping with an alcoholic or a drug addict. With tact and care, Eugenia did her best to restore her son's health. Margherita, always so critical of her youngest brother, spent the vacation staying with Emanuele and his wife Vera. Umberto, now a fully qualified engineer, was away working; presumably Flaminio, Modigliani's father, was at home. His name is rarely mentioned in family documents. Laure, however, stayed with them during Amedeo's visit home. Laure was sensitive, and aunt and nephew shared a special sympathy. So Amedeo was surrounded by a loving, cultured family.

Yet in his own home he was totally out of his element. In the Jewish community of Livorno, young men of his age were leading careful, sensible lives, most of them married and prospering as respected shopkeepers and burghers. The artists he had studied with were still living quietly with no conception of the dangers and the exhilaration of artistic Paris.

Once he was rested there were family reunions and meetings with old friends. He made a painting of his sister-in-law Vera, a portrait in red, and when he saw Bice Boralevi again, a former pupil at Eugenia's school, he was eager to paint the young woman with the 'interminable neck'. Eugenia was delighted and encouraged the friendship and the portrait. 'Posing this way you'll make him stay quiet', she told Bice, who was 22. Later, she dimly remembered that Modigliani's studies of her were sombre in tone, the only bright note being a lace collar . . . the features were very stylized.[1]

But the hope that meeting young ladies in lace collars or painting decorous

Modigliani in profile, aged
about twenty five.

family portraits could contain Amedeo was unrealistic, as his mother must
have known in her heart. 'Dedo is out all day with a friend who has a studio',
Eugenia told Margherita in a letter. His old friend from Micheli's, Gino Romiti,
generously allowed him to work in his studio. Afterwards he often joined
Romiti and other local artists at the Café Bardi, the 'Lapin Agile' of Livorno.
One summer afternoon he came across two friends from Micheli's studio,
Benvenuto Benvenuti and Aristide Sommati. Modigliani and Benvenuto
decided to sketch Aristide Sommati. After crumpling up his first attempt
Benvenuto, three years older than Modigliani, had just started a second,
when Modigliani grabbed the paper from him and completed the sketch with
a few strokes of the pencil. Benvenuto signed the portrait and gave it to
Sommati as a present. Jeanne Modigliani, who met the subject over forty
years later, recognized the old Tuscan, 'shrewd, soft-hearted and lonely',
from her father's sketch. His portraiture had increasingly a prophetic quality,
so that his subjects came to resemble their pictures many years later.
Nevertheless Modigliani's unthinking action was high-handed, and there are

Aristide Sommati, drawn at the Café Bardi.

memories and stories of his arrogance passed from one artist to the next in Livorno to this day.

In Modigliani's mind his actions were prompted not by arrogance but with the certainty, despite all his hesitancies, that he possessed the key to understanding. Eugenia perceived it: 'Dedo and Laure are writing articles together, but they are too much up in the clouds for me',[2] she wrote to Margherita in an undated letter. The studious young man working with such application with his maiden aunt on philosophical essays seems irreconcilable with the 'Modi' of Montparnasse.

He was fond of his family and at first enjoyed the sense of being cosseted by them, but as the summer wore on he felt more and more stifled at home. He missed his real friends: Paul Alexandre, Latourettes and Utrillo, 'Letrillo' as the street children of Paris called him. Sometimes he yearned for a night out in a Paris bar. Above all he was anxious to continue his experiments in sculpture. In a letter to Paul Alexandre he asked the doctor to send regards to Brancusi: 'I do like that man very much'.[3]

During his stay Modigliani was asked to advise the family on an artistic inheritance. They had been left a legacy by a Signor Castelnuovo, and included in it were a late-Renaissance copy of a Greek statue of Hermes, a

pastoral landscape attributed to Salvator Rosa, a seascape by Tempesta and a seventeenth-century Neapolitan painting of a beggar. Naturally the family had hoped that the works were of some value, but Amedeo's opinion was disappointing: 'Dedo has seen the pictures which he considers worthless, including the famous statue', Eugenia reported to her daughter. Jeanne Modigliani believed that her father's painting 'The Beggar', which was exhibited in the Salon des Indépendants in 1910, was an interpretation of the old Neapolitan picture which he adapted in a 'watered-down, Cézannesque structure'.

Eugenia had secretly hoped that Amedeo might settle down in another city in Italy, if not at home. But she accepted the inevitable parting, and in preparation sent for the family dressmaker Caterina, to make a new wardrobe for Dedo. Caterina, a foul-mouthed peasant woman, came in by the day, proud to work for the family and determined to make young Signor Modigliani look a credit to her. Modigliani enjoyed clothes and wore them with a studied casualness that made memorable even the shabbiest cords; 'the only artist in Paris who knows how to dress', in Picasso's estimation. When the new clothes were finished, Modigliani tried them on, shortened the sleeve of the jacket with one slash of the scissors and tore the lining out of his smart Borsalino hat to make it lighter. 'Extravagant and ungrateful', was Margherita's verdict on her brother's behaviour. A hard-working schoolmistress, with limited imagination, she was judging by the standards of Livorno, not knowing that the most famous modern artists in Paris wore workmen's overalls.

Modigliani may have painted one other picture while he was at home in Livorno, 'The Beggar Woman' – the companion to 'The Beggar' – before he left for Paris in the autumn of 1909, sadly and hopefully.

Laure had found him living in Montparnasse before his holiday, staying at La Ruche, the famous artists' colony, where 'young geniuses lived in a beehive', an octagonal building on two floors, each with twelve triangular studios, so narrow the artists called them coffins. Probably they were all occupied on Modi's return. His next address was No. 14 Cité Falguière, just beyond the Boulevard Montparnasse, reached through a courtyard which led to a small bridge and stairs down to the studios. Like all the 'picturesque' buildings artists worked in at the time, it was miserably uncomfortable and sparsely furnished, with a bare floor. In the year that Modigliani moved to Montparnasse, most of the moderns crossed the Seine to the left bank. All the genuine Montmartre atmosphere had been spoilt by tourists, looking for excitement and nostalgia in the night-clubs and sending up the prices. By coincidence, Picasso moved to Montparnasse about the same time as Modi in

October 1909. His move marked his new status in the art world; he now occupied a large studio with a north light on the Boulevard de Schoelcher and lived in the adjoining apartment, furnished with heavy oak pieces and the grand piano Modi had been falsely credited with. Fernande Olivier, his mistress, found the new way of life, with a uniformed maid waiting at table, too formal for her liking.

Modigliani's tastes would have embraced luxury, not bourgeois living, but his family's allowance barely allowed him to rent a decent studio. Eager to see Paul Alexandre again, he called round to show him the work he had brought back from home and left a note:

Dear P,
Have been in Paris for a week. Paid a fruitless call at Avenue Malakoff. Want very much to see you again.
Regards

Modigliani[4]

By now, although he was still painting, sculpture was his main passion. One of the few people to see Modigliani at work in his studio was the German critic Curt Stoermer: 'He had a tremendous urge to make sculptures. Having ordered a large piece of sandstone to be placed in his studio, he cut directly into the stone. Just as there were times when he loved idleness and indulged in it with the greatest sophistication, there were also times when he plunged himself deep into work. He cut all his sculptures directly into stone, never touching clay or plaster . . . when this urge [to sculpt] came upon him, thrusting all painting tools aside he snatched up the hammer . . .'[5]

Latourettes, who met him after he came back from Italy, recalls Modigliani, previously so reserved about artistic matters, talking incessantly of the inspiration of Negro art and its enriching influence upon the moderns. However, Latourettes noted that he was irritated by his rivals' efforts.

That year Modigliani went to see an exhibition of works by Elie Nadelman, a Polish sculptor, whose disturbing geometrics of the human body had a profound effect on Modigliani and other modern artists. For years he had dreamt of making great monuments, now he began to sketch out his plans. The theme of the caryatid, the female figure designed to bear weight, obsessed him. He planned a great Temple of Beauty dedicated to Humanity with hundreds of large figures, columns of tenderness he called them. Again and again he drew and perfected his drawings of caryatids bearing a great weight, the women holding up the Temple of Beauty. The early figures, stylized, simplified drawings, playful and elegant, were probably inspired most

Caryatid, 1910.

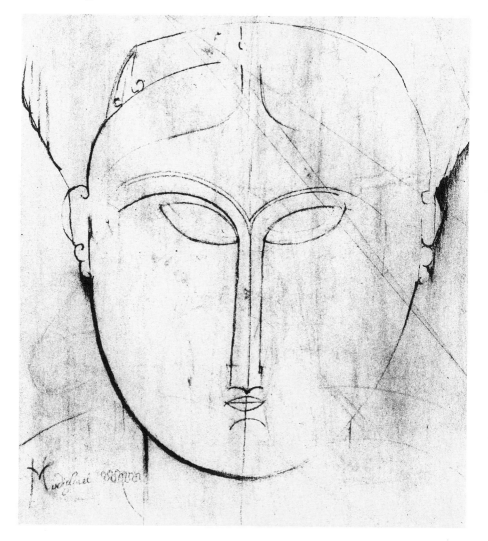

Head of Caryatid.

directly by figurines from the Ivory Coast. The later ones, graceful, oval figures, including a series of watercolours, were considered by some critics as among his finest work, 'a refined and altered version of archaic Greek motifs with hints of Gothic rhythms about them'.[6] Modigliani always felt a tremendous empathy as well as attraction towards women, and the fascination of the theme of the woman bearing the load must have emanated, at some level, from his own early experiences.

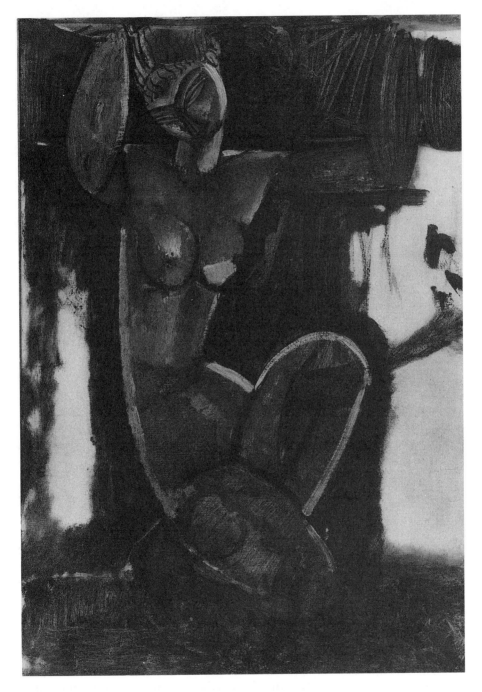

Caryatid 1911/1912.

As an artist he was more isolated than ever. 'I've only got one buyer and he's blind,' Modigliani quipped. The buyer, Père Angely, a retired lawyer's clerk, was so near-sighted that he had to peer at paintings a few inches from his face when he studied them. The old man bought paintings by young artists he considered promising at low prices and hoped to hold a grand auction later to provide him with an income. Jean Alexandre, Paul's brother bought 'The Beggar' and 'The Beggar Woman', and Paul continued to collect Modigliani's work, but compared to other painters with dealers, he was a nobody; Cubism was in the spotlight of modern art and the Cubist painters exhibited prominently at the Salon d'Automne in 1909. A new group of Modigliani's compatriots, the Futurists, had made their break with the art of the past and proclaimed in ringing rhetoric the art of the future. The Italian poet, Filippo Tommaso Marinetti, rallied the movement and gathered a group of poets and painters around him. A Manifesto in *Le Figaro* in February launched the movement, and a group of Italian painters led by Umberto Boccioni, a fellow student of Modigliani's in Venice, decided to publish a Manifesto of Futuristic Painters. In February 1910 the painters proclaimed:

1. That all forms of imitation should be held in contempt and that all forms of originality should be glorified.
2. That we should rebel against the tyranny of the words 'harmony' and 'good taste'. With these expressions, which are too elastic, it would be an easy matter to demolish the works of Rembrandt, Goya and Rodin.
3. That art criticism is either useless or detrimental.
4. That a clean sweep should be made of all stale and threadbare matter in order to express the vortex of modern life – a life of steel, fever, pride and headlong speed.
5. That the accusation 'madmen', which has been employed to gag innovators, should be considered an honourable title.

There were ten positive statements in the declaration. One of the negative statements condemned the nude in painting: 'as sickening and tedious as the adulterer in literature'. The Futurists objected to the nude, not on grounds of immorality, but because they considered that 'obsessed by the need to display their mistresses' bodies, artists had transformed the Salons into fairs for rotting hams'. They called for a ten-year ban on the nude.[7]

At some time in 1909 Modigliani was approached by the painter Severini to join the Futurists. The Manifesto struck him as ridiculous and of course he refused. Once again he found himself classed as the outsider, the reactionary. But Modigliani worshipped the nude and took classes in life drawing as long

as he lived. He had learnt valuable lessons from the museums and, although he admired the aviators who circled the Eiffel Tower, his world was not one of speed and machines.

Since his vacation his mother had addressed her letters to 'Amedeo Modigliani, Sculptor', painstakingly noting the many changes of address. 'Dedo is in Paris, rich in hope,' she commented in her diary early in 1910. Once again he sent in his work to the Salon des Indépendants that spring. There were six of his exhibits in all: 'The Cellist'; 'Lunaire'; two studies, one of Bice Boralevi and one of a man known as Piquemal; as well as 'The Beggar' and 'The Beggar Woman'. Paul Alexandre was immensely enthusiastic about 'The Cellist' and told him it was 'better than Cézanne'. The sitter, a neighbour of Modigliani's, came in to huddle by the painter's stove for warmth during the winter and the portrait reveals Modigliani's compassion and understanding of the musician and the world he inhabited, with the cello dominating the complex and sculptural forms of the painting. But in the excitable city of Paris of 1910, novelty and surprise were 'in'. The sensation at the Salon that year was a painting by one Joachim Raphael Boronali entitled 'Sunset over the Adriatic'. Lolo, the donkey owned by Frédé, proprietor of the famous Lapin Agile, was the real 'artist'. Two jokers, the poet and journalist Roland Dorgeles and André Warnod, had tied a paint brush to the donkey's tail and held a blank canvas against it. First they fed Lolo with oats, then they emptied tube after tube of colour on to the canvas as the donkey lashed wildly. The result, 'producing an extraordinary mixture of colour and weird effects', drew the crowds, to the fury of the Cubists. They, however, received publicity and extensive coverage in the press. Modigliani's name was mentioned once by Apollinaire in one of the four daily columns he wrote in *L'Intransigeant*. André Salmon, who later appointed himself Amedeo's champion, managed one mention in a large article taking up a page and a half of the Paris *Journal* (18 March 1910). The critic Arsène Alexandre is also said to have praised Modigliani's paintings at the Salon des Indépendants, but no trace remains. Modigliani sent home the cutting, at least his name was in print. 'What a thrill I gave them,' he told Latourettes. In his heart he knew that he was still faced with the struggle to survive.

Paul Alexandre was still the only buyer he could count on. 'I paint at least three pictures a day in my head,' he told a friend who reproached him for his idleness. 'What's the use of spoiling canvases when nobody will buy?' For whole days Modigliani dragged his canvases to the dealers and as a last resort to the cafés. But he always sold his work defiantly and could not bring himself to be obsequious or pleasing to prospective customers. On one occasion when a dealer, eager to buy a batch of Modigliani's drawings, tried to beat the

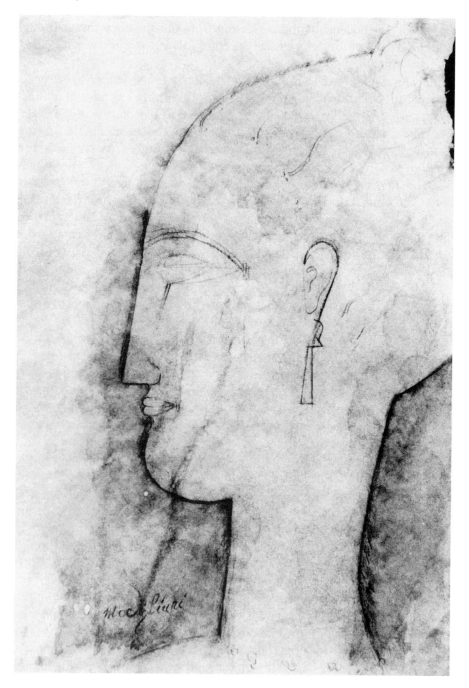

Head of Caryatid.

painter down from the modest price he had asked, Modigliani argued quietly at first. The merchant offered ten francs, then lowered it to a final offer of five. Modi refused to haggle. He grabbed a knife from the counter, jabbed a hole through the batch, tied them on a string and marched to the latrine at the back of the shop and hung his delicate drawings on the hook beside the lavatory.

Anecdotes of Modigliani's life in Montparnasse often seem to jar against the haunting nobility of works like 'The Cellist'. Yet the encounter with Anna Akhmatova, the Russian poetess, in 1910 and 1911 seems to step straight out of a Modigliani canvas. Anna was 22, recently married, romantic, enigmatic and beautiful. Years later she remembered Modigliani, nobly courteous, 'enclosed in a ring of solitude.' He never mentioned past love affairs, spoke the name of a friend or talked of mundane matters. Anna was captivated by the solemn young man with golden eyes who worked at his sculpture in the courtyard of the Cité Falguière.

Presumably one of the Russian artists introduced them. When he escorted Anna to the Louvre, he took her straight to the Egyptian department, dismissing all the other galleries as of no importance. Later he made about twenty drawings of Anna as Nefertiti. Only one exquisite sketch remains; the rest were lost or confiscated. When they passed the Venus de Milo Amedeo turned and remarked: 'Women of a beauty worth painting or sculpting often seem encumbered by their clothes.' One summer evening in the Luxembourg Gardens the two sat together on a public bench (Modi hadn't the money for deck chairs) and recited Verlaine, sheltering from the soft summer rain beneath his vast, dilapidated black umbrella. Through a misunderstanding, Anna went to his studio one day to find Modigliani out. So she threw the red roses she had brought into the upper window above the big studio door. They landed so gracefully on his bed that he thought she had arranged them for him. At night she would hear him wandering through the sleeping streets, his shadow slowing down as it passed her window.

Throughout the winter Modigliani wrote to her, but sadly those letters are gone. To Anna, as to Oscar ten years earlier, Modigliani would have revealed his aspirations and his inner feelings. As an artist, with a gift of psychological insight, he was uncomfortably aware of the true nature of the people he met. With a poetic nature like Anna's Modigliani could be himself.

He told her that he was taking hashish to heighten his perceptions. Perhaps it also gave him the courage to develop in his own way. She remembered his utter indifference to the fashionable. Cubism was foreign to him (although later he was to incorporate certain cubist elements in his work) and he confessed to Anna that he was 'one of the victims of Picasso'.[8]

This echoes André Salmon's comments on Modigliani paintings at the 1910 Salon des Indépendants.

Although he was naturally truthful, he was far from literal-minded and was sometimes a perplexing companion. His aunt Laure, who tried to keep in touch after he returned from Livorno, was never quite at ease with this nephew. She worried about his health, his strange habits and the odd company he kept. When she visited Paris he escorted her politely and considerately round the city, and his knowledge of the museums and galleries was a wonder to her. 'Tante Nature', he called her teasingly, since she knew nothing of art. But she never knew what to expect. One day, when she told him garrulously that she had managed to prevent an old woman from crossing the street just in time to save her being run over by an approaching motor-car, he looked at her quizzically and said: 'So you save old ladies, do you?'[9] In August 1911 Laure rented a small house by the sea at Yport and tried to persuade Amedeo to leave Paris with her. He still had a weakness in the lungs and a bad cough and she thought that the sea air would do him good, but he procrastinated and delayed his departure twice. One likely explanation is that on 21 August the sensational news that the Mona Lisa had been stolen from the Louvre electrified the art world. Apollinaire, the critic and writer who, that year, had sold some of Modigliani's paintings for him, was arrested and imprisoned on 7 September and released a week later. Picasso, who had earlier bought stolen statuettes from the Louvre for a prank, was also suspect. Both men were cleared but among the artists the effect was explosive and Modigliani must have been loath to leave Paris.

His aunt Laure remembered his arriving in Yport at the beginning of September. She had already given him money for travelling expenses three times: 'I knew perfectly well how he was spending it in Paris; he was buying paints and settling small debts, and up to that point I understood his behaviour and approved of it. What I could neither understand nor approve of was his arrival at the Villa André in an open carriage, soaking wet. With the little money left over from the third lot, after he had paid his travelling expenses, he suddenly decided to treat himself to a trip to Fécamp. He had heard of the beauty of its beach, a few miles from Yport, and, in spite of the downpour, he wanted to have a sight of it without wasting any time.' Laure's reaction was somewhat exaggerated: 'You will understand what a weight his amazing folly placed on my shoulders. I felt that I had made an enormous mistake in bringing an invalid who calmly exposed himself to all weathers to such a damp climate. I was haunted by the terrifying idea that I would find myself with no means of heating the house, with no means of avoiding a

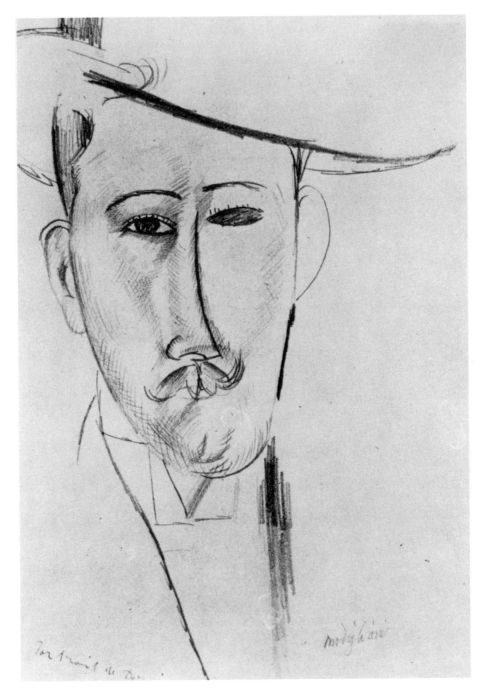

André Derain, 1918.

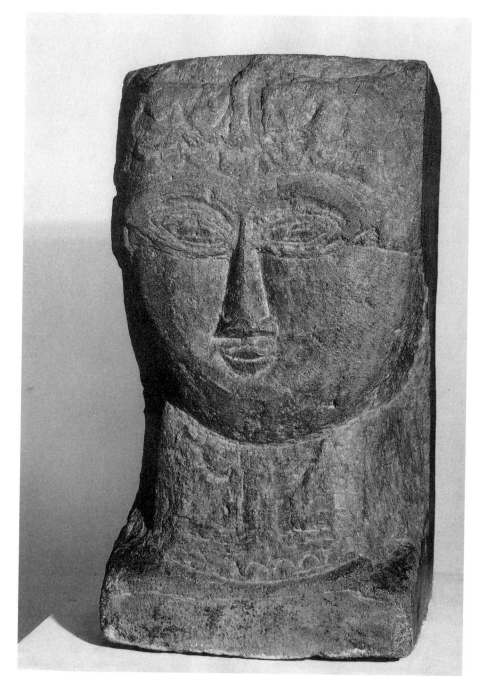

Woman's head, 1912.

return of his illness, in a village where I knew no one except the peasant woman whom I had taken on as maid-of-all-work. No! it was absolutely impossible to do anything to help him. We left Yport – Dedo thought, because of a whim of mine – without, so far as I can remember, having spent even a week together.'

Modigliani's restlessness was reflected in a bewildering number of moves. Where he lived was not always certain, even to himself. He sometimes spent all night in a café, or at the railway station, and often stayed in friends' studios. Sometimes he spent the night with Adolph Basler, the dealer: 'My wife and I slept on one side of the studio and I put the other end of the room at his disposal. I always found it difficult to wake him in the morning and get him up because he was usually drunk.'[10] Drunk or sober Basler found Modi charming and modest. The Baslers had the large self-portrait of Derain with a pipe in their studio and believed that Modigliani was greatly influenced by Derain at the time. One day when he was getting dressed, half asleep, he looked up at the Derain painting and said with a smile: 'Ah, ah. There is a painter of masterpieces.'

Between 1910 and 1912 Modigliani moved frequently, sometimes back to Montmartre where he lived for a time at No. 39, Passage de L'Elysée des Beaux-Arts. An abandoned convent on the Rue Douai became a temporary home when he fell in love with a young actress who belonged to a bohemian troupe acting in the gardens of the convent. One day in 1910 he sold some paintings and celebrated the rare event by buying some furniture for his room and inviting all his friends round to a party. The rowdy gathering woke the landlord in the middle of the night. Furious, he sent the guests packing and demanded his back rent on threat of confiscating the furniture. Early that morning the artist's friends stole back into the room and helped to ease Modi and his newly acquired furniture out of the window.[11]

Understandably he is remembered through these wild parties, yet it seems remarkable that close friendships with Anna Akhmatova and with Amedeo de Souza Cardoso only came to light almost forty years after his death, despite the vast literature about him.

Cardoso, a Portuguese artist from a well-to-do family, arrived in Paris the same year as Modigliani. At first he studied architecture, but soon decided to become a painter. In 1909 Cardoso lived for a time at the Cité Falguière, the haunt of other Portuguese artists. They may have met there or possibly at some Montparnasse bar, where the poet Max Jacob, a friend of both men, introduced them. In some ways they were very similar, handsome, distinguished, given to mad pranks, yet sensitive and gentle. Cardoso's life was much more comfortable than Modigliani's, as his family could afford to

send him a generous allowance and Cardoso was no drinker. In artistic style, as well as in temperament, the two friends became close. 'Only Cardoso's more highly coloured use of drawing . . . and the more decorative value of his line allow us to distinguish his works from those of Modigliani . . . Cardoso's line is an arabesque, an end in itself, or is used to suggest colour; Modigliani's is an outline meant to suggest volume and depth of plane'.[12] The two artists encouraged each other, and in 1911, when Cardoso exhibited at the Salon des Indépendants, Modigliani went to see his friend's six exhibits and stayed looking at them for a long time. 'There, there', he pointed excitedly, 'it's almost great. He only lacks a little courage and then he'll be able to shit on all those daubers . . .'[13]

That year, 1911, Cardoso had married and moved to a new and spacious studio in an imposing building, No. 3 Rue du Colonel Combes, near the Quai d'Orsay. Ignored by the gallery owners, the two Amedeos decided to hold their own Exhibition, probably in the autumn.[14] Cardoso generously offered to share his premises with Modigliani and the pair sent out invitations to their friends. Cardoso's colourful paintings and drawings as well as a number of Modigliani's caryatids decorated the walls. Posted about the floor stood seven of Modigliani's marvellous, mysterious heads, carved in limestone. The guests, including Apollinaire, Max Jacob, Picasso and Ortiz de Zarate, came to view the exhibits and enjoy a drink. But although individuals of discrimination may have admired their work, the critics ignored the brave attempt and nothing was sold.

Almost a year later, in the summer of 1912, the sculptor Jacob Epstein arrived in Paris to complete his work on the tomb of Oscar Wilde on site, at the stately Père Lachaise cemetery. One morning he came to put the final touches to the carving of the head, only to find the tomb covered with an enormous tarpaulin and a gendarme standing on guard beside it. He was told that his work was banned. The figure had offended Parisian prudery, although it had been praised by critics in England. A few days later Epstein brought a party of artists with him to show them the tomb, and as they removed the tarpaulin a gendarme came hurrying up and covered it again. Artists and writers joined in protest in the press and issued a manifesto.

Among Epstein's first friends in Montparnasse were Picasso, Ortiz de Zarate, Brancusi and Modigliani. Epstein's fiery temperament as well as his talent appealed to Modi. The two men became good friends, and even planned to work together. They trudged all over the Butte in Montmartre looking for an empty shed and a suitable grass plot where they could work side by side in the open air. But the sight of the two wild-eyed artists aroused the suspicion of caretakers and landlords, so after an unsuccessful day they

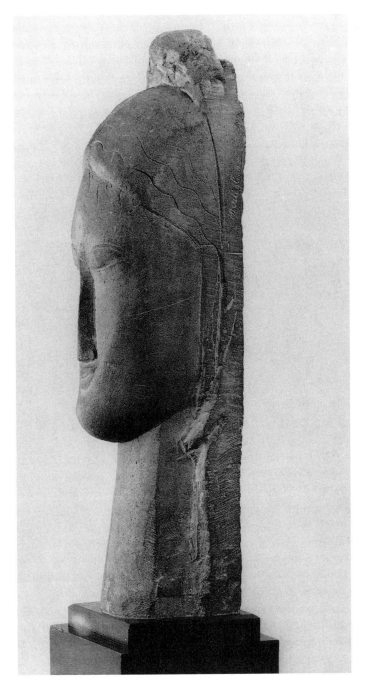

Woman's head, 1912–13.

consoled themselves with a meal at a good Italian restaurant. Everywhere Modigliani was welcome: 'All bohemian Paris knew him. His geniality and esprit were proverbial.'[15] Their favourite haunt was Rosalie's, a forlorn little Italian restaurant in the Rue Campagne Première with four marble-topped tables where Rosalie, a former artist's model, served them with simply hearty food, spaghetti, stews and pungent cheeses, for a modest sum. Amedeo was a favourite of hers. They would talk loudly in Italian, gesticulate and she would scold him for abusing her other clients. 'A beefsteak is more important than a drawing,' Modi would say. 'I can easily make drawings, but I can't make a beefsteak.' If someone exasperated him (and Epstein felt that Modigliani's abuse was always well deserved) he would attack them with great energy. 'With friends he was charming and witty in conversation and without any affectations'. Often Italian stonemasons ate at Rosalie's crémerie and Modigliani liked their company; he had a great respect for craftsmen. They, in their turn, accepted him to the extent that Modigliani was allowed to work in a quiet corner on the building site, where they lent him tools and smuggled him stone. When that was not possible, he would buy a block of ordinary stone for a few francs and wheel it back to his place. His studio was 'a miserable hole within a courtyard' when Epstein saw it. Standing in it were nine or ten long heads suggested by African masks carved in stone '. . . At night he would place candles on top of each one and the effect was that of a primitive temple. A legend in the quarter said that Modigliani, when under the influence of hashish, embraced those sculptures.'

Like Anna Akhmatova, Epstein noticed Modigliani's restlessness at night. 'I recall that one night, when we had left very late, he came running down the passage after us, calling us to come back like a frightened child.' Some invalids who have spend a great deal of their early life in bed dread the night. And in Modigliani's case, since lying down exacerbated his cough, his reluctance to submit himself to sleep is more understandable.

Although all bohemian Paris knew him as a character, it was only the artists of Montparnasse who knew his work. By then he was making drawings in the morning to sell in the cafés at night in order to carry on sculpting. The work was exhausting and he was drained by the anxiety and the isolation of his life. Yet the physical effort of sculpting, imposing his will on the stone, gave him a sense of satisfaction and a rare peace that nothing else could equal. Ever since his adolescent visit to the great art cities of Italy, Modigliani had dreamt of creating an architectural, life-sized sculpture that would ennoble the environment. 'The heads in stone and the many drawings for caryatids . . . show to what an extent he understood the formal power of sculpture'.

'You are not alive unless you know you are living', he scrawled on a studio wall. To develop as an artist in his particular way he had to allow himself to be vulnerable, to go beyond himself. He told Epstein of a book he kept by him, *Les Chants de Maldoror*, an explosion is how he described it. The author, Isidore Ducasse, who adopted the romantic pen-name of the 'Comte de Lautréamont' was considered insane by early critics; although published during his lifetime, his prose poems were never put on sale in the bookshops for fear of prosecution. Through his hero, Maldoror, Lautréamont set out to explore the realm of evil and to challenge the taboos of society. In scenes of powerful and arresting imagery, God visits a brothel, a beautiful young girl is violated by a shepherd's dog and Maldoror couples with a female shark. Maldoror inhabits this nightmarish world in a state of trance, induced by sleeplessness. Clearly Modigliani found an echo of his own nocturnal restlessness in the author who delved into the unconscious mind. Modigliani saw Maldoror as a liberating force, a work which amplified his imagination and he gave copies to his artist friends. The book excited André Gide 'to the point of delirium' and, significantly, the Surrealists claimed it as their Bible in the 1920s. Modigliani told Nina Hamnett that Maldoror had been the making or the ruin of him. Undoubtedly the book had a profound effect on him, but the only indication that it influenced his work was an inscription on a drawing of a caryatid in 1913: 'Maldoror to Madame.'

Unlike most of the other artists in Paris, in all the eight years Modigliani lived there before the First World War he had no wife or constant woman friend and was frequently without a place of his own. With his attraction for women and his lone status, the stories about him were legion. One evening at the Closerie des Lilas, the café where Paul Fort, the Prince of Poets, held court and arranged poetry readings, Modigliani was sketching at a table when a wealthy businessman's wife noticed him. Modigliani began to draw the lady and, intrigued, she wanted to meet him. He was summoned to their table and given a commission to paint the fashionable woman. The sessions took place in a summer-house in the garden of the businessman's home. The husband was mysteriously absent, abroad on business it was assumed, and Modi was painting furiously. One afternoon the businessman walked in unexpectedly to find his wife posing in the nude. Almost demented with jealousy, he was about to pounce on his wife and throw Modigliani out, but the artist turned on him so ferociously, yelling menaces and grinding his teeth, that the master of the house fled, terrified. A private detective was hired to keep watch on the lovers. One afternoon when Modi was out, his mistress was kidnapped. When he came back all that he found in the empty summer-house were his magnificent nude paintings. According to the fertile legend, Modigliani

introduced the lady to drugs and after a time she was confined to a nursing home where she died. All this drama was laid at Modigliani's door.

The English war artist, C.R.W. Nevinson, shared a studio with Modigliani and was a friend from 1911 until Modigliani died. He described him as '. . . a quiet man of charming manners . . . I knew him as well as, if not better, than most men . . . Modigliani should have been the father of a family. He was kind, constant, correct and considerate: a bourgeois Jew', and added, 'he loved women and women loved him. They seemed to know instinctively that though he was poor, they were in the presence of a great man. Painters were two a penny in Montparnasse, yet even the most mercenary of the girls would treat him as the painter and the prince. They would look after him, scrub for him, cook for him, sit for him; and before they went away they would beg him to accept a little gift "for art's sake"'.[16]

Montparnasse revelled in gossip and many of those who wrote later about Modi picked up their knowledge of him in the cafés. A company of poets and journalists were well qualified to weave a lurid yarn from the wispiest thread. Certainties in Modigliani's life were few, and he was exhibitionist enough to play jester to the fools who baited him. In the cafés, artists and poets outdid each other in outlandish wear: cowboy hats, top hats, stocking caps, straw hats. To be in the 'swing' they smoked opium, swallowed pills of hashish and drank cheap red wine. Money did not matter, but you did need a biting sense

of humour to score with the crowd. Among so many talented, ambitious young artists there were rivalries long forgotten in the eulogies that followed an artist's death.

Modigliani did not need to dress up or follow others to be memorable. Despite a sarcastic tongue for stupidity, he was a wonderful companion, witty, exuberant and full of life. No one who knew him at the time would have recognized the tragic hero of romantic biography. The American sculptor Jacques Lipchitz met him in 1912 or 1913 one summer day in the Luxembourg Gardens. He was introduced by Max Jacob. Modigliani began to recite Dante's *Divine Comedy*, so eloquently that although Lipchitz could not understand a word of Italian he was entranced. Modigliani invited Lipchitz to his studio at the Cité Falguière. One afternoon Lipchitz passed by to find Modigliani working outdoors, stooping over five of his limestone heads, adjusting them, one to another. Modigliani was delighted to see his new friend and explained that he conceived of the heads as an ensemble. The two men spoke of sculpture. Like Brancusi, Modigliani believed that contemporary sculpture was decadent, corrupted by Rodin's influence. Sculptors were modelling too much in clay, 'too much mud',[17] he explained. The only way to revitalize the art was to carve directly into the stone. Lipchitz disagreed and they argued vehemently. Modigliani insisted that the nature of the stone itself, hard or soft, made very little difference to the finished work. The sculptor himself gave the stone the feeling of hardness, he insisted; that came from within. Some sculptors made their work look soft, regardless of the material they used, whilst others could use the softest of stones and give their sculptures a hardness. That was what Modigliani did; he worked in limestone, yet his heads and figures have a feeling of solidity. The comments were characteristic: 'His own art was an art of personal feeling. He worked

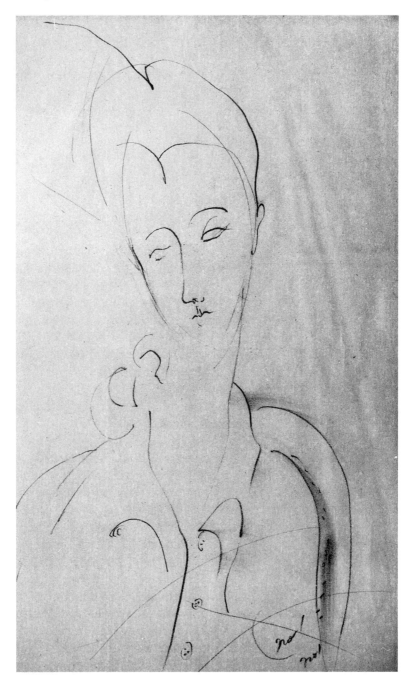

Non (left) and Si (right). Two drawings from a series of seven of the same model.

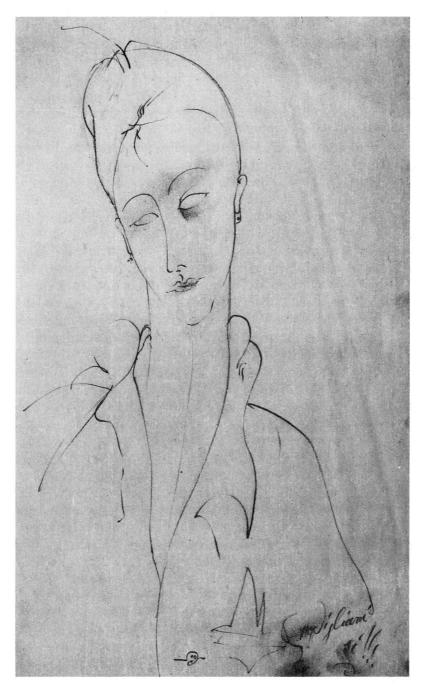

furiously, dashing off drawing after drawing without stopping to correct or ponder'. This account by Lipchitz helped to create the myth, for although Modigliani worked rapidly, he produced sketch after sketch before he was satisfied and he did occasionally use a rubber.

Those large stone heads Lipchitz had seen in Modigliani's courtyard were accepted by the Salon d'Automne and exhibited 'stepwise' like tubes of an organ. The exhibit was titled 'Decorative Ensemble' and made a strong impression on a handful of artists. But Modigliani was ignored by the critics and the familiar pattern of disappointment persisted. Perhaps it was the discouragement of the cold weather that prevented him from doing very much work on his sculpture during the winter of 1912–13. Individual friends found him in desperate circumstances. Brancusi visited the Cité Falguière one day and was alarmed to find Modigliani lying unconscious, close to a block of stone he had been carving. He had dropped from sheer exhaustion. But there were moments of defiance too. One night Brancusi came to see Modi with a group of artists. After they had all drunk quantities of red wine, they decided to go to Les Halles for onion soup. Modi and Brancusi broke away from the crowd, grabbed baskets of vegetables from the market and handed them out to passers-by, shinning up the lamp-posts as they weaved their way home.[18]

For part of that winter Modigliani lived in a hovel at the bottom of the garden of No. 216, Boulevard Raspail, almost frozen with cold, his hut cluttered with debris, stones and unfinished figures. When the concierge discovered he was ill, police using stretchers had to clamber over the frozen stones to rescue Modi. Ortiz de Zarate, a staunch friend, was so worried when he called round and found Modigliani in a faint that he took up a collection to raise money for his fare home. Dates and places in the Modigliani story, recalled in a haze of sentiment after many years, are often muddled. But Paul Alexandre, the doctor who continued to buy his work, remembered distinctly that Modigliani brought a handcart, loaded with about twenty sculptured stones, to his house for safe keeping in April 1913. The artist was tired and worn out, planning a vacation in Italy.

Although Modigliani had been working as a sculptor for four years, he had not sold a single work until Augustus John visited the studio in 1913 with his wife Dorelia. John found the studio floor 'covered with statues, all much alike and prodigiously long and narrow' and bought two of the large heads for a few hundred francs. Delighted at the sale, Modigliani went back to Montparnasse with John and his wife, pressing a well-thumbed copy of his precious book, *Les Chants de Maldoror*, on his benefactor and murmuring in half-mocking style 'How chic to be in the swim'.[19] John was half amused, half

irritated by Modigliani. Modi was a charming and modest companion when he was sober; he described himself as a 'decorator', a maker of garden statues. But when he had swallowed pills of hashish, he became impossible, insulting passers-by.

The stone heads John bought produced a powerful effect on him: 'For some days afterwards, I found myself under the hallucination of meeting people in the street who might have posed for them . . . Can Modi have discovered a new and secret aspect of reality?' Strangely, his paintings affected Epstein in a similar way. 'I was amazed once when we were at the Gaieté Montparnasse (a small music hall) to see near us a girl who was the image of his peculiar type, with a long oval face and a very slender neck. A Modigliani alive.' Artists perceptive enough to recognize it saw that Modigliani had created his own haunting world and his vision affected their view. Since he left Livorno, he had produced some revolutionary, if unrecognized, sculpture, and had changed himself almost beyond recognition. At home he could no longer keep up even the pretence of conformity.

He arrived in Livorno in the hot summer of 1913, looking ill and drawn. More restless than ever, he rushed out to visit his friends at the Café Bardi. From the beginning there was misunderstanding. Dedo dashed in and shouted for his old friends from Micheli's Academy, Romiti and Natali, behaviour both crude and incomprehensible to the courteous provincials. And he looked wild, with his head shaven 'like an escaped convict', no shirt under his linen jacket, only a vest, his trousers tied up with string, a pair of espadrilles on his feet and another dangling from his wrist. He told his friends airily that he had come back to Livorno to buy the comfortable rope-soled shoes and added that he was dying for a *torta di ceci* (a small chickpea tart). When he suggested a drink and ordered absinthe they were convinced that Dedo had fallen prey to Parisian ways. When Dedo insisted on talking about his sculpture and refused to discuss painting at all, his old friends were amazed. The young artists were frankly baffled by the photos he produced so proudly of elongated heads, with their 'sad, secretive expressions'. In their eyes his obsession with primitive sculpture was fanatical and for him, as always, there was the disappointment. 'I can still see him holding those photographs, admiring them himself and calling on us to admire them too – while all the time his enthusiasm and melancholy were increasing'.[20]

The irony of the position did not escape Modigliani. As a student he had been the visual explorer, pointing the way to his friends, and now here as in Paris he was dismissed as a wilful eccentric. He said nothing, merely asked them to help him to find a place where he could work and to bring him some paving-stones. They were reluctant, but as he persisted they found a big

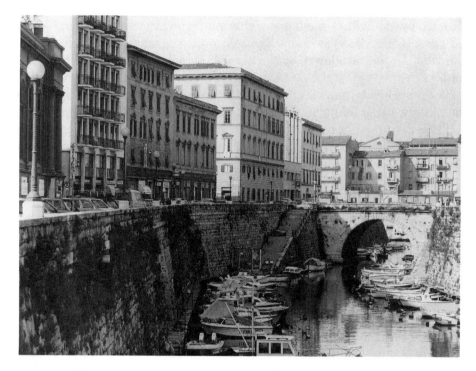

The Canal, Livorno.

store-room near the market for him and Modigliani closed himself in to work. No one was invited to visit his makeshift studio.

The family was of course concerned at the deterioration in his health and felt that it would be dangerous for him to return to Paris. At first they tried to find a suitable studio in Livorno. Then they heard of a place in Carrara, which has one of the largest marble quarries in the world. Amedeo went with his eldest brother to look at it, first by main-line train for an hour, then they had to change to a slow train which made Amedeo restless. Emanuele found the place quite beautiful. The studio was a small house surrounded by a garden full of flowers, protected from the wind. Large slabs of marble were lying about on the beach, and in the garden near the house. Emanuele pointed out that the place was ideal, but Amedeo was nervous and excitable. He said: 'Yes, yes. You are right, it's all true, but this place is not for me. It's too remote. I can't stand that. I need a big city to be able to work'.[21] He became so agitated that they left for Livorno immediately and the matter was never discussed again.

Caterina was again sent for to make a new suit for Dedo and Amedeo

travelled back to Paris in the autumn. Before he left, he asked his friends from art school if there was anywhere where he could store his sculptures. They shook their heads, and when he persisted in asking them what he should do with them they chorused in one voice: 'Throw them in the moat.' The mystery of what really became of his sculptures remains to this day . . .

The turbulent years

EVERYONE in the artistic world of Montparnasse knew Modi, drank with Modi or had been sketched by him. When he came back from Livorno in the late summer of 1913 he made straight for the Café Rotonde, to be greeted rapturously by artists and models on the terrace. Drinks were ordered and the crowd celebrated Modi's return. He was in top form, witty and debonair, and the party continued until the next day when Modigliani, still in a happy mood, became so rowdy that he had to be thrown out and locked in a police cell all night. Senior police officials profited from their prisoner. Commissioner Descaves bought up canvases ten at a time, at a hundred francs each. Zamaron bought the paintings of both Modigliani and Utrillo and let them out after a sobering night in the cells. Sometimes Zamaron entertained the artists at his home.

At the age of 29, apart from a reputation for wild behaviour, Modigliani had little to show for his seven years in Paris. His marvellous carvings were unappreciated, some of them lost, broken or half finished: his painting output had dwindled. It was still unthinkable to see him without his sketchbook and pencil, but of the hundreds and hundreds of drawings he made, he gave away many or sold them for a few francs. All around him his friends and contemporaries were exhibiting and selling their work, some of them under contract. Cubism was the rage, but Modigliani remained aloof. When Charles Beadle, an English journalist living in Paris, asked him what his manner was, he replied imperiously: 'Modigliani. When an artist needs a label he is lost.'[1]

But his talent did not go entirely unnoticed. Art dealers were beginning to realize that paintings could become valuable investments for speculators. The market in modern art was not yet developed and contemporary painters rarely had a one-man show. Paul Chéron, Modigliani's first dealer, a former bookmaker and wine merchant from the south of France, had entered the business through marriage. His father-in-law owned one of the best-known galleries in Paris on Place Saint-Augustine. Chéron lacked the finesse of the old-established dealers in the art world, but he brought energy and a flair for spotting new talent to the trade. He deliberately cultivated a policy of signing up young, unknown artists whose works would appreciate. To encourage speculators Chéron published a brochure, assuring his would-be customers that by collecting paintings of promising young artists and selling them ten or fifteen years later, they could realize an increase of five to ten times on the purchase price. A gambler by instinct, Chéron listened to the gossip and hung about in the artists' cafés. Foujita, the Japanese artist, swore that the dealer bought the artists drinks and gave them a contract to sign when they were drunk. Modigliani and Utrillo were not difficult to enlist by this method. Chéron also made sure that his string of artists produced. He considered that he gave Modigliani a fair deal: 'He came to my shop about ten o'clock in the morning. I shut him up in my cellar with all he needed for painting and a bottle of cognac, and my maid, who was a very pretty girl, served as his model. When he finished, he kicked at the door, I opened it and gave him something to eat. And a new masterpiece was born.' To economize, Chéron sent his wife to pose for Modi, but he was furious and sent the unfortunate lady upstairs. The maid was a young country girl, more acceptable as a model, and Modi painted her as 'The Girl With Red Hands'.[2] Chéron paid Modigliani a louis, a gold piece worth twenty francs, for his day's work in his shop on the Rue de la Boétie. The arrangement allowed Modigliani materials, food, and a model but the status of hired hand was humiliating and Modigliani hated it. The contract between two individuals with such

opposing values obviously could not last. Chéron boasted of Modigliani's masterpieces. One day Modi had made a collage by pasting a verse from a popular song around a painting, in Cubist fashion. Chéron took it off and replaced it with a poem by Baudelaire, considering that he had elevated the tone. Appalled at the dealer's vulgarity and furious that he had changed the work, Modi told Chéron he was a cheapskate. In the fierce row that followed the 'contract' was dissolved. Apparently Chéron hid Modi's clothes to keep him in, for Brancusi claimed to have rescued the stranded painter by buying him a jersey and a pair of trousers so that he could go out into the street.[3]

Almost all Modigliani's portraits have an air of mystery which raises them above the level of the mundane. The portrait of Chéron, however, shows a mild, mean little man with bowler hat and moustache, sitting legs wide apart as if astride a horse. His eyes are pinpoints, surely the smallest in any Modigliani portrait, as if to reveal to us the man's utter lack of vision. The painting is dated 1917, but was probably earlier, since dealers preferred to date the works from Modigliani's more profitable years.

There were affairs inevitably, and important friendships were made that year. Gaby, a handsome woman of 30, was a very experienced and alluring person, madly in love with Modi. The love affair gave him new life, he looked better, drank less and stayed away from the cafés. Gaby also shared her favours with her 'official' lover, a lawyer without a practice. When he came to hear of her liaison with a penniless painter, his vanity was stung and he insisted that 'honour' be satisfied. He demanded an interview with Modi at the Café Panthéon on the Boulevard Saint-Michel. On the appointed day Modigliani appeared looking confident and distinguished in his cords and red scarf; he ordered a good bottle of wine and began to rhapsodize about Gaby's beauty and charm. No man of distinction, he insisted, certainly no artist, could fail to fall for her. The affronted lover tried to interrupt, to insist that Gaby was under *his* protection and that the arrangement was impossible, but Modigliani insisted that he had painted several portraits of Madame in the nude that would be worth 'thousands' one day and pressed one on her luckless lover. The toasts to Gaby, the protestations persisted and in the end the two reeled out of the café arm-in-arm at two in the morning swearing eternal friendship. Without his love of women, so often reciprocal, Modigliani would not have been able to afford to paint the beautiful women in his repertoire. He disliked paid models, and his success in love affairs and his access to 'free' models infuriated the bohemian community.

He was still extremely conscious of his position as an outsider in Paris. To friends and lovers he always made it clear that he was a Jew, perhaps to anticipate and reject the rebuff. Critics noticed that he was one of the few

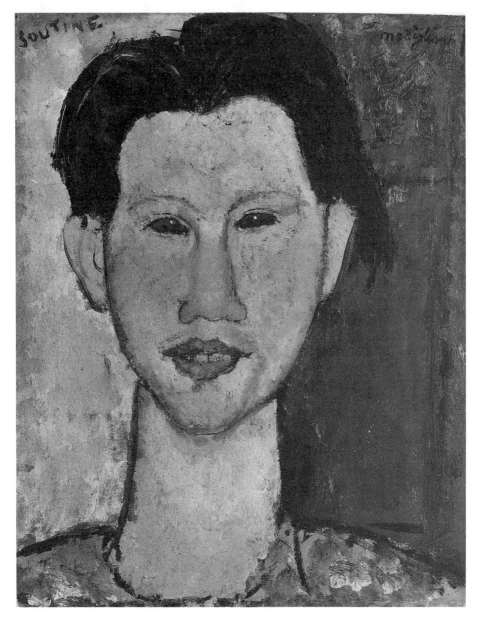

Chaim Soutine, 1915.

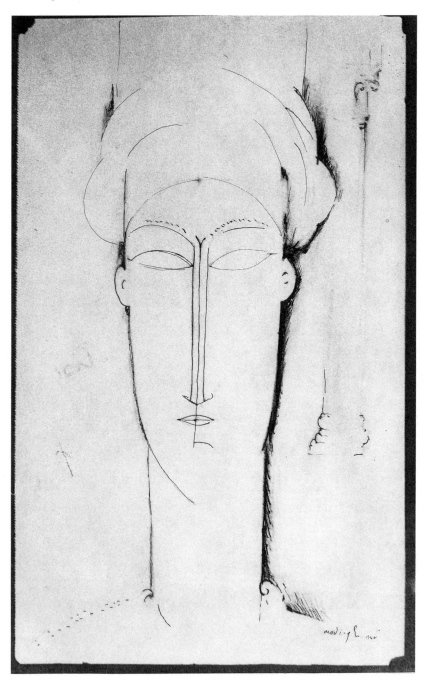

Caryatid, 1913.

artists genuinely enthusiastic about new talent. 'He never worried about exhibiting his work: never came to steal from neighbours; he lived in and for himself'.[4] The tribute may sound fulsome, but Modigliani showed exceptional appreciation of nascent ability. Years before others, he recognized the difficult genius of Chaim Soutine. The gauche, twenty-year-old art student from Russia with his stoop, short neck and thick lips, coupled with the crudest of manners, repelled most people at first. But Modigliani saw the torment in the deep, hooded eyes and admired the power and fantasy of his work. Through his friendship Soutine was introduced to other young artists and saw them work in their studios and Modigliani guided him round the Louvre, pointing out the Italian painters he admired, the primitives and Giotto, Botticelli and Tintoretto.[5] Soutine could speak hardly a word of French. Modigliani helped him with the language and, with surprising patience, taught him to wield a knife and fork, to use a pocket handkerchief and to mix in society. Modigliani was blamed later for encouraging Soutine to drink, but Soutine already had a taste for drink when he came to Paris. The difference between them was that Soutine slunk away ashamed when he was drunk whilst Modi displayed a theatrical abandon. One hot summer's night in 1913 Léon Indenbaum, a Russian Jewish sculptor, called round to visit Soutine at the Cité Falguière. The two men lay stretched out on their truckle beds with bowls of water placed round the room to attract the bugs. Modigliani was reading *Crime and Punishment* by candlelight, so engrossed in his book that at first he didn't notice the visitor. Then he looked up, slapped the book closed and said 'Dostoevsky: he was a man.'[6]

The vivid impression that Modi made on his artist friends, coupled with the resonance of the legend, makes descriptive anecdotes about him read like captions for frames in a film. Ossip Zadkine, a Russian Jewish sculptor, often repeated stories of encounters with Modigliani at the time, always with slight variations: 'Modigliani's studio was a glass box. Coming near, I saw him lying on this tiny bed. His magnificent grey velvet suit seemed to be floating aimlessly in a raging sea, as if petrified in the expectation of waking. Around and everywhere the white sheets of his drawings . . . made fluttering wave crests . . .'[7] And, more realistically, describing Modigliani on his work: '. . . He did not explain everything; we did not discuss sculpture itself. His only response to my comments as a professional sculptor was a pleased laugh . . .' And Zadkine referred to Modigliani's unfinished heads, outside in the mud, most of them still in a rough stage.

In 1912 Nina Hamnett, a modern and talented young artist from England, briefly visited Paris, where she met Epstein and his wife. Ever since the visit she had longed to be part of the artistic excitement of the city. In February

1914 she scraped together the money for the trip and took lodgings in Montparnasse in a foul-smelling room on the Boulevard Raspail. On her first night she went to eat at Rosalie's, the cheap restaurant Epstein had recommended. As she sat alone in the smoky little room eating her dinner, in walked a handsome man, with curly black hair and brown eyes, wearing a black hat and corduroy suit. He marched straight up to Nina and, pointing to his chest, said: 'Je suis Modigliani, Juif, Jew', and unrolled a roll of newspaper he had been carrying. In it were his drawings, curious long heads with pupil-less eyes, some of them in blue and red chalk. He gave her his price: five francs. Nina found them very beautiful, looked through carefully and chose a pencilled head and paid him. Then he sat down beside her. They tried to communicate and got on very well, despite the language difficulties.

By then La Rotonde, which had opened in 1911, had become the place for artists to meet, and every morning Nina met Modi selling his drawings for five francs (although in bad times he reduced the price to three francs). By twelve o'clock he had usually earned enough to live on for the day. 'He was then quite happy and able to work and drink all day.' Modigliani's studio was on the Boulevard Raspail where Nina lived. She glimpsed him through the glass walls of his studio as she walked past, his watch nailed to a tree so that he could see the time. The neighbours thought him very odd, because he would start to carve at two or three in the morning when he came home. One hot night he came home drunk and lay down on the flower-bed in the garden just outside the studio and fell fast asleep. Suddenly two cats on the roof dropped down on to his naked body and woke him. He ran yelling up the Boulevard Raspail into the arms of an astonished policeman.[8]

At the time he was hardly painting at all, concentrating on drawing and sculpting. Whenever she could afford it Nina tried to buy one of his drawings, but most of the artists thought he was simply a nuisance and told her she was wasting her money. She noticed, however, that 'Picasso and the really good artists' considered him very talented and bought his work. Modi's drink was wine, she said, absinthe when he could afford it; and every night he would sit beside Nina at the Rotonde and draw while she watched him. When he became too drunk or sleepy to go on he would put his head on her shoulder and go to sleep. She sat up straight, feeling proud but rather foolish. The atmosphere just before the First World War was free, live and very young. At Van Dongen's studio negro boxers sparred with the guests on Thursday afternoons, critics came in to drink liqueurs and Nina danced naked under a black veil. Every two or three weeks there were fancy-dress parties. At a certain stage in the evening Modigliani would decide to undress, unravelling the long red scarf he wore around his waist in theatrical fashion. Since they

knew exactly what was going to happen the others usually grabbed him, tied up the red scarf and sat him down. On Saturday nights the crowd stayed out nearly all night. One night Zadkine, Modigliani, Nina and Marie Wassilieff walked to a café in the Boulevard St Michel frequented by 'painted ladies, dull students from the Sorbonne and sometimes businessmen who bought everyone drinks. We drank cheap red wine and talked and laughed and sang'. Zadkine and Modigliani bought Nina a large bouquet of roses and at seven-thirty in the morning escorted her back to her hotel after a marvellous night. Nina and Modi flirted playfully. She was marked out by her brightly coloured stockings, some red, some yellow and some that looked like a chessboard. Early in the morning, after the Rotonde had closed, Modigliani would chase her up the street. One night he nearly caught her, so she climbed up a lamppost. and waited until he had gone. All-night parties, Nina dancing in the nude, Modi stumbling into the sketching class very drunk, the weekly visits to the Gaieté Montparnasse, a small, bawdy music-hall where they sat up in the gallery, all paint a happy-go-lucky picture. In Nina's stories it is Modigliani who was pushed off the bench, made to carry the beer in for a party. To her, at least, he seemed to be a part of the gaiety, having a wonderful time.

Jacob Epstein had been the unwitting means of introducing Nina Hamnett (Miss Hamlet to Montparnasse) to Modigliani by recommending Rosalie's restaurant to her. By coincidence it was also Epstein who brought Modigliani together with a woman writer who was to have a profound effect upon his life – Beatrice Hastings. At a party in Soho in 1914 Epstein was talking to Beatrice, who made it clear that she was at a loose end in her life. 'Go to Paris', he advised, 'there is a painter there who is a beautiful man and a genius – Modigliani.'[9]

At 35 Beatrice looked like the thoroughly modern woman she was, with high breasts, a little pert head, and a slim body. She wore smocked Liberty dresses and sandals and smoked in the street, considered very daring. On her bedpost, it was said, she notched up a mark for every new lover.[10] The daughter of a wool dealer from Hackney, Beatrice had spent much of her life in South Africa, where she married and then divorced a professional boxer. In London her intense interest in the occult and the mysterious Madame Blavatsky led to a meeting with Alfred Richard Orage, editor and owner of *The New Age*, an important weekly review of politics, literature and art. As Beatrice and Orage became lovers, she worked for the paper, assuming increasing importance editorially and soon writing about a third of the contents herself as reviewer, poet, satirist and literary adviser. *The New Age* numbered Shaw, Wells, Chesterton and Belloc among its contributors and

new writers encouraged by them both included Katherine Mansfield, Wyndham Lewis and Herbert Read.

A spirited campaigner for women's rights and for abortion at a time when birth-control was practically unavailable, Beatrice was sometimes incomprehensible and hysterical in her arguments, driven by her exposed position to extremes. She was passionately attached to Wyndham Lewis and advised all young artists 'to go on boozing and wasting' because they were such odd creatures.[11] 'Men have to do with morals', she wrote, 'women with conventions. It seems to have been against creative law that the female should be endowed with morals. Convention is less disastrous to culture than the nature of women unrestrained . . .'[12]

As her relations with Orage deteriorated her influence in the paper declined, and by 1913 he had replaced her column of literary criticism with his own. She had a cruel pen and a reputation for physical violence to match. By 1914, she described her domestic affairs as 'quite intolerable'. When she arrived in Paris in May 1914, she was in a dangerous frame of mind, footloose, resentful and spoiling for adventure. However, the charm of the city raised her spirits and her first impressions after a night out at an artists' ball were fresh and delightful: 'You can't walk home at dawn in Paris, even two hundred yards. The streets are all being washed. Much laughter, much applause for your frock, if it is chic. Three hundred people inside and outside the Rotonde, very much alive! Models arrived in a flame or a half-moon dancing down the boulevard to the ball and absolutely unmolested, an Indian in full war-paint, Spaniards, Chinese, Bacchus, everybody you can think of. No old fat men, no painted women: all young, agreeable and spirited.'[13]

Even in that company Beatrice would look original; sometimes she carried an open wicker basket with a live duck inside. A tangle of witnesses confuses the Beatrice/Modi romance. Both Nina and Zadkine claim the privilege of introducing them. And there is a third story of Beatrice passing provocatively by Modigliani's table at the Rotonde. He whistled after her and shouted a coarse word, whilst Beatrice looked down at him, unshaven and dishevelled, and asked who the big Sicilian was (an insult, of course to an Italian). 'Beatrice Hastings – poetess – Amedeo Modigliani – drunk', Picasso told her laconically. After the affair Beatrice described him sourly: 'A complex character. A pig and a pearl. Met in 1914 at a crémerie [Rosalie's]. I sat opposite him. Hashish and brandy. Not at all impressed. Didn't know who he was. He looked ugly, ferocious and greedy. Met again at the Café Rotonde. He was shaved and charming. Raised his cap with a pretty gesture, blushed to his eyes and asked me to come and see his work.' With hindsight, Beatrice's

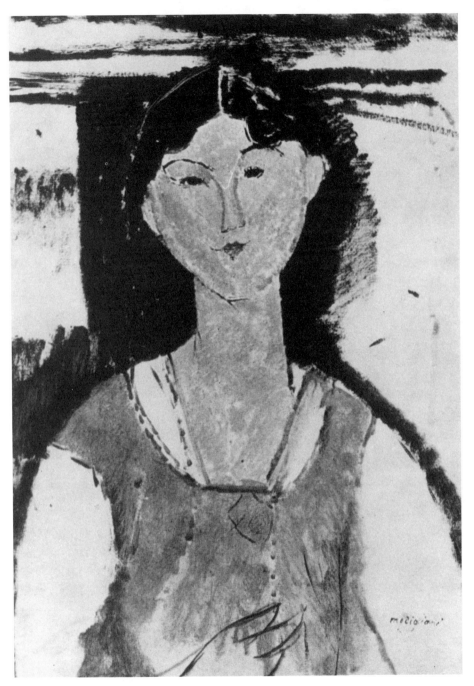

Beatrice, 1915.

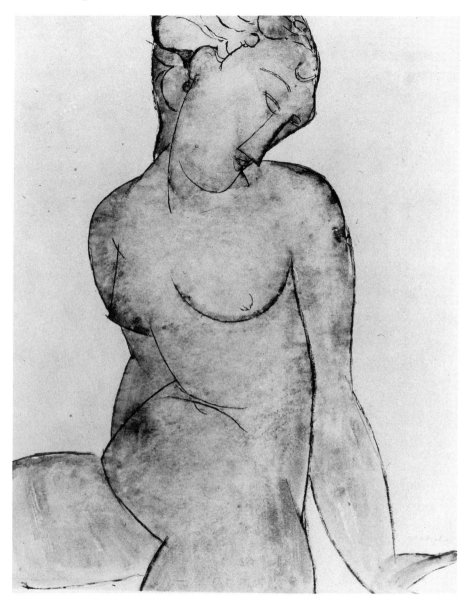

Nude.

remark that she was not at all impressed and didn't know who he was seems significant. She was looking for her genius . . .

In her column, which she used almost as a diary, she gives a charming account of the early encounters. In June 1914, she was sitting inside the Rotonde because the weather was cold and was delighted to shock 'the fair and pure English bourgeoise' by being 'very glad with the bad garçon of a sculptor. He has mislaid the last thread of that natty rig he had recently and is entirely back in cap, scarf and corduroy. Rose-Bud was quite shook with the pale and ravishing villain'. (Nina Hamnett mentions a new outfit of blue suit and yellowish brown cap that Modigliani had bought just like Picasso's, with money from the sale of a head. Then he fell in the mud . . .)

A week later, 11 June, her column is full of the sculptor tempting her: 'You're only seeing Paris . . . come and see "Par-ee" . . . leave all these people' (Modigliani delighted in showing his visitors the *real* Paris). 'I thought it was like London when we sat in the cinema', she went on. '"Ah! j'adore ça", he said and never looked at a single picture. "You mustn't go to sleep on my shoulder", I objected, "all the world knows you". "Not a soul," he said and waved anew to somebody else. "You mustn't fall in love with me . . . it's no use – yes, do! No, don't, it's no use." "Don't be absolutely ridiculous," I said. "You're much more likely." "Ah! that's all accomplished", he said, "but you look at me responsively, like my first statue . . ."'

In her obsession with Modi, Beatrice glosses lightly over more weighty concerns. There was no female suffrage in Paris that she could observe. She remarked tartly: 'The women count money all day long and make love on Sunday . . .!' But when she writes of herself, her tone is almost girlish: 'The romantic world seems to have supposed that I kissed the sculptor last week. Not a bit of it . . .!'[14]

In the opening stage of their affair she could not keep her column free of the subject of her lover, even indirectly. Walter Sickert, the English artist, a contributor to *The New Age*, praised Parisian artists who had the courage to sell their drawings in the cafés. Apparently in Paris the 'aesthetic nuts' disapproved of the practice. 'Nuts are awful bores . . .', Beatrice remarked casually.

On 9 July, for the first time, she manages to introduce Modigliani's name to readers of *The New Age*. She had been twice to see Rousseau's paintings very reluctantly. Although they were in vogue she could not abide them: 'What beats me is when an unsentimental artist like Modigliani says: "Oui, très joli" about them. One of Modigliani's stone heads was on a table below the painting of Picasso and the contrast between the true thing and the true-to-life thing nearly split me. I would like to buy one of those heads, but I'm sure

they cost pounds to make and the Italian is liable to give you anything you look interested in. No wonder he is the spoilt child of the quarter, enfant, sometimes terrible, but always forgiven.' (A sentimental view if one contrasts it with Nina Hamnett's, who said that most people found him an awful nuisance.)

'"Nothing's lost," he says and bang goes another drawing for 2d. or nothing, while he dreams off to some café to borrow some paper. He will have, as an art dealer said to me, "a good remember". They say here that he will do no more of these questionless immobile heads as his designs begin to set the immobile against the mobile. He is a very beautiful person to look at when he is shaven, about 28 I should think [he was just 30, as she probably knew], always laughing or quarrelling à la Rotonde . . . he horrifies some English friends by tubbing at two-hour intervals in the garden and occasionally lighting up all after midnight, apparently as an aid to sculpturing Babel.'

Early entries about Modigliani are all written in this playful, slightly sardonic tone. In the middle of July she left Paris for a brief trip to England. Modigliani stopped her taxi as it was crossing Montparnasse and implored to be allowed to ride with her, and even that was relayed to her readers. 'It was so chic, like being his rich uncle who died of the gout. On the station Modi fainted loudly against the side of the carriage and all the English stared,' she wrote gleefully. 'Modi was muttering "Oh! Madame, don't go". "Modig-liani", someone said, "you've been three years fiddling about with one type of head and you'll be another three on the new design." "Cretin", he glared at me as if I'd said it. "Mais, ma petite, he is right. I might as well have grown asparagus in the time."'[15] Obviously, Beatrice was enjoying taunting her editor and former lover with her constant references to another man which he would have understood.

In her column, La Rotonde is the café that Beatrice always mentions, although of course Modi and the other artists often visited the Café du Dôme opposite, favoured by Germans and Americans, Au Closerie des Lilas or Le Petit Napolitain. But Libion, the fat, good-natured proprietor of La Rotonde, created a homely atmosphere in the little café with sawdust on the floor. Everyone was welcome, including prostitutes whom Libion would advise to become models, even drug traffickers, provided their dealings were discreet, as well as Slav families, Russian revolutionaries and the artists, Libion's favourites. Hungry and often lonely, they hung about all day for the warmth and company, for Libion's good coffee and the hot croissants, soup and ham sandwiches and red wine they could barter for their work. The colony, always hard up, came to look on Libion as a kind of father and the café as their own.

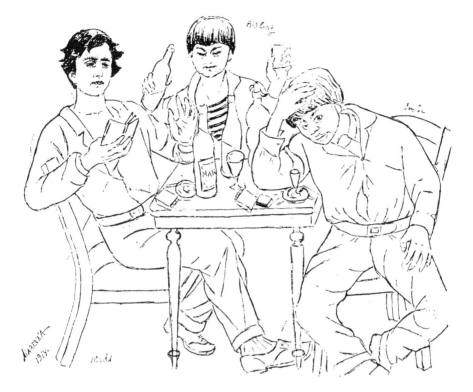

Modi, Kisling and Soutine, 1914.

Marevna (Maria Vorobiev), a talented young art student from Russia, ran to La Rotonde for comfort and consolation whenever she was in difficulty. She had arrived in Paris in 1912 and soon became a good friend of Soutine and a familiar Montparnasse character. In the summer of 1914 Marevna drew Modigliani, Kisling, the Polish Jewish painter, and Soutine seated round a table. Kisling is attempting to refill Modi's glass. Modigliani, engrossed in a book, holds up his hand to refuse disdainfully whilst Soutine, head in hands, looks plunged in despair.[16] The drawing just pre-dated the wilder stories of Modigliani's debauchery, before he became the established drunk of Montparnasse in the eyes of the world. It makes an interesting comment on the legend. They were all young, all the artists of Montparnasse, all talented to a greater or lesser degree, all bravely pitting themselves against the indifference of the public. After the war, most of Montparnasse would claim to have been intimate friends of Modigliani. It is perhaps worth remembering that both Epstein, Akhmatova and Nevinson knew him as solitary and an intensely private man.

Perhaps it is only in retrospect that the artists' balls, the fancy-dress dances, the 14th of July celebration seemed more brilliant than usual that summer just before the First World War. Nina Hamnett dressed up as a Paris Apache, in a pair of French workman's trousers, a blue jersey, corduroy coat and cap borrowed from Modigliani and a toy butcher's knife. For three days and nights she danced in the streets with the crowd. Modigliani did not recognize her when she met him and brandished her knife on the corner of the Rue Delambre and the Boulevard Montparnasse. He ran away from the fearsome ruffian.

Just over two weeks later war broke out, and the happy mood of Paris changed to one of agitation and anger. In the first week a German dairy was pillaged, two Germans were battered and an Austrian student was surrounded by a hostile mob, whilst traffic came almost to a standstill. The smaller shops closed down, the larger ones put up their shutters and long queues formed for vegetables. Only gold and silver coins were accepted, paper money was refused everywhere. Foreign artists were desperately hunting out their papers and passports and some of them, including Amedeo de Sousa Cardoso, decided to leave Paris and go home. Modigliani's family urged him to come back to Livorno too but his work, his world, was now in Paris. And so was Beatrice.

She decided to brave it out and applied for permission from the Prefect of Police. Everyone thought the war would be over in a matter of months. 'All is war now,' she records in her column early in August,[17] 'and art is under worse than lock and key. Very little fresh food is delivered in Montparnasse and one keeps open house on bread, cheese and fragments.' It was impossible to dine out in view of hungry acquaintances.

The foreign artists and the dealers were thrown together by the prospect of the destruction of their world. One Sunday afternoon, just after war broke out, Picasso, Rosenberg the dealer and Modigliani were sharing a table at the Dôme when André Level, a young and enthusiastic collector of modern art, came and sat down beside them. Level was introduced to Modigliani and was impressed by the intelligent and fine-looking young man.[18] When they left the café, Picasso suggested to the other two that they should visit Modigliani's studio to see his work. Level was captivated by one of Modigliani's large caryatids in watercolour and wanted to buy it. But it was Picasso who fixed the price, knowing that Modigliani would undersell himself. Level paid twenty-five francs and took the beautiful work home under his arm. The price was one of the highest Modigliani ever received at the time. He would have asked far less. Modigliani's style was so entirely different from Picasso's that the two were in no way rivals. That he took his

dealer to see it is a measure of Picasso's opinion of Modi's work.

Soon after Beatrice came back to Paris, Modigliani moved into her studio on the Rue de Montparnasse, his large drawings of caryatids on the walls. At the time he was still sculpting and he continued to carve his large heads, sometimes in polychrome, until 1915 or 1916. But in wartime everything was more difficult: building had ceased, building sites were closed and workmen were mobilized, so that he had no easy source of stone.

Increasingly, the physical effort of carving in stone provoked fits of coughing and the mess and the rubble annoyed Beatrice. Besides, he was tempted to paint her. He captured her in a variety of poses and moods which reflect her many facets: as a grande dame in a hat and fur collar; as a great courtesan – 'Madam Pompadour' he called the painting, perhaps deliberately mis-spelling it; in a wicker chair; demure in front of the piano; and he sketched her all the time, with quick, deft strokes. One beautiful drawing reveals Beatrice nude, weary and bedraggled, holding a sheet which barely covers her pubic hair. 'Someone has done a lovely drawing of me. I look like the best type of Virgin Mary, without worldly accessories as it were', she wrote in *The New Age* of 5 November. For a time Beatrice was a wonderful companion; she had taste, style, wit and a knowledge of literature and an interest in philosophy which matched Modi's own. Editorially in *The New Age* she had encouraged and brought on new poets and writers. It seems certain that to Modigliani she acted as stimulant, irritant and catalyst for his work. If she could say playfully, in public, that he had been fiddling about with one design for three years, their conversations on his work in private must have been explosive. Their violent, witty, literate affair at first amused and intrigued their friends at a time when life was grim. Beatrice's column is full of the distress and hardship among the artists. 'Foreigners get poorer and poorer, those that are left – and there are hardly any left',[19] she wrote in the first month of the war. Most of Modigliani's friends joined the Army. Paul Alexandre, his loyal and sympathetic supporter, left Paris to serve in the army medical service. Kisling and Zadkine, both Poles, joined the Foreign Legion. Modi, too, tried to join the Foreign Legion, felt it was the 'price' to pay for living as a foreigner in France, and justified his inconsistency by saying: 'I'm so much a revolutionary that I'm even willing to be a soldier and revolt against my own anti-militarist beliefs. A little contempt for military life makes it all the easier . . . Nothing can be done without the spirit of contradiction'.[20] He was, predictably, rejected on health grounds. That provoked a depression and a drinking bout. Asked by a passer-by if he had enrolled, the artist replied: 'I fight your battle, my friend, every day. Go you now and fight mine. Keep the German bombs off the Louvre'. That anecdote, told in Beatrice Hastings' *New*

Age column, seems true to life. For, if he used her as a model, she used him as good copy.

At the end of August, the first German warplanes bombed Paris and also distributed leaflets warning Parisians to surrender: the Germans were at the gates. After that the bombers came nightly, the city was blacked out, cafés closed at 8pm and the sale of absinthe was banned. The blackout extended to news of the war and the German advance on Paris; newspapers suspended publication temporarily and crowds gathered round the official bulletins pasted on the walls as rumour raced round the city. Life as the artists had known it only a few weeks earlier no longer existed. There was, as Beatrice wrote graphically, a 'universal and systematic suppression of everything but grief and groceries'. Sales of art were difficult and prices of paintings and sculpture even went down. Foreign artists tried hopelessly to find work, dig trenches, look after the four cows in the Bois de Boulogne, anything to earn a few francs.

To feed the foreign artists, who were literally starving, a committee headed by a wealthy American woman was set up and a canteen quickly opened. A meal was provided at a nominal price at midday in two studios each seating about sixty artists and models. In the evenings Marie Wassilieff, the enterprising little Russian artist, began to serve dinners in a courtyard next door to her studio in the Avenue du Maine. She persuaded her friends to bring chairs, stools, tables and a hotchpotch of furniture, and three artists cooked surprisingly good meals. For fifty centimes (fivepence), sixty with a cigarette, guests were offered soup, meat, fruit and tea or coffee. When Beatrice visited the canteen in October 1914 she found a good deal of atmosphere, although there was no beer or wine. An international crowd of Belgians, Japanese, Russians, Czechs, Italians, Spaniards, Argentinians, Swiss and a Finn shared a meal. Visitors were expected to pay in advance but credit was always given to favourites like Modigliani and Leon Trotsky the Russian revolutionary. Every evening a crowd gathered to squabble over politics or new art forms or to 'dance to Zadkine's mad music, "The Camel's Tango".' On Saturdays, after dinner, concerts of classical music were so popular that artists sat on the floor or perched on tables to listen. The Russian writer, Ilya Ehrenburg, remembered evenings at the canteen when Modi sat on the stairs: 'sometimes declaiming Dante, sometimes talking of the slaughterhouse, of the end of civilization, of poetry, of anything except paintings.'[21]

Modigliani's innately pessimistic view of life was fuelled by the war. He spoke to Ehrenburg of the prophecies of Nostradamus, the French sixteenth-century mystic, and quoted from a battered book: 'Nostradamus foresaw military aviation. Soon all those who dare to smile or weep at the wrong

moment will be sent to the poles . . . a cruel ruler will seize power, everyone who does not learn to keep silent will be put in prison and the extermination of mankind will begin.'

Very quickly the quarter of Montparnasse adjusted to wartime. The German bombers came about six every evening but nobody stayed indoors. And although absinthe was banned, cafés shut early and many bars closed down, secret drinking-clubs offered liquor and amusement through the night. In the two-roomed apartment on the Rue de Montparnasse, Beatrice kept a 'twixty', a bottle of brandy so named because it was never full and never empty. She appealed unashamedly to her English readers for money for the foreign artists: 'If anyone likes to send some money, I will promise to dispense it with the most rigid favouritism towards people who would probably sooner beg than risk the jaundice of a free meal and would sooner have a note of twenty francs all at once than beg every day.'[22] She had announced that she would stay in Paris until October, but by October she was looking for a new place to rent, now deeply involved with Modi and unable to leave.

Curiously this dead period in Paris, when the city was preoccupied with war, coincided with a time of intense growth and change for Modigliani. By temperament he could never be a member of a group, but at the time he was associated with a talented wartime circle which included Max Jacob, the poet Cocteau, the composer Eric Satie, the painters Juan Gris, Kisling, Foujita and, more rarely, Picasso and the sculptors Archipenko, Zadkine and Lipchitz. Max Jacob and Modigliani were always assumed to be good friends; they had a great deal in common. They were both intellectual Jews with a deep knowledge of literature and art enmeshed with a taste for mysticism and the occult. Temperamentally they were worlds apart. Max Jacob, subtle and devious, was driven by a deep sense of insecurity to please everybody and to stage-manage his friends' lives, whereas Modi was direct and uncompromising, always his own man despite his inner anxiety. Max Jacob was homosexual, trying desperately to look distinguished in his top hat, evening dress, spats and monocle, whilst Modi's affairs with women were known all over the quarter. He looked right whatever he wore, so handsome that girls stood up to catch a glimpse of him when he walked into a café. Relations between the two were complex, very close for a time during the war. Max Jacob believed he should have been given full credit for persuading Modi to return to painting.

Max, with his shining bald head, big nose and wide mouth, was a tortured and talented man, a gifted prose poet, a painter as well as an astrologer, a palmist and an antiquarian. He knew everyone worth knowing and liked

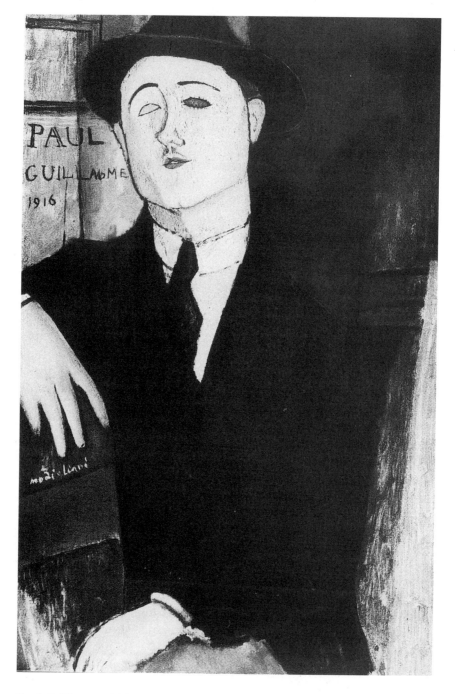

Paul Guillaume, 1916.

nothing better than to make connections. He had spoken to Paul Guillaume, an ambitious and knowledgeable young dealer, about Modigliani and went to some trouble to arrange an introduction. Guillaume had already bought some drawings of Modigliani's, but one afternoon at the Rotonde Max Jacob and Modi were sitting together on the terrace with Modi sketching as usual on the Rotonde's thin paper napkins when Paul Guillaume sat down at their table and asked Modigliani whether he ever painted. 'Say yes,' Max whispered urgently into his ear, 'you'll make out.' Modigliani accepted his advice and muttered 'Yes, I paint a bit.' 'You'll bring me your canvases, then,' the imperious young dealer said as he left the café. As soon as he had gone a furious argument broke out. 'You've put me in an impossible position,' Modigliani said angrily. 'You know I don't paint at all.' 'Draw on the canvas then and fill in the outlines with colour,'²³ Max replied. Later, when Max told his friend effusively that Guillaume adored his painting, Modigliani spat on Max Jacob's shoes. From then on relations between the two were strained. Max Jacob's resentment revealed itself years later in private letters. In public he was unctuous. He believed he had had a determining influence on Modigliani's evolution although the painter was too haughty to admit it. Later Marie Wassilieff too was to claim that she had persuaded Modigliani to take up painting again.

In some measure Max's intervention was a help. Modi, cut off from his family's allowance by the war, needed the money. And the prospect of the buyer forced him to concentrate. During 1914 he completed only eight portraits, tentatively and experimentally, for he was struggling to find himself, trying out different styles. He worked either at Beatrice Hastings's place or at the large studio owned by the painter Frank Burty Haviland, in the Rue du Schoelcher – conveniently near Picasso's place, for Frank was a disciple. Known as 'le riche', Frank Haviland was the envy of the artists of Montparnasse because of his comfortable life, the luxurious meals he ate, the smart clothes he wore, the paintings and Negro sculptures he could afford to buy. Fernande Olivier, Picasso's mistress, described him as stingy, but he was a good friend to Modigliani, encouraged him to paint and lent him colours, brushes and canvas. More in love with art than an artist himself, he later became a museum curator. Modigliani painted him in tiny brush strokes of colours reminiscent of the Divisionist style, in vibrant reds and blues, as if he was celebrating a return to the colours of the spectrum. Yet despite the vibrant colours Modigliani captured something of the wistful yearning of his nature.

Ilya Ehrenburg knew Modi better than most; he said, 'Of course he could have painted portraits that might have pleased the critics and buyers . . . But

Modigliani knew neither how to lie nor how to adapt himself; everyone who met him knows how very straightforward he was.'[24] All the people that he painted that Ehrenburg knew resembled their portraits: 'What is extraordinary is that Modigliani's portraits resemble each other; it is not a matter of an assumed style or some superficial trick of painting, but of the artist's view of the world . . . I believe that the world seemed to Modigliani like an enormous kindergarten run by unkind adults.' And Modigliani's paintings, Ehrenburg added, not only resembled their models, they disclosed the inner nature of the subject: 'Diego Rivera, for instance, is large and heavy, almost savage . . .'

Diego Rivera, who became a world-famous fresco painter when he went back to his native Mexico, was 28 when he came to Paris in 1914, a political as well as an artistic rebel and just the sort of companion Modi enjoyed. A huge, dark, bearded man with a large stomach protruding from blue dungarees, the 'kindly cannibal' had a voracious appetite for women and drink. In 1914 he was living with Angelina Beloff, a Russian engraver several years his senior by whom he had a child. He also fathered a child by Marevna (Maria Vorobiev) and abandoned both women when he left for Mexico in 1921. Quick-witted, volcanic, with a profound knowledge of painting, Rivera was unusual even in the exotic milieu of Montparnasse and Modigliani badly wanted to portray him. He persuaded the Mexican to share a room with him, at least whilst Modi painted his portrait. Leon Indenbaum remembered seeing Modigliani, rather merry, sitting on the floor sketching Rivera one evening when he was visiting. For his exciting portrait of Rivera, Modigliani made two drawings and a preparatory sketch in oils. The big man, sensual and mysterious, with hooded eyes and thick lips, almost overflows off the paper. The sensual luminous face appears from whirling blobs of dark colour whilst the great bulk, barely contained in the frame, is merely suggested. In his painting Modigliani evoked the power and the volcanic nature of his model in a style which mirrored the inner world of his subject in a marvellously inventive way. At that time he was 30, now completely cut off from his family and their protection and released from all their loving bonds. Perhaps it is no accident that he began at last to find his true identity as a painter, although his dream of sculpting still haunted him. One day in 1915 he arrived in Berthe Weill's gallery and begged her to come and look at his stone heads. He was so drunk that he almost fell on top of her. She recoiled and of course refused his invitation. 'How sad, such a fine and cultured person with a magnificent head,' she wrote later. 'Is he really a drunkard?'[25] His friends disagreed on the question. 'We all [drank], he and I and the others,' wrote the poet and critic Charles-Albert Cingria, a close friend. 'I

Diego Rivera, 1914.

Head of a man, 1915.

don't think wine is made for any other reason . . . As to the question of Modigliani's terrible drinking, there has been a lot of talk. It has been exaggerated . . . To drink is not to be a drunkard!'[26] The painter Vlaminck maintained that Modi never lost his quality of distinction: 'I knew Modigliani well. I've seen him drunk. I've seen him when he had money. I've seen him without. Never have I found a trace of low sentiment. But I have seen him angry, irritable at the power that money, which he so much despised, had to cross his will and his pride'.[27] His personal life in the years with Beatrice had never been so wild.

'You sat on a low step, Modigliani, your cries were those of a stormy petrel . . .',[28] wrote Ehrenburg in a poem written early in 1915. On good days Ehrenburg found him calm, courteous, clean-shaven, gentle and friendly. On bad days he was frantic, with black bristles sprouting over his face, screaming shrilly so that he was quite incomprehensible. The idyll which had promised so much with Beatrice was gradually deteriorating into a drawn-out brawl. Their love affair was carried on against a background of nightly bombings, wartime tension, the advance of the German army on Paris. They quarrelled and argued about everything: spiritualism, art, philosophy and poetry. Neither would give in and they both had fierce tempers. Modigliani would come home drunk. Beatrice, too, drank; she had no doubt learnt a few tricks from her ex-pugilist husband and could take care of herself spiritedly. Blaise Cendrars witnessed a fight in which she was getting the better of Modigliani. The concierge would listen at the door with a running commentary: 'The Italian's had a drop', or 'the Englishwoman seems to be winning'. The stories grew more inflamed with the telling and witnesses were about equally divided as to whether Beatrice encouraged Modi to debauchery or he provoked her. Late one night, the concierge knocked on the door of Beatrice's apartment, alarmed at the commotion, and demanded to know what was going on. 'I assure you, madame, nothing untoward is happening', Modigliani replied in his most urbane manner. 'I am merely chopping firewood in the salon and beating my mistress like a gentleman.' According to another story from Lipchitz he complained bitterly that Beatrice had 'bitten him in the balls'.

Beatrice's column provides a coded guide to their affair. Sometimes she used it to further her arguments with Modi. At others she seemed to air his concerns. In *The New Age* of 5 November, for example, she complained of the influence of *Les Chants de Maldoror* (the book that was Modigliani's constant companion): 'No one would deny the mischief done by Maldoror during recent years'. The book, said Beatrice, was used like opium or cocaine by poets and painters as a 'defence from modern life, this very modern life of

noise and advertisement which they profess to find more real than the glory and the grandeur of earlier civilizations . . .' Beatrice's own escapism took many forms: she wrote under different names, always as Alice Morning in her 'Impressions of Paris' but also as Robert West, Cynicus, Beatrice Tina, Robert A. Field, T.K.L., Minnie Pinnikin and occasionally in her own name. In imagination she saw herself as a devotee of Bacchus, in the golden world of the Greeks, as these extracts from her poem 'The Lost Bacchante' reveal. It was written originally in 1910 and republished in February 1941 in *The Democrat*, a one-woman paper of four pages, which contrived to be both anti-Semitic and anti-Catholic:

> I'll tear my robe from a tiger spine
> I'll bind up my ruddy hair
> In a band of tendrils plucked from the vine
> And ivy grapes will I wear.

and in the last stanza which deteriorates into doggerel:

> I'll work in the timid heart of the maid
> With magic I'll ripen her bosom scanty
> Till her lover gasp – nor will know that he clasp
> No mortal maid but a lost Bacchante.

However 'decadent' his taste, Modigliani looked to literature, Dante, Lautréamont, D'Annunzio. Beatrice saw him reading *Les Liaisons Dangéreuses* and slated that too, claiming that it was a steamy romance seized upon by the mothers of France 'and said to have been largely responsible for the modern severity towards young daughters'. It is difficult to know Beatrice's intention from her column. Few of her readers would have read the books and in wartime would be unlikely to obtain them. Perhaps she was merely scoring points, in print, off her lover. But in the same column Modigliani's hand seems to be guiding her pen when she raises the question of the Turkish Jews in France, ordered to leave the country. 'The question of peace for the Jews is not less important to civilization for their being a scattered tribe, and ever-rancorous Catholicism may yet have to be bloodily taught not to provoke the persecution and murder of those whom life abides even with partiality'. Beatrice pointed out that Christian Turks, Orthodox Turks, Catholics Turks and Armenian Turks were allowed to stay in the country. Later in her life she became a Fascist sympathizer.[29]

Anti-semitism increased in wartime, and Ilya Ehrenburg remembered an

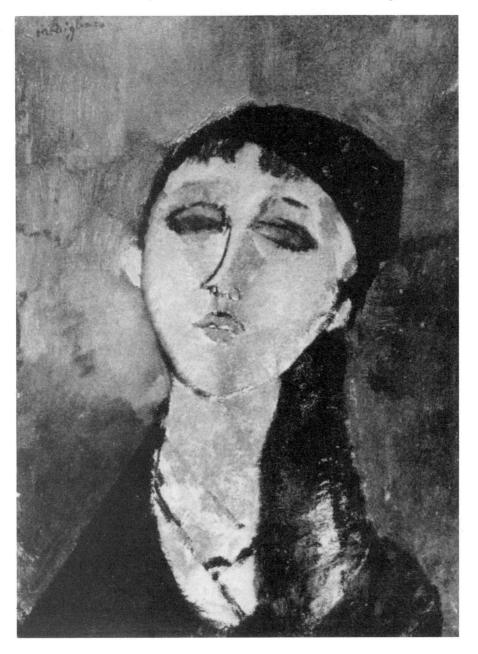

Luisa, 1915.

incident in a café on the Boulevard Pasteur when Modigliani confronted a group of card-players at a neighbouring table who were making anti-semitic remarks and subdued them into silence by his withering contempt. Modigliani read Ehrenburg sonnets by an Italian Jewish poet of the fourteenth century, Emmanuele Romano, 'mocking, bitter poems that were nevertheless full of the love of life'. Then he told Ehrenburg how in bygone days the Romans had celebrated the carnival by forcing the Jewish community to elect a Jewish runner who had to run naked three times round the city, whilst the elegant crowd of bishops, ambassadors and ladies looked on.[30]

It is tempting to imagine that Modigliani was acting out the runner's part in his life with Beatrice in those years. The atmosphere was restless, impatient and mad, a word that kept cropping up. At Christmas, as a gesture of defiance against the general gloom, Beatrice flung a party. 'It wasn't meant to be mad, but it went; because half the people turned out to hate the other half and so everybody had to strive like anything to make things go. We strove and we strove; we played and sang to each other; we improvised, we dashed out and fetched guitars, we danced . . . And then Sylvia came in with apologies and that perennially green hat, and we lowered the lights while she recited De Musset's "Nuit de Mai". And I wept nearly. But what a poem. They don't write like that now . . .'[31]

Beatrice had a wonderfully fluent French-flavoured pen and captured the frenetic quality of their life together in those first few months of the war. But the drinking, drug-taking and the high-pitched battles soon toppled the frail structure of their romance. And although Modigliani and Beatrice were deeply embroiled, the early enchantment was over.

Will he flower?

MORE than any other woman he had met, Beatrice was able to share in Modigliani's life, and his work changed dramatically during her reign. By 1915, Modigliani had begun to paint the portraits reproduced in every art book: Paul Guillaume, his dealer; the painter Moise Kisling; the fat child; the bride and groom. His years as a sculptor had taught him to see the human figure in solid, three-dimensional form, and his people now have necks like columns, oval or elongated faces and noses sharply drawn, as if cut into the planes of the face. He always began a portrait with the eyes.[1] And the eyes in his paintings hold the key to the psychologically charged atmosphere. Even when they are blanks, sightless as in sculpture, they focus the attention hypnotically. He had begun to paint some portraits with one eye 'blind', the other seeing. 'With one eye you look out at the world; with the other you look in at yourself', was Modigliani's explanation.[2]

But even when both eyes are painted within the normal convention he makes the expression in each subtly different, as if to express the duality in his subject. In 1915 he was still experimenting with different styles. His paintings were rather angular, with the nose, in particular, appearing as if it was glued to the canvas in an echo of Cubism. The exquisite lyricism of line of his later paintings is not yet present, but by now the work is in his handwriting, unmistakably Modigliani.

With Beatrice his life was as turbulent as ever. Although he had a key to her apartment and tried to lock her out once when she lost hers[3] he did not live permanently with her. He often worked in a friend's studio, and took his meals at Rosalie's where he peeled potatoes or washed up to pay for the meals. An artist, he told her, ought not to have to starve. When he slept with Beatrice at No. 53 Boulevard Montparnasse, he often turned up at Indenbaum's next morning, still in a euphoric state from the after-effects of a drug, almost certainly hashish. Indenbaum remembered that he was gentle,

with a beatific smile, and asked for a tune on the harmonium . . .⁴ There were days and nights when the lovers did not see each other, and when they did they often fought, verbal arguments at first which turned into brawls as they drank. They were both dreamers, rudely awoken by the reality of the other. Signs of Beatrice's disillusion can be read into her column in *The New Age*. She vents her spleen on the war, the blackout, the Zeppelins which made it imperative to shut the shutters at night; the price of groceries; the petty bourgeois; the landlords and the concierges. The 'mad' quarter of Montparnasse where illicit drugs were so cheap and available earns her special scorn. In print she boasts that she is not in the least attracted by drugs, even scared to touch 'ordinary cheerful liquor'.⁵ But her comments about her own behaviour are foggy and sometimes wildly misleading. Beatrice was often out drinking that winter, at the Rotonde or the Closerie des Lilas. Max Jacob was delighted to discover 'an English poetess who gets drunk alone with a bottle of whisky'.⁶ They must have drunk deeply because the very next week in her column Beatrice introduces her readers to a 'charming book of Breton verse by Max Jacob', translates a poem of his and describes him as 'one of the few classical critics in the world'.

She adored celebrities and hoped to meet Picasso through Jacob, a close friend and admirer who had even shared a bed with Picasso in the painter's early years. Picasso was working at night and sleeping during the day, whilst Max earned the rent by taking a job in a department store. Picasso did not take to Beatrice, but her column two weeks later benefited: 'By the way', she wrote, 'M. Picasso is painting a portrait of M. Max Jacob in a style, the mere rumour of which is causing all the little men to begin to say that, of course, Cubism was all very well in its way, but was never more than an experiment. The style is rumoured to be very photographic, in any case, very simple and severe.'⁷ Picasso was quite capable of working conventionally as well as experimentally, and Max Jacob himself was not keen on the drawing, which made him look 'very much the old peasant'.

Modigliani was intensely unhappy and suspicious of Beatrice's growing intimacy with Jacob and by extension Picasso. Although he knew Max would not share her bed, the poet was malicious and a great gossip. If Max knew about Modigliani's private life then all Montparnasse would soon be seething with the story. Modigliani did not gossip, he was too preoccupied and always discreet about his love affairs.

Beatrice's column of 11 February 1915 gives fascinating clues to their complex relationship. She has not seen much of Montparnasse recently, she confesses to her readers, she has been staying indoors 'nursing a sick wasp and writing a comic romance. The wasp strays in, eats a little honey, warms

itself, tries to sting and travels out to some winter lair. I suspect it is more sleepy than sick.' The reference to her unsatisfactory lover is clear. But in the same column Beatrice complains that she nearly had her apartment burnt down after casually remarking that artists were rarely able to distinguish between their good work and their bad and therefore only critics could decide upon the value of a work. Suddenly a fire broke out. (By implication Modigliani started the fire – or the quarrel.) And then: 'I possess a stone head by Modigliani which I would not part with for a hundred pounds even at this crisis: and I routed out this head from a corner sacred to the rubbish of centuries and was called stupid for my pains in taking it away. Nothing human, save the mean, is missing from the stone. It has a fearful chip above the right eye but it can stand a few chips. I am told it was never finished, that it never will be finished, that it is not worth finishing. There is nothing that matters to finish! The whole head equally smiles in contemplation of knowledge; of madness of grace and sensibility; of stupidity of sensuality; of illusions and disillusions – all locked away as matter of perpetual meditation. It is as readable as *Ecclesiastes* and more consoling for there is no lugubrious looking-back in this effulgent, unforbidding smile of intelligent equilibrium. What avail for the artist to denounce such a work? One replies that one can live by it as by great literature. I will never part with it unless to a poet: he will find what I find and the unfortunate artist will have no choice as to his immortality. But I don't think artists understand or bother much about immortality (I hope no flames of wrath are about!)'.

Artists, Beatrice generalizes with a fine sweep of her pen, have no principles whatsoever. They are driven to cunning in order to buy the materials they need for their work . . . they are vain, envious and antagonistic to writers 'who are really their best friends, who control the public and try to bring it to a greater state of culture which will offer the artists great subject for their work . . .' This seems to be the root of the quarrel between Modigliani and Beatrice, a battle of the egos, her determination to patronize and his fury at her presumption. Yet even if Beatrice's regard for her lover had diminished, her admiration for his art had not. Her imaginative and generous appreciation of his stone head at a time when his sculpture was rarely valued or sold shows her to be a woman of taste and courage as well as a dangerous and destructive lover.

As Max Jacob became one of Beatrice's favourites, his name begins to appear more frequently in *The New Age*. In March 1915 Beatrice decided to leave Montparnasse and move to the Right Bank, to Montmartre. She settled in a four-roomed cottage with a garden at No. 13 Rue Norvins, where Zola had once lived. And Max Jacob was there to help her, she informs her readers.

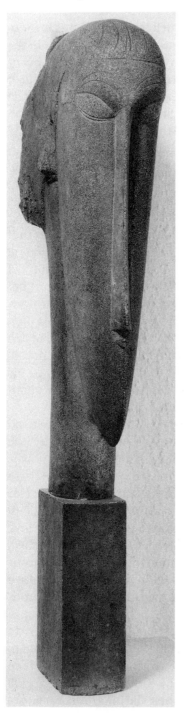

Head, 1911.

She found him far more useful and reliable in household matters than Modigliani. A week after she had settled in, the writer Katherine Mansfield came to call. Earlier that year, Katherine, en route to a romantic assignation with the writer Francis Carco at Gray, a banned military zone, had got drunk in Paris with Beatrice. The two women knew each other from London and *The New Age*. As a young writer Katherine had been encouraged and dominated by Beatrice, who instructed her 'in bitchiness and swank'. Behind her back Katherine, who was almost mesmerized as well as scared by Beatrice, nicknamed her 'Biggy B.'. Since both women were sexually ambiguous their encounters were highly charged.

On the 20th of March Katherine and Beatrice dined together at the Closerie des Lilas. Katherine visited the 'very jolly' new flat and described it in detail: 'four rooms and a kitchen, a big hall, a cabinet and a conservatory. Two rooms open on to a garden. A big china stove in the *salle à manger* heats the place. All her furniture is second-hand and rather nice. The faithful M. [Max Jacob] conducts her shopping. Her own room, with a grey self-colour carpet, lamps in bowls with Chinese shades, a piano, 2 divans, 2 armchairs, books, flowers, a bright fire was really unlike Paris, very charming. But the house I think detestable. One creeps up and down stairs. She has dismissed D. [Dedo] and transferred her virgin heart to P., who lives close by [Alfredo Pina, an Italian sculptor]. Strange and really beautiful though she is, still with the fairy air about her and her pretty little head so fine, she is ruined. There is no doubt of it. I love her but I take an intense, cold interest in noting the signs. She says "It's no good me having a crowd of people. If there are more than four I go to the cupboard and nip cognacs till it's all over for me, my dear", or "Last Sunday I had a fearful *crise*. I got drunk on *rhum* by myself at the Rotonde and ran up and down the streets crying and ringing bells and saying 'Save me from this man!' There wasn't anybody there at all." And then she says with a faint show of importance, "Of course the people here simply love me for it. There hasn't been a real woman of feeling here since the war . . ."'

The dismissal of Dedo was temporary; the affair with Pina contrived. Sporadically, Katherine Mansfield conveys the volatile atmosphere in the comfortable apartment and Beatrice emerges as a deluded and rather pathetic exhibitionist. Katherine described the terrors of war, in 1915, the trumpets sounding the alarm, the searchlights sweeping the sky, the Zeppelins gliding by, the bombs. She went to tea with Beatrice and found the atmosphere almost as dramatic: 'At B.'s this afternoon there arrived *du monde* including a very lovely young woman, married and curious – and blonde – and passionate. We danced together. I was still so angry about the horrid state of things . . . I can't talk about the tea-party tonight. At any rate it isn't

worth it really. It ended in a great row. I enjoyed it in a way, but B. was very impossible – she must have drunk nearly a bottle of brandy, and then at 9 o'clock I left and refused either to stay any longer or spend the night there. She flared up in a fury and we parted for life again . . . B. makes me sad tonight. I never touched anything but soda-water and so I realize how other people played on her drunkenness and she was so . . . half-charming and such a fool'.[8] In May Katherine returned to Paris to write. She kept her resolution not to see Beatrice any more but wrote revealingly to Middleton Murry, who later became her husband: 'I wonder if Beatrice Hastings has maxed her jacob yet or if she flew to Italy with her Dado [Dedo]. I am not really curious and I'll never seek to know.'[9] This is the clearest indication, apart from Beatrice's column in *The New Age*, that Beatrice was playing Max off against Modigliani.

She took to asking Jacob to sleep in a shed at the bottom of the garden to defend her against Modigliani's violent forays. 'When she wouldn't open the door to him, he broke the window panes . . . When he finally got in there were scenes with revolvers and bottles of rum', Max Jacob, her night-watchman declared.[10] Beatrice described his assaults in her fluent, showy style, the nights when Modigliani came home drunk: 'If I happened to be drunk too, there was a great scene! But I was writing, usually, and just plagued to hear him ring. If Max was there when Dedo arrived the chances were not altogether against a peaceful conversazione and the witty exit of Modigliani to his own atelier close by . . .' Beatrice complained that she was run down in health and beginning to dread 'the swoop of the Assyrian on my fold'.[11] In one of their battles they chased each other ten times up and down the house, Beatrice armed with a long straw broom and Modigliani with a pot. One cannot, of course, take Beatrice's accounts at their face value. But there is no doubt that in her company Modigliani was wild, over-excitable and sometimes frightening. Witnesses at their wild parties saw his restlessness and rage.

Ilya Ehrenburg visited a party one night in a studio littered with rubbish. Beatrice kept repeating in a pronounced English accent: "Modigliani, don't forget that you're a gentleman. Your mother is a lady of the highest social standing.' These words acted on Modi like a spell. He sat in silence for a long time. Then he could not bear it any longer and started breaking down the wall. First he scratched away the plaster, then he tried to pull out the bricks. His fingers were bloody and in his eyes there was such despair that I could not stand it and went out into the filthy courtyard".[12] Ilya realized, as did Beatrice, that the way to wound Modigliani was to attack his family pride, to bait him about his mother. No matter how long he lived in Paris, or how wild

his life was, he retained a love for Eugenia and a sense of family honour that jibed awkwardly with the easy amorality of the crowd. Beatrice knew that and bitterly resented the influence of her greatest rival, his mother. Perhaps it was at that same party that Marevna, who stayed until dawn, saw Modigliani and Beatrice fighting ferociously until Modi grabbed her and flung her through a closed window. Later Beatrice was carried in and laid on the sofa, sobered by the experience, her breasts daubed in blood. 'She wept while Modigliani repeated "Non mea culpa, non mea culpa".' When Marevna finally went home at dawn: 'Max Jacob stood with a missal in his hand and Modigliani was still on his feet methodically tearing the rest of the wallpaper off the walls and singing an Italian song.'[13] There were too many stories of that nature, and it was in that year that Modi was labelled for long after his life.

A down-at-heel English journalist, Charles Beadle, lived nearby and shared a passion for gardening with Beatrice. He collected the scurrilous gossip and the half-truths about Modi, much of it from Beatrice, and sent it to be collated by Douglas Goldring (Charles Douglas was his pseudonym), who produced the book *Artist Quarter*,[14] the first extensive biography in English of Modigliani. Published in 1941, it influenced many biographers.

In spite of his wild nights, Modigliani completed thirty-six oils and gouaches during 1915, approximately three paintings a month, apart from the preliminary studies and his sketchbooks full of drawings. That year the young dealer who had expressed interest in his work, Paul Guillaume, opened his own gallery and Modigliani was elated to have a professional dealer at last. Beatrice was pleased and invited Guillaume to her cottage for tea. Both Beatrice and Modigliani behaved impeccably for the occasion. Several times Paul Guillaume came back to the house to have his portrait painted in a discreet, dark suit, starched collar and tie, jaunty trilby hat, a gloved hand languidly holding a cigarette and thinly parted lips which seem to be saying 'I am a man of exquisite taste'. Guillaume was a pioneer in buying the work of the new painters, the 'extremists', Picasso, Matisse, Derain, Chirico and Modigliani, and also had a fine collection of Negro sculpture himself. Modigliani wrote the words 'Nova Pilota' (new pilot) and 'Stella Maris' (guiding star of the sea) on his portrait: he was no longer, he felt, with a mere merchant but with a man of vision.

Inevitably, as he visited Modigliani more frequently, Paul Guillaume began to realize how disorderly the artist's domestic life was. One evening, walking along the street, he heard screams and bangs coming from Beatrice's cottage. As soon as he was inside the garden he saw the couple hitting each other with chairs; 'The woman hit harder and had the upper hand'.[15]

Guillaume, a careful and prudent man, was quietly appalled. He was able to sell Modigliani's work during 1915 to André Level, a well-known collector, for from twenty-five to sixty francs. Guillaume believed in Modigliani's gift and felt convinced that the price of his work would appreciate, but only if the painter was allowed to develop in peace. A man who tempered sentiment with business sense, it was said of Guillaume that he revealed the price of a painting with the same air of awed reverence that he mentioned a woman's age. In 1915 he rented a studio for Modigliani in the Bateau Lavoir. The investment was modest but it was an indication of his faith in the painter at a time when Modigliani badly needed the support.

Almost all the evidence of Modigliani's behaviour in the years with Beatrice comes either from her or from outsiders. Only from the mood of his paintings and from the cryptic jottings on his work, mottoes, inscriptions, aphorisms, quotations from Dante and other poets written in French, Italian or Latin, can one attempt to decipher his state of mind. 'Don't say: "Don't do that"': say "Do that"'; 'The empty seeks the full and the full seeks the empty'; 'No. Integrity does not lie that way'; 'What is true is equally true in three worlds'. On one drawing he wrote: 'The Flamboyant Style', underlined it and underneath wrote: '3 designs: 3 worlds: 3 dimensions'. He portrayed himself as Pierrot in one painting and wrote on it in Italian: 'Will he flower?' Paul Guillaume considered Modi a poet as much as a painter and remembered two improvised rhymes:

> *Il y a dans le corridor*
> *Un homme qui m'en veut à mort.*
> (There is a man in the corridor who wants to see me dead)

This was a reference, perhaps, to the illness stalking him. And:

> *Ma plus belle mâitresse*
> *C'est la paresse.*
> (Idleness is my most beautiful mistress.)

On some drawings there are figures and symbols considered to be cabbalistic. He drew the Star of David, the Jewish symbol, a number of times and Paul Guillaume said that Modigliani liked his work to be considered Jewish.[16] The question of his origins was much on his mind in those years. His friend Max Jacob was just about to be received into the Catholic church when he became entangled in the affairs of Modi and Beatrice. Born in Brittany, the son of a Jewish tailor and antique dealer, Max Jacob had seen a vision of Christ on the

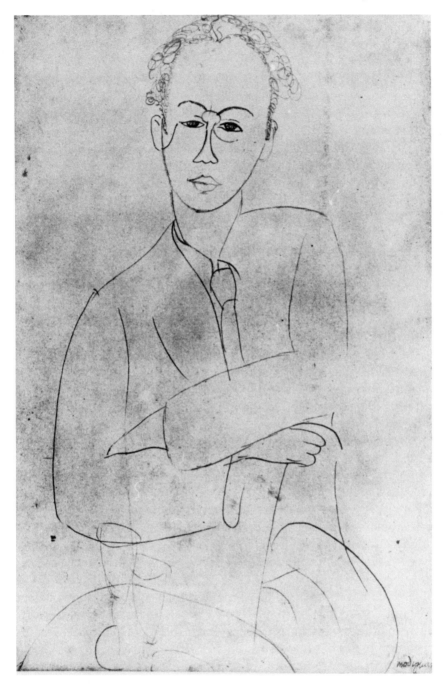

Kikoine, 1917.

wall of his little room in the Rue Ravignan. After lengthy instruction and considerable scepticism on the part of his friends as Max veered from piety and a longing for the monastic life to drug-taking and debauchery, he found a priest in Montparnasse willing to baptize him. The ceremony took place with Picasso acting as godfather. Picasso presented Max Jacob with a bound copy of *L'Imitation de Jésus-Christ* and inscribed it: 'To my brother Cyprien Max Jacob, Souvenir of his Baptism, Thursday 18 February 1915. Pablo.' The conversion was the cause of both amusement and astonishment amongst the artists. Beatrice Hastings commented on it obliquely in her column[17] and the sculptor Jacques Lipchitz, who used to invite Max Jacob and Modi to lunch when he could afford it, found himself warmly advised to embrace the faith. 'Just take communion', Jacob urged him, 'and all your worries will disappear.'[18] Modigliani was more interested in the rites and rituals of Judaism, always asking questions, although Max Jacob would wave his talk away with an impatient gesture.

For seventy years Max Jacob has been regarded as Modigliani's closest friend. In public he paid handsome tribute to Modigliani, but the truth of their private relations is more tangled. During 1915 Modigliani came to feel that Max had betrayed him by siding with Beatrice. 'He admired and loved Max at first but when Jacob tried to take Beatrice Hastings from him, Modigliani wanted to kill him'.[19] Max's conversion must have seemed like a second betrayal. The rift between the two men was particularly painful since they had been so close at first. Although Jacob was eight years older than Modigliani, as an astrologer he believed that they shared a common destiny, both ultra-sensitive Cancerians, Modigliani born on 12 July, Max on the 13th. For a time the two saw each other daily. Modigliani dedicated a drawing to Jacob '*très tendrement, comme un frère*', and Jacob wrote a poem: 'To M. Modigliani, to prove that I am a poet', on the subject of embracing religion rather than woman. 'Jews want me to flatter their pride of race', Max Jacob complained bitterly and added that they 'imagine themselves superior and ignore the rest of the world', in a book of 'Ecstasies, remorse, visions, prayers, poems and meditations of a converted Jew', entitled *La Défense de Tartuffe*.[20]

Modigliani never practised his faith. For him it was a question of identity rather than creed and, particularly in a period of rising anti-semitism, he could no more deny his ancestry than change his name. The bitterness of the rift between the two is revealed in a letter written by Max Jacob in January 1943, the year before he died tragically on his way to the gas chambers. 'Modigliani was the most unpleasant man I knew. Proud, angry, insensitive, wicked and rather stupid, sardonic and narcissistic'.[21] The tone of that extraordinary attack, written almost thirty years after his close friendship

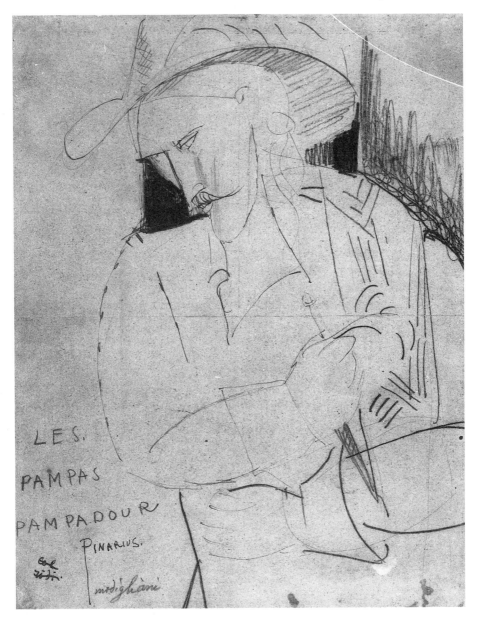

Les Pampas, 1916.

with Modigliani, suggests the disappointment of a lover spurned, rather than a disillusioned friend.

During the First World War the little colony of gifted foreigners in Montparnasse and French artists unfit for military service was increasingly shunned by the rest of society at a time when xenophobia was rife and contempt for any man out of uniform was universal. The artists lived as one extended bickering family and writers and painters who would never have seen each other before the war were thrown together. Perhaps it was this atmosphere, coupled with Max Jacob's fierce Catholicism, that led Modigliani to seek out his roots. Chana Orloff, the gifted sculptor from Palestine, did not especially like Modigliani; she was repelled by the permanent smell of drink on his breath. Whenever he saw her he would ask her to explain the Bible to him, and in the drawing he made of her, he wrote the Hebrew version of her name, Chana, daughter of Rafael, in Hebrew characters across the top of the head. 'I carry no religion,' he told her, 'but if I did it would be the ancient Jewish religion of my ancestors'.[22]

In 1915 Modigliani asked Lipchitz to introduce him to the small group of Jewish artists living in La Ruche, the beehive-shaped building with small studios in Le Passage Dantzig. They were delighted and arranged a reception for him in a studio formerly occupied by Chagall, who had left France before the war to go back to Russia to get married. Before he left, Chagall twisted a coil of stout wire around the door handle twenty-five times, certain that the one hundred and fifty paintings he had left inside would be secure. When he returned in the spring of 1923, Chagall found a new lock on the door, a new occupant inside and all the paintings gone.

A man named Maisel, a retoucher of photographs, was living in the studio in 1915 and the Jewish artists who knew Modigliani's work gathered to welcome him. They offered him hot wine and canella, surrounded him and talked eagerly in a mixture of Russian, French and Yiddish. Modigliani, delighted with the atmosphere of warmth and sincerity, resumed his friendship with Soutine and Indenbaum. Pinchas Kremegne and Chaim Soutine became his constant companions. The two men, who both came from a small village in Lithuania, almost hero-worshipped the handsome Italian with his love of liquor and of women. In their small hamlets drink was associated with Cossack brutality, when horsemen would swoop down into the Jewish shtetels after Easter and terrorize the people. As for women, the choice was limited and marriages were often arranged. But Modigliani broke all the taboos and behaved like a modern-day King David. When he was speaking, the pair would stand at a respectful distance, to hear him declaim poetry or discuss painting with a breadth of knowledge. They admired his

ability to handle an awkward bill in a café or fix lodgings for the night. Soutine, in particular, tried to capture the secret of Modigliani's style by using his models. But Modigliani recognized the anguished power of Soutine's painting and encouraged him to develop along his own path. 'He gave me confidence in myself',[23] Soutine admitted. Modigliani needed encouragement himself and he enjoyed the admiration of the two and gave them his ageing clothes when he could. Under his guidance the little group shared his special feeling for Rembrandt, who painted Jewish faces from the Amsterdam ghetto with such humanity that Modigliani insisted he must have been a Jew.

The contrast between the mondaine world of Beatrice Hastings and the ghetto of Jewish painters from Eastern Europe could hardly have been greater, and Beatrice had little patience for Modigliani's gauche, unsophisticated friends. She did travel to Italy in June 1915, but not with Modigliani as Katherine Mansfield had suggested. Perhaps she went in secret with the good-looking, but rather boring Italian sculptor Alfredo Pina. 'Love', she wrote in July 1915, 'is one of the means of perfection: a voice only, a way of calling men onwards . . . Love . . . has nothing to do with sexual relations. It is a state of exaltation of the individual, a great and rare gift of a great and rare invigorating dream. It visits some people never. It visits others many, many times . . . the rest are the great artists whose works are all love, though they may never indicate this by any common sign.' That was one of Beatrice's most tender passages, and it seems impossible that she did not have Modigliani in mind.

Despite her irritating affectations, she did have a genuine flair for divining quality in both literature and the visual arts. Modigliani still admired Beatrice's sense of style. She liked to dazzle Montparnasse with her originality; sometimes she wore long flowing veils, usually she appeared in the smocked Liberty dresses that suited her pert little-girl look. One evening they were planning to go to a ball. It was only a small gathering in a studio, but in wartime those were great occasions. But Beatrice complained sadly that she had nothing to wear that hadn't been seen a hundred times. Modi told her to put on a tightly fitted black silk dress. 'But that's an old thing,' she protested, 'everybody has seen it.' 'Do as I say,' he replied, 'and I'll make you the best-dressed, most beautiful woman at the ball.' Curious, she did as he said and Modi looked at her critically and fetched his box of pastel crayons. First he sketched an arabesque design on the dress in white to make it appear décolleté, then he covered her dress with magnificent, multi-coloured flowers and finally sprayed his design with fixative. Once the dress had dried, Modigliani told Beatrice to cut the neckline where he had drawn the white line. The originality of the dress drew a gasp when Beatrice walked into the

- RUE DE LA Gaité- „ PARAD

Parade, Rue de la Gâité, Paris. Modi, Soutine, Rivera, Marevna, Voloshin, Ehrenburg, Picasso, Max Jacob. Drawing by Marevna.

room, and since he did not dance he was content to watch her dance the tango with a number of admirers. Then she flirted a little too blatantly and Modi roared off to get drunk. She turned up at the Café Dôme one night, her beautiful dress torn to shreds. 'Modi's been naughty', she explained sweetly. Another evening when she invited some of their friends, including Juan Gris and his wife, to dinner at the cottage, Modi turned up late, drunk and covered with mud. 'Go and wash,' she said disgustedly, 'you look like a cabman.' 'I may look like a cabman,' he countered, 'but I'm a charm in a salon.'[24]

The private combat between Modi and Beatrice took place against the background of nightly air-raids, appalling casualties and wartime shortages. Modigliani's health deteriorated, he was drinking and smoking more, taking hashish, so that he could no longer hide his ill-health behind his good looks and gaiety of manner. Although he was opposed to war and sometimes his pacifist fervour offended strangers during the war years, nevertheless to be rejected as a weakling was an affront to a proud and physically courageous man like Modigliani. For the first time, in 1915, a tinge of cynicism appeared in his painting. Modigliani sketched a middle-aged couple in evening dress who had probably dropped in to the Rotonde late one night. Modigliani clearly felt no empathy towards the stuffed shirt towering above his wife. The elegance of the woman's appearance, her hoop ear-rings, is carefully realized, but the couple stare out of the canvas blankly, nothing has

registered on their faces, neither pain nor passion, and Modigliani remains detached, if faintly amused, by their front of respectability. There is a trace of the multiple overview of Cubism in the treatment of their faces; for once Modigliani was experimenting in technique, not engaged in grappling with the secret of personality.

Raymond Radiguet was a youth of 12 when Modigliani painted him, a brilliant schoolboy who had won a scholarship to a Paris Lycée and began coming in daily to the city from the suburbs. Raymond's father, a free-lance artist, often sent him to deliver his caricatures and satirical drawings to newspaper offices. Raymond was witty and unusual and from time to time he was invited to drink coffee at the artists' cafés. The talk at the Dôme and Rotonde struck him as far more amusing than his lessons at the Lycée and before long he had dropped out of school. By the time he was 18, the youth had written his best-selling novel *Le Diable au Corps*, a striking and original book of love and infidelity. Modigliani must have sensed the originality in the young boy's personality even at that age; perhaps he saw something of himself as a youth. He painted Raymond as a mysterious and sensitive young man with an air of extraordinary prescience in an as yet unmoulded face. The painting has been described as the 'masterpiece of Modigliani's Cubist adventures . . . [the] small head is divided into two clearly defined zones, each of which has its own viewpoint'. In the left-hand zone of the picture the features are treated almost realistically and 'brought forward towards the observer. In the other half of the picture the shoulder-line tilts towards us . . . and the face retreats and takes on a mask-like, wall-like quality', wrote John Russell.[25] Raymond has one blank eye, looking in on himself, in the mask-like side of the painting. Modigliani saw the potential of the boy, who ironically became Beatrice's lover within a few years when he was 18 and she was over 40. After a wild success Raymond died at the age of 20 from typhoid brought about by eating oysters.

Modigliani did not have a formal contract with his dealer. 'To ask him to sign a legal contract was ridiculous',[26] Paul Guillaume said. The dealer found him a difficult artist to deal with. If he fixed a price with the buyer, and the buyer asked for Modigliani's address, the painter was likely to give away his work at a lower price or offer it as a present if the purchaser was shrewd enough to take him out for a meal and a few drinks. Unfortunately there is no record of Modi's side of the story. He remained desperately poor and obstinately proud. And although he would borrow happily enough to buy painting materials or drinks, he had his own sense of honour. When he was living in Montparnasse, the sculptor Leon Indenbaum had bought a head by Modigliani for two hundred francs when he was in funds. The heavy stone

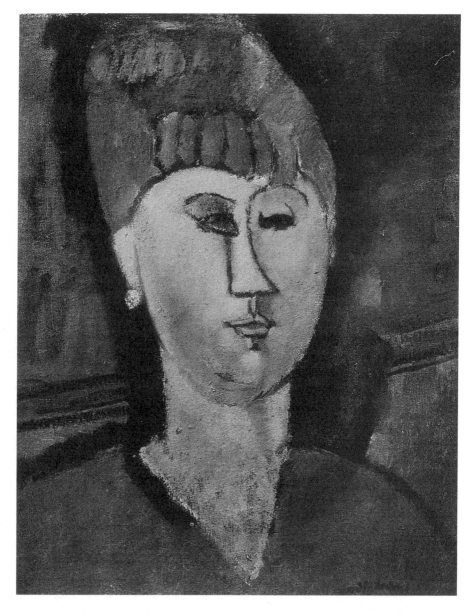

Woman with red hair, 1915.

head remained in Modigliani's cluttered studio until one day Modi marched up to Indenbaum at the Rotonde and said baldly, 'I've sold your head'. 'You did the right thing', replied the sculptor generously. But Modigliani did not forget and in 1915, when Indenbaum met him in Montparnasse, looking pale and unshaven, Modi came up to him and said in a hoarse voice, 'I'm going to paint your portrait.' Indenbaum did not take the proposition seriously, as he felt sure that Modi would have forgotten all about it in the morning, but Modigliani was insistent and asked Indenbaum if he had canvas and paint at home. Eventually they agreed on an appointment at nine o'clock the next morning, but Indenbaum was still convinced that Modigliani would not turn up. Promptly at nine next morning Modigliani rang Indenbaum's door bell, clean-shaven, his hair carefully brushed. 'I could see that he had not had a drink yet and I was doubly surprised that he seemed in a good mood.' Indenbaum offered him some old pictures to paint over, but Modigliani picked carefully through them so as not to paint over any painting, however unimportant, which showed a hint of talent. Finally they found a canvas and Modi seated Indenbaum at one end of the long narrow studio while he sat at the other. While he was painting, Modigliani barely looked at his model, 'or if he did it was merely to check against his portrait. He had made himself an internal picture of me and now only examined it against my external appearance'. To complete the portrait took three sittings and each time, to Indenbaum's surprise, Modigliani turned up clean-shaven and well-groomed, and behaved in a modest, almost shy manner. When he had finished the portrait he looked at it with an expression of satisfaction and said to Indenbaum: 'There – that is for you'.[27] Indenbaum knew how badly Modigliani needed money so he tried to offer him a sum within his means for the beautiful oil, but Modigliani was offended and obliged Indenbaum to accept the portrait as a present.

When he was involved in serious work, Modigliani could control his drinking and live more moderately, keeping clear of Beatrice's hectic parties. All Montparnasse knew that Beatrice had other lovers during her time with Modi. But no one has suggest that Modigliani, the womanizer, was ever unfaithful to her. By September 1915 the tone of her writing in *The New Age* had changed completely. Gone were the carefree, witty passages written in the first person, the conversational style, the caustic bitter comments. Instead Beatrice retreated behind long translations of French poetry, light satire and erudite literary discussion, almost as if a part of her had died. Charles Beadle, Beatrice's neighbour, tells many stories of Modigliani, full of drink and drugs, quarrelling, when he was in the garden with Beatrice innocently discussing the plants; of Modigliani walking in the cemetery

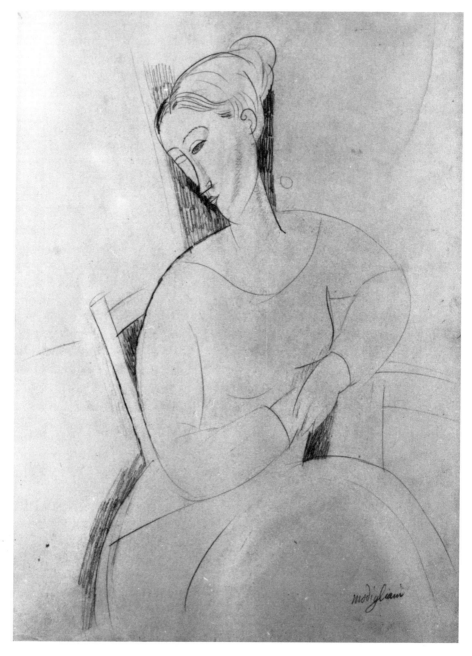

Seated woman, 1916.

because 'death was not far off' ('Wouldn't it be magnificent', he said to Beadle, if we could contemplate our own skeletons?'); of Modigliani reciting Lautréamont beside the graves, hungry for drugs, suspecting all Beatrice's male friends. Modi's elder brother, Emanuele the politician, who visited Paris some time during 1914, knew all about the affair. According to him Beatrice was so jealous that she locked Modi up in the cottage to keep him from going off with other women. Whatever the truth of it, by the end of the year Modigliani seems to have turned away from the brawling and tension.

On 9 November 1916 he sent his mother a postcard:

My dear Mamma,
 I am a criminal to leave you so long without news. But – but so many things have happened. First of all I have moved. My new address is 13, Place Emile Goudeau, XVIII. But in spite of all the commotion, I am relatively happy. I am painting again and I'm selling and that means a lot. I'm very pleased that my brother [Umberto] is in munitions. As to Laure, I feel that if she keeps her intelligence that is very important. I am greatly touched that she thinks of me and remembers me even in the state of forgetfulness of human affairs in which she now finds herself. It seems impossible to me that she cannot be brought back to life, that such a person cannot be brought back to normal life. Give my father a hug from me when you write to him. Letters and I are enemies but never think that I forget you or the others.
 A big kiss

 Dedo[28]

Laure, his favourite aunt, was suffering from a severe mental breakdown. Her sister Gabrielle Garsin, who had lived with Eugenia and the family when Dedo was a child, had committed suicide that year by throwing herself down a steep flight of stairs. Laure's distress was obviously compounded by her sister's suicide. Modigliani did not mention Beatrice; it seems likely that Eugenia never heard about the affair from him, and she remained an unintegrated part of his life.

Towards the intense life

'**P**ICASSO keeps taking me to the Rotonde,' the rising young poet Jean Cocteau wrote to a friend in 1916. 'Gloves, cane and collar astonish these artists in shirt-sleeves – they have always looked on them as the insignia of feeble-mindedness . . . still, it's great to be in the thick of the dog-fights of great art.'[1] That year the twenty-five-year-old Cocteau was working on the book of *Parade*, Diaghilev's controversial new ballet which was to express the new spirit in the arts, with music by Satie and Cubist costumes and sets by Picasso. 'I was on my way towards the intense life,' wrote Cocteau, 'towards Picasso – towards Modigliani – towards Satie.' A rising star, Cocteau was very much the dandy, full of elegance and highly conscious of the impression he made. So aware of the 'internationalism of art' (he told the story himself) that when a journalist asked him who the great French artists were, he replied: 'Why, Picasso, Modigliani, Lipchitz, Stravinsky' – a Spaniard, an Italian and two Russians.[2]

Cocteau would have been delighted to introduce Modigliani to his world of the new couturiers and of Diaghilev's Ballets Russes, to help him to become a fashionable and popular portrait painter. And apparently he did try. But with his damnable purity, which they all praised after his death, Modigliani insisted on going his own way. He despised what he called the '*snobs d'art*' and all the high-falutin discussion of art. 'We working artists suffer from them', he once told Epstein.[3]

He was still seen intermittently with the 'bizarre Englishwoman', but by 1916 the love affair was effectively over. For both Beatrice and Modigliani it had been a glorious adventure at first, the excitement of the sexual encounters heightened by intellectual friction. But their feelings for each other had been irreparably damaged by the brawls and fights and the recriminations afterwards. Now Modigliani was living and working in his own place, producing about four paintings a month. By 1917 his paintings

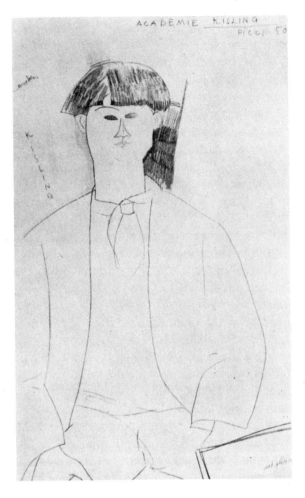

Kisling, at his 'Academy'.

were to fetch the highest prices during his lifetime and in that year he is credited with painting one hundred and twenty-five canvases, a painting every three days. But his daughter implies that the high prices paid for work executed after 1916 may have affected the chronology.[4] That seems extremely likely, as although he worked rapidly, all Modigliani's models speak of two- or three-day sittings. Of course when he was living with Beatrice – and he painted her at least fourteen times – he could resume his sittings more or less at will. By 1916 Kisling, who had served in the French Foreign Legion, was discharged wounded and working at his studio, No. 3 Rue Joseph Bara, and Modigliani often worked there with him. An easy-going, good-natured man, Kisling had a strong constitution and enjoyed the bohemian life of 'chance romances, shindigs, drinking parties, sing-songs,

brawls and wordy discussions', unclouded by guilt or ill-health. Whatever time he went to bed, Kisling was at his easel working early next morning, painting agreeable, nostalgic portraits of women. Kisling adored women and had an easy way with them, his face alive with sexual vitality. Never desperately short of money, he was lucky in attracting funds and spent his money generously. One day when he had sold a painting for a hundred francs, he spent it all on buying flowers for every woman who passed by in the street in a gesture that Modi much admired. However, when he invited Beatrice Hastings to come and model for him nude early on in their affair, Modigliani objected and she failed to keep the appointment. This happened twice. When Kisling asked Beatrice why she had not turned up, Modigliani replied: 'I am responsible. If a woman poses for you, she gives herself to you.'[5] Kisling allowed Modigliani to use his studio, often lent him brushes and paints and behaved with a careless generosity towards him, but the two men were too different in temperament to become intimate friends. Modigliani appreciated Kisling for what he was, a sweet-natured, high-spirited, sensual young man.

Jean Cocteau came to Kisling's studio to have his portrait painted and Kisling and Modigliani both painted him, side by side. No doubt Picasso had advised Kisling of Modigliani's talent. Pierre Reverdy, the poet, sat in the large studio watching the artists at work. Cocteau would not stop talking. He kept up a non-stop stream of words against the patter of the raindrops beating against the skylight, to Modigliani's silent exasperation. In Kisling's studio, where there was always a bottle or two open, Modigliani wrote on one of the preparatory pencil sketches that he made: 'I, the undersigned, author of the drawing, swear never to get drunk again for the duration of the war'. In Kisling's portrait Cocteau appears as a small, sensitive, dreaming figure, almost lost in the large room, with its chairs and table, open window, blue sky and a cat. Whereas Modigliani cut out all extraneous detail and painted Cocteau in a high-backed chair, looking every inch a peacock, angular and dominant. When he saw the finished portrait Cocteau was shaken and described it privately as 'diabolical'.[6] The painting was proof, he said, that Modigliani detested him. Cocteau was acute, yet the exaggerated portrait had a curiously prophetic quality. By 1956, when Cocteau was a man in his sixties, he had grown to have an uncanny resemblance to the painting.[7] Despite the unspoken antipathy he felt, Modigliani was reluctant to accept a fee for the painting. When Cocteau insisted, Modigliani stipulated his price: five francs. The canvas was too large for Cocteau to carry, and since he did not have the cash to hire a fiacre, the painting remained at the Rotonde for years. Modigliani's paintings always reveal what the painter thought of his

model. In the majority of his work, he displays a sympathy which reaches to the inner core of his subject. But Modigliani found Cocteau unbearably pretentious, a name-dropper with an instinct for self-advertisement. Possibly Cocteau's exaggerated, precious manner made Modigliani feel threatened in his own sexuality. Although he was plainly heterosexual, he had an unusually sensitive, almost feminine, side to his nature. And then again perhaps Modigliani's exasperation stemmed in part from envy of this brilliant young man.

By deliberately turning his back on the new spirit in art, Modigliani found himself excluded from most of the excitement and gaiety in the arts that flourished in spite of the war. Picasso and Matisse sponsored a Granados–Satie concert in 1916, a very fashionable occasion with a select audience. Later in the year, when the poet Apollinaire came back from the war with a head wound, a grand banquet was held in his honour at the Palais d'Orléans in the Boulevard du Maine. Ninety guests, including André Gide, Picasso, Max Jacob, Matisse, Vlaminck and Cocteau, sat down to a meal of fantasy. The twelve courses included '*Hors d'oeuvres cubistes, orphistes, futuristes*: *Méditations esthétiques en salade*: *Café des Soirées de Paris*', and *Alcools*.[8] The evening ended in a brawl between the different factions in Cubism, but it brought a moment of splendour into the blackouts and bombings of war.

Yet Modigliani was too much a part of the life of Montparnasse, too involved with the individuals leading the 'new art', to remain completely aloof. In 1914 he had met Hans Arp, the French painter who was to become prominent in the new Dada movement, at the artists' canteen in the Avenue du Maine. Two years later Arp was living in Zurich, a member of a group of talented émigré artists who had left their own countries because of the war. Through casual meetings at cafés, the artists drew together to form a movement in protest against the waste of war, against nationalism and against everything pompous, conventional or boring in the art of the Western world. Since they held the bourgeois responsible for the war, they went out of their way to shock. In New York Duchamp provided the Mona Lisa with a moustache and Picabia painted absurd machines that mocked technology and efficiency. But it was in Zurich that the first shot was fired. The Dadaists, a nonsense name chosen at random, evolved the idea of a miniature variety show and held their first show in a little bar, the Cabaret Voltaire. Hugo Ball, a German actor and playwright, Hans Arp, Tristan Tzara and Marcel Janco, a poet and artist from Rumania, and Richard Huselsen-beck, a German poet, were the leaders of Dada. 'We wanted to make the Cabaret Voltaire a focal point of the "newest art", although we did not neglect, from time to time, to tell the fat and utterly uncomprehending Zurich

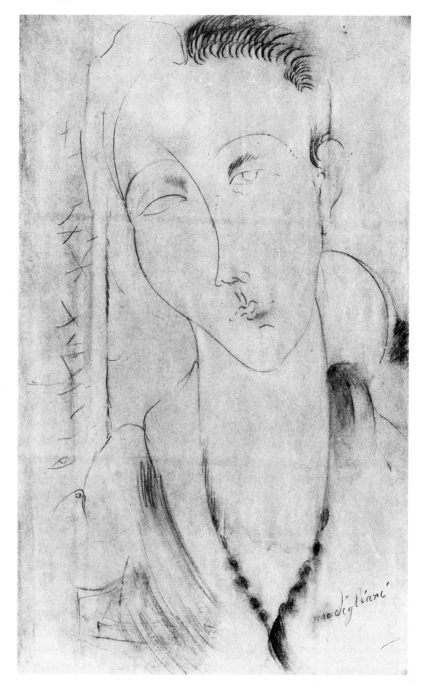

Lunia, 1918.

philistines that we regarded them as pigs and the German Kaiser as the initiator of the war . . . The Cabaret Voltaire group were all artists in the sense that they were keenly sensitive to newly developed artistic possibilities . . . In that period as we danced, sang and recited night after night in the Cabaret Voltaire, abstract art was for us tantamount to absolute honour. Naturalism was a psychological penetration of the motives of the bourgeois, in whom we saw our mortal enemy, and psychological penetration, despite all efforts at resistance, brings an identification with the various precepts of bourgeois morality . . . Dada was to be a rallying point for abstract energies and a lasting slingshot for the great international artistic movements'.[9] Modigliani was in sympathy with the broad sentiments of the movement, the internationalism, the disgust at the war and those who profited from it, and the sensitivity to the new possibilities in art, although the emphasis on abstract art did not fit into his creed. But at the time of the launch of Dada, Modigliani was not clear about the meaning of the new movement and no one else seemed to know. 'With psychological astuteness, the Dadaists spoke of energy and will and assured the world that they had amazing plans. But concerning the nature of these plans, no information was forthcoming.'

When the Dada brochure, *Cabaret Voltaire*, was published in June 1916 it was 'a catch-all for the most diverse directions in art which at that time seemed to us to constitute "Dada".' The cover design was by Arp and inside were contributions from Picasso, Kandinsky and Modigliani as well as the leaders of the movement. Modigliani's contribution was a portrait of Arp. Very probably he gave Arp the drawing, who used it with the artist's consent. His work was also shown at the Dada gallery in 1917, the Cabaret Voltaire, with a very mixed group of artists including Picasso, Arp, De Chirico, Paul Klee and Oscar Kokoshka.

For Modigliani it was important for his work to be seen outside France in an international setting. By now he had come to symbolize the Montparnasse adventure, and even in his worst moments he had a glamour about him, a sense of intensity, that excited envy and admiration. Jean Cocteau recognized it, although there was no personal sympathy between them and Jean Cocteau was deeply involved in the avant-garde. In Paris, at No. 6 Rue Huyghens, in a dingy, badly heated studio which belonged to a Swiss painter, Lejeune, modern art exhibitions, poetry readings and performances of new music were held in wartime. Paul Guillaume arranged the art exhibitions. Sometimes in a display of the new 'simultaneity' that was all the rage, there would be a combined performance of art, poetry reading and music of high quality with a fashionable, well-dressed crowd mingling with the artists. Modigliani was among the painters who showed their work at the studio in

the narrow street off Boulevard Montparnasse in 1916. Visitors to the studio could gain an impression of his work as a whole and grasp the cumulative effect.

One evening Leopold Zborowski, a Polish poet, came to look at the modern paintings exhibited and was immediately taken by Modigliani's remarkable talent. Zborowski had arrived in Paris before the war to study literature on a government grant. When the grant ceased Zbo, as he was called, tried to earn a living by selling books and prints along the quayside, and gradually began to deal in the paintings of the modern and as yet unrecognized artists. Zborowski displayed an intuitive and passionate enthusiasm for works of art. A gambler and a dreamer by temperament, he and Modigliani felt an immediate recognition and understanding. Not since Paul Alexandre had supported Modigliani eight years previously had anyone shown such excitement and deep interest in his work. 'He is a very great artist,' he told Lunia Czechowska, 'it is disgraceful that he has to sell his work on the café terraces.' Lunia Czechowska came from a prominent family of Polish intellectuals. With her husband Casimir Czechowski, a soldier on leave, she was Zborowski's guest for the evening and after the exhibition Zborowski invited the couple to the Rotonde, which was only a short walk away. As they sat with their drinks on the terrace, Lunia noticed a handsome young man in a velvet suit wearing a large black felt hat and a red scarf crossing the Boulevard Montparnasse. Under his arm he carried a large portfolio of drawings and she saw that he had pencils sticking out from his pocket. Lunia was a beautiful young woman with an air of great distinction. Modigliani, of course, spotted her at once and came and sat at the next table. She was enchanted by the artist, by his distinguished looks, 'his radiance and the beauty of his eyes. He was at the same time very simple and very noble. How different he was in his least gestures, even to his way of shaking your hand'.[10] As they talked, Modigliani began to sketch her. In the presence of a lovely woman he was carried away and, ignoring her husband completely, presented Lunia with the finished sketch and invited her to go out with him that evening. Madame Czechowska felt embarrassed and it was Zborowski who coped with the awkward moment. He explained that they had made plans for the evening and politely invited Modigliani to join them. Modigliani declined as politely but suggested to Lunia that she should come to his studio and pose for him the following day. Arrangements were carefully made so that Lunia would not be compromised and Modigliani came to paint her portrait the following day in the Sunny Hotel on the Boulevard de Port-Royal, the little lodging house where Zborowski was living with his

handsome and somewhat forbidding common-law wife, Anna (Hanka) Zborowska. As well as admiring Modigliani's talent, Zborowski found him a romantic figure, living a life he would have liked to lead. He was already acting for a number of young painters including Kisling, Hayden and Kremegne, and was determined to find a way of fostering Modigliani's talent. He was poor himself but passionate in his conviction that Modigliani deserved a sponsor. He was to become Modigliani's only permanent dealer, linked with his legend. With poetic licence he described their first meeting:

> In the open street towards evening in July,
> the vagrant crowd, haggard and dejected;
>
> they need warmth, these men,
> new passions.
> On both sides a café.
>
> A young man, my neighbour, gets up from his seat, takes several steps
> forward and stops in the middle of the road.
> He heeds neither motors nor tramways – the young man takes the
> notebook in his hands, opens its blue covers – the loose leaves fall on
> the warm pavement.
>
> A kind of swooning,
> An evening prayer.
> Come on, let's take this gentleman home.
>
> Policeman.
> Friends.
> The door closes like weary lids at night.
> That is how my life became linked with Modigliani one July night.[11]

Lunia was flattered at having her portrait painted by a gifted artist, but at first she felt rather intimidated by the experience. Modigliani painted her with such ferocity, in his shirt-sleeves, his hair all ruffled. From time to time he stretched out his hand to take a swig from a bottle of cheap, raw brandy. 'I could see the alcohol taking effect; he became so excited that he began to talk to me in Italian. He painted with such intensity that the painting fell on his head as he leant forward to see me better. I was terrified. Ashamed of having frightened me, he looked at me sweetly and began to sing Italian songs to make me forget the incident'.[12] How much of a comfort Modigliani's singing was remains in doubt. He sang 'horribly out of tune' and had a very limited

repertoire. Often he sang a Livornese song with the words: 'I work for a hundred lire a month. My wife wears a silk costume . . . and a hat with black feathers'.

His speaking voice by contrast was pleasing, his diction in French and Italian excellent. When he wanted to emphasize a point he rolled his rrrs. 'Admir – rable' he would say.[13]

In her eighties Lunia recalled a slightly different first meeting with Modigliani.[14] In this account he realized her timidity and managed to pretend that he was not looking at her, which seems extremely unlikely. During the sittings, which lasted for three afternoons, he was drinking grappa and reciting Dante. Since he painted her fourteen times in all, the detail may be mistaken. But alive in her memory was the friendship with Modi. They strolled through Paris together, after her husband went back to the front. Lunia insisted that Modigliani did not drink to excess, that the stories of his drinking and drug-taking are extremely exaggerated. He only drank when he was worried, she claimed, then he became quarrelsome, but never with his friends. In company where he felt at ease, able to be himself, with Paul Alexandre, Anna Akhmatova, Lunia Czechowska, Modigliani still behaved like the well-bred and courteous young man who had first charmed Paris. His extreme empathy coloured his behaviour and made him a heady, if unpredictable companion.

On 7 July Amedeo wrote a card to his mother telling her, somewhat cruelly, that as Italy was now in the war, he had thought that he might be called back for military service, even though he was an invalid and had felt a slight desire to return to Italy. 'But – I am still here.' The new hope that Zborowski would be able to sell his paintings and manage his affairs might have affected his decision to stay in Paris. First of all he had to free himself of his arrangement with Paul Guillaume.

Guillaume relinquished Modigliani as a client without too much regret. 'The young man has a real gift', he told Zborowski patronizingly. 'It's a pity he is not a bit more French.' Guillaume would have liked Modigliani's work to be more Cubist, more à la mode. Guillaume was also disturbed by Modi's unpredictable and unbusinesslike behaviour: 'the mere idea of asking him for a signature, which would have legalized a relationship, seemed ridiculous to me'. So the arrangement was tenuous and Modigliani revealed his feelings about his dealer in the 1916 portrait which shows Paul as a worldly, superior-looking figure, detached and ironic. Guillaume understood that Zborowski, 'who led the same kind of life as Modigliani, haunted the cafés with him',[15] would be far more suitable. Unfortunately Zborowski fell ill that summer and travelled to the south of France to recuperate. Modigliani found

work wherever he could. When André Warnod came home on leave he asked him politely whether he would like to have his portrait painted in uniform. Warnod had to decline, to his later regret. But Jacques Lipchitz, who had recently married, decided to commission Modigliani to paint a wedding portrait. Now under contract to Léonce Rosenburg, Picasso's dealer, Lipchitz felt more secure financially. Rosenburg, of course, knew of Modigliani's work and perhaps Lipchitz felt he could put some work Modigliani's way and at the same time acquire a beautiful painting that might appreciate.

When Lipchitz asked Modigliani what he charged, he replied: 'You know my price. Ten francs a sitting and a little alcohol.' The next day Modigliani turned up at Lipchitz's studio and made a number of preliminary drawings of Lipchitz and his wife with speed and precision. The three of them discussed the pose for the painting and Lipchitz brought out the wedding photograph to help Modigliani decide on the pose. The formal sitting began at one o'clock the following day. Modigliani arrived with a box of paints and a canvas he had already worked on. He preferred painting on a closely woven canvas, and sometimes when he had finished the work he placed a sheet of paper carefully over the fresh paint to merge the colours. He worked without an easel and with the minimum of fuss, placing his canvas on a chair and painting quietly, 'interrupting only now and then to take a gulp of alcohol from a bottle. From time to time he would get up and glance critically over his work and look at his models. By the end of the day he said: 'Well, I guess it's finished.' Although the portrait was finished Lipchitz felt loath to pay Modigliani so little for his work, so he invented reasons for extra sittings. 'Can't you work on it a little more?' he asked Modigliani. 'You know we sculptors like a little more mud, a little more substance.' Modigliani agreed reluctantly: 'If you want me to ruin it I can continue.'[16] For almost two weeks Modigliani worked on the painting, an unusually long time for him and perhaps the only time when he agreed to 'continue' a painting. Ironically, when it was finished, and it certainly was not 'ruined', Lipchitz preferred the drawings to the painting, which he put away in a cupboard. Soon after Modigliani's death Lipchitz exchanged the portrait to buy back two of his own stone heads from his dealer.

Lipchitz was a kindly man, who came from a small, close-knit Jewish village community in Russia. His background had taught him to be sober, frugal and methodical. He could not understand Modigliani's disregard for both his health and his money and found it shocking. Not only Modigliani's drinking worried Lipchitz, he criticized his way of eating his food highly seasoned, with piles of salt and pepper on his plate. Modi also liked his food smothered in garlic: 'when I eat garlic it's as if I kiss the mouth of the woman I

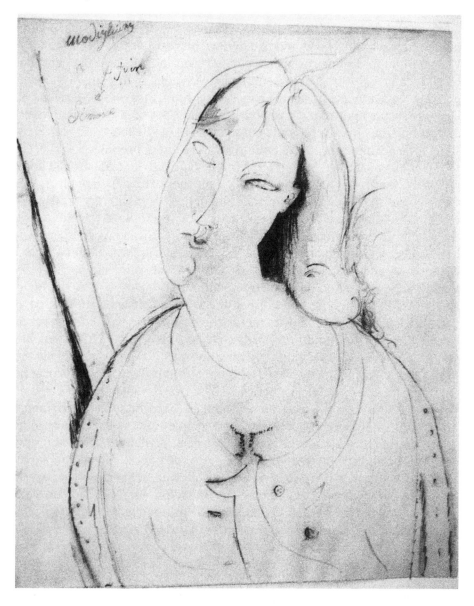

Simone, 1918.

love.' Lipchitz felt sure this was a means of reviving his jaded palate. He felt bound to reproach his friend for his excesses, which made Modi furious. 'You talk just like my family,' he retorted. 'But you're shortening your life,' Lipchitz pointed out patiently. 'Too bad,' snorted Modi. 'I want a short life but an intense one.'[17] Biographers have always taken that to mean that Modigliani was hell-bent on self-destruction. In context it seems more likely that it was his impatient response to Lipchitz's well-intentioned nannying.

Women, too, often felt the temptation to look after Modigliani. Marie Wassilieff, who ran the artists' canteen, gave him free meals and heaped advice upon him lavishly. A young woman called Simone Thiroux had eyed Modigliani for a long time. Simone was a wealthy French Canadian girl who had come to live with an aunt in Paris. She was a pretty, rather fleshy blonde, who revelled in the bohemian life of Montparnasse and enjoyed hanging round artists, posing for them, helping them to buy paints and cigarettes, studying intermittently at the Sorbonne until she had spent most of her inheritance and could no longer afford to pay for tuition. At Rosalie's little restaurant Simone watched the handsome Modigliani making a magnificent scene or sketching beautiful women at the Rotonde and, with her girl-friends, she had found him ravishing. She longed to get near him, and when he was quite drunk Simone would gently steer him to his room and help him get to bed. Inevitably one night she ended up by going to bed with him. Some people said she was a scalp-hunter, but most agreed that she was genuinely devoted to Modi, more interested in the man than the artist. Modigliani found her attentions annoying; he enjoyed the sport of courting and did not like to be chased. Although for a time Simone tagged along in his life, he never took the affair seriously. When the weather was cold Simone bought him scarves and warm clothes. When it was wet she would turn up at the cafés with galoshes. Lipchitz remembered her coming to watch when Modigliani painted his wedding portrait. He found her solicitude touching but Modigliani dismissed her, calling her a milksop.

Whilst Zborowski was still in the south of France Modigliani met Madame Zborowska in the street and asked her to pose for him. His relations with her were formal and wary, and she clearly looked on painters as a necessary evil for her husband's livelihood. Nevertheless, she was a handsome woman and very competent and Modi persuaded her to pose for him nude. Throughout his chaotic years in Paris he continued to go to life classes, but he could not afford the five francs an hour for a model and so rarely had a chance to paint the nude, except for his girl-friends, and that, as he was beginning to realize, was expensive too. Anna Zborowska posed for two nude paintings, presumably painted in her rooms at the Sunny Hotel with Lunia acting as

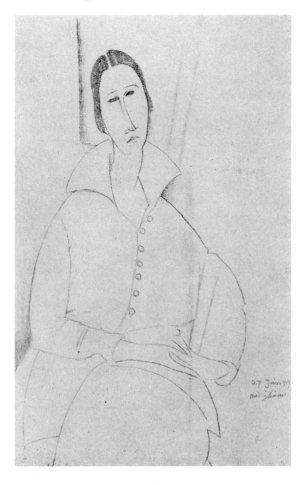

Hanka Zborowska.

chaperone. These he sold, on the spot, to a barber in the district, more interested in the salacious aspect than the superb swelling line of his work. The third portrait he promised to give to Madame Zborowska in gratitude for acting as a model. But as the painting was not yet dry he kept it in his room, and when a buyer came unexpectedly to see Modigliani and offered him ten francs for her portrait he took the money. When Hanka Zborowska arrived asking for her portrait Modigliani was shamefaced. He apologized and explained, but she did not waste time in argument.

They were all barely managing with their money. By selling paintings by Derain and a study by Kisling, Hanka raised the train fare for Zbo's return journey to Paris. Zborowski had a stroke of luck when he came back. He sold one of Derain's paintings for a thousand francs to a Norwegian dealer and was able to offer Modigliani a contract. Unlike Guillaume, Zborowski was

unbusinesslike, and a poor book-keeper, but he did have a wonderful faith in Modigliani's talent. From the autumn of 1916, Modigliani used a room in Zborowski's apartment in the Sunny Hotel as a studio, until they moved late in the year to an apartment in the Rue Joseph Bara. In a bare, narrow room, which also served as Zbo's 'gallery', Modigliani worked daily for fifteen francs. Zborowski supplied the charcoal, paints, canvas, and brushes; he also hired the models (Modigliani insisted that they must be paid three to five francs an hour) and any accessories, although the painter rarely asked for anything but the human figure for his work. Despite his reputation, Modi behaved impeccably at first. He never came to the hotel drunk and for the first time for years worked almost to a routine. After a late sleep and lunch at Rosalie's restaurant, he worked steadily through from 2 to 6pm. In the course of an afternoon he usually managed to finish a medium-sized painting, although larger paintings took two or three sessions. He also smoked the cigarettes Zborowski provided as part of the contract and managed to get through a bottle of wine.[18] By now two or three glasses had become indispensable to his output. 'After the first it didn't work; after the second things were a little better; after the third his hand worked by itself'.[19] Surprisingly little drink was enough to intoxicate him but it seemed as if the wine released the power in him. All his friends noticed that no matter how

Reclining nude, 1917.

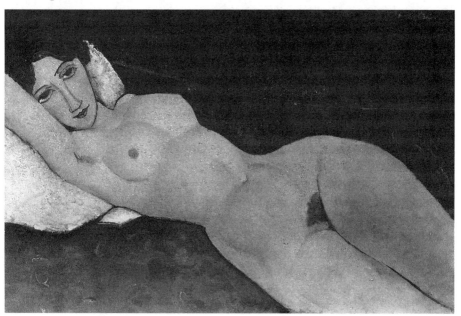

drunk he was, his hand remained steady and he could draw with astonishing skill and sensitivity. At the time, Maurice Utrillo was confined to a lunatic asylum through his chronic alcoholism and Lunia and the Zborowskis went to visit him every day. Modigliani felt the pain of these visits more than any of them, and was horrified to see his old friend in dingy and sinister surroundings, humiliated and frightened. They bought him canvas and paints and Maurice continued to paint from postcards. Occasionally they contrived to smuggle in a small bottle of crème-de-menthe in response to Utrillo's pathetic pleas. Modigliani often asked Lunia to accompany him when he took Utrillo out for a walk. Periodically Utrillo was allowed out of the asylum for a few days and occasionally he escaped. Then, unerringly, he found his way to Modigliani, wherever he was, and the two of them would drink the night away until they were unconscious, taken to the police station and beaten up.

Despite Zborowski's frantic efforts to sell his work, Modigliani's living was still very precarious. Kisling, Lipchitz, Utrillo, all his friends were selling and it was bitter for him to realize that his work was not yet marketable, not to the public taste. On the rare nights when Zborowski had a sale he left the lights on in the room. More often Hanka Zborowska switched the lights off and they pretended to be out so that Modigliani would not come up and ask for an advance on the next day's work. When he came to work at lunchtime, his first question was: 'How goes it? Have you sold anything?' But apart from the occasional buyer, Modigliani's paintings remained stacked in a corner in Zborowski's apartment and the price was depressingly low. Zborowski did have a buyer for the drawings in Lucien Descaves, the brother of the Police Commissioner who bought them up by the batch. To Zborowski's annoyance, Modigliani still clung to his old habits in the cafés, making dozens of sketches and giving most of his work away or bartering it to buy drinks. One evening when Zbo and Modi were sitting together in a café, Modigliani finished a sketch he had made and then tore the page out of his blue sketchbook. Thinking he was going to throw it away, Zborowski put out his hand to take it but Modigliani cowed him with a look and gravely presented the drawing to the sitter. If he was annoyed, Zborowski smothered his feelings: he was somewhat in awe of Modigliani who was, after all, a gentleman.

Blaise Cendrars, the writer, saw Modigliani let fall a twenty-franc note one evening when a well-known pauper came in to sit at the next table. 'I say, you're in luck,' Modi said pointing to the note at the poor man's foot. 'Look what you've found,' and he hurried away.[20] Many anecdotes of this kind were repeated in Montparnasse and they found their way to the Zborowskis,

À notre Amour, 1917.

who were struggling themselves. Sometimes Hanka Zborowska would go to the grocer and buy a kilo of red beans which they would share with Modigliani, just to make sure they all had something to eat. Even if other painters had to wait for their money, Zbo tried desperately hard to make sure that Modi did not go without. His 'good behaviour' did not last too long. For whole days he wandered off to the cafés and bars in a stand to assert his independence. 'I'm neither a boss nor a workman', he would say. Simone tagged along in his life, sometimes rooming with him. Inevitably he painted 'La Canadienne', but although she was deeply in love, Modigliani's emotions never seem to have been engaged in the affair. One evening, when the two of them were sitting at the Rotonde, Beatrice, 'the lady of Montmartre', entered with a handsome escort. A furious row broke out and in the confusion Modigliani got the blame and poor Simone was cut over the eye with broken

glass and scarred for life. Libion, the kindly café proprietor, was so exasperated that he had them all thrown out.[21]

For Simone, who was dependent and entirely besotted, Modigliani proved an impossible lover. If he disappeared for more than a few hours she became frantic and ran to the Zborowskis' apartment in the Rue Joseph Bara to ask for news, and almost lived there until he was eventually found. Zbo did his best to placate her, telling her that Modigliani often behaved oddly; in the end he went out to telephone the hospitals and the police stations. One day when Modi finally turned up he was penniless, unable to account for his lost weekend, hungry and dirty. Zbo, who had been out all day trying to sell his paintings, returned to find Modigliani sleeping off his drunken stupor on their sofa. Zborowski said nothing but went into his room and changed into worn summer clothes and came out carrying his only winter suit parcelled up to take to the pawnbroker. However romanticized that account[22] may be, it remains true that, whether through loyalty, vision or ambition for himself, Zborowski trudged the streets of Paris trying to sell Modigliani's work to dealers, critics and collectors. In his anxiety he often allowed himself to be beaten down in price. Writing a dutiful postcard to his mother on 16 November 1916 Modigliani, as uninformative as ever, tries to reassure her and is optimistic:

> Darling Mother,
> I have let too much time pass without writing, but I haven't forgotten you. Don't worry about me. I'm working and if I am sometimes worried, at least I am not as short of money as I was before. I wanted to send you some photographs but they didn't turn out too well. Send me your news.
> A big hug from
>
> Dedo[23]

Zborowski's constant, if precarious, backing had meant that Modigliani was not so desperately short of money. The war was still on, with nightly air-raids when the signal whined and the wardens cried '*Garde à vous*' and cleared the streets, and Modigliani sometimes stayed to watch the 'show' and then continued to drink after it was over.

Since his student days in Venice, when he went to seances, he had been fascinated by the occult. In 1908 he had made a drawing of a table-turning. In Paris during the war, 'La Rotonde was full of Russians who told fortunes, necromancers, palmists and spiritualists', and Modigliani was extremely susceptible to the mood of mysticism. In the face of the city's desperation he expressed his melancholy through his painting. During 1916 he drew a

series of drawings of Christian significance, of a crucifixion, a monk and of Max Jacob as a Benedictine monk. The drawings bore Latin inscriptions – 'Day of Resurrection', 'Day of Wrath' – that are so unlike any of the rest of his works that they have been largely ignored, and sell for far less than any other of Modigliani's works. Carol Mann suggests that Max Jacob may have invited Modigliani to illustrate his book, *La Défense de Tartuffe*, ecstasies, remorse, visions, prayers, poems and meditations of a converted Jew.[24] That seems possible because in one of Jacob's books, *Cornet à Dés*, there was a dedication to Modigliani in the edition published in 1917 which was deleted subsequently, presumably as a result of the mysterious quarrel over Beatrice. From Jacob's correspondence it is clear that he knew little of Modigliani's life in the last years.[25]

An unusually cold winter in 1916/17 brought the city of Paris almost to a halt. Lamp-oil was impossible to get and candles were scarce, but the worst shortage was of coal. All over Paris people queued to buy a small bagful to heat their homes, and in the Rue de la Paix the most fashionable jeweller in Paris placed a lump of coal, surrounded by diamonds, in his window. In this frigid season, crowds lined up to buy sugar, milk, chocolate and potatoes. The U-boat activity and the occupation of part of France by the enemy were responsible for the food shortages, which sent prices soaring. At the beginning of March 1917, the cost of Modigliani's favourite food, fish, rose by fifty per cent in one day. Shop windows were still frosted over and dustbins lay unemptied in the icy streets.

One winter morning Vlaminck noticed Modigliani standing on a street island in the Boulevard Raspail. 'With the haughty air of a general in charge of manoeuvres he was watching the taxis streaming past [there was no petrol rationing until April 1917]. An icy wind was blowing, but the moment Modi saw me he came and said, quite casually, as if referring to something he didn't need in the least: "Look here, I'll sell you my overcoat, it's much too big for me and should fit you nicely."'[28] Vlaminck was a bulky man, taller than Modi, and the overcoat would not have fitted him. Modigliani also tried to sell an old suitcase to an artist friend, but without success.

In recent years it has become fashionable to say that Modi only suffered from poverty because of his drinking and drug-taking. Hashish pills cost about twenty-five centimes a day and there is no evidence that Modigliani took anything else. As for drink, he drew endlessly to supply his need. You could get a meal for five francs at Rosalie's little place, and Modi often bartered a meal for drawings which she believed were worthless. His contract allowed him fifteen francs a day, if Zborowski could manage it, to cover all his needs. In Paul Guillaume's gallery a book on African sculpture was selling for

Mechan, 1917.

fifty francs in 1917; it was a book Modigliani would have prized, but at the cost of three days' subsistence plus one meal, it was out of the question.

In 1917, as if in defiance of the death and destruction all around him, Modigliani painted his most glorious series of nudes. Ever since he was a student in Florence and Venice, Modigliani had studied the female form repeatedly and passionately and when he came to Paris he continued to go to life classes. Unlike almost all his portraits, the nudes are not melancholy, but direct, open, sensuous in form and sumptuous in colour. The faces of the nudes are simpler, less tormented than those of his portraits, but since his friends were intellectuals, artists and writers, intense, complex men and women, consumed by an inner reality, that is hardly surprising; the girls who posed for his nudes were healthy young women, models, maids, waitresses, milkmaids revelling in their bodies and their sexuality. He painted about thirty nudes in Zborowski's apartment in 1917. Other painters would complain if a model did not please them, but Modigliani never swore at the girls or reproached them. But if he laughed all through a sitting or recited passages of Dante, Rimbaud or Verlaine by heart, that was a dangerous sign, 'Then one knew that he shouldn't be annoyed.'[27]

Seventy years ago Francis Carco, the writer, was one of the first private buyers of Modigliani's nudes. A corporal, home on leave from the army, he was a friend of both Modi and Zborowski. When Carco called to see the paintings Zborowski ran to buy a candle, stuck it into the neck of a bottle, then showed Carco into a narrow, unfurnished room where a stack of Modigliani's canvases stood in the corner. The dealer 'showed you his marvels, caressing them with his hands and his eyes, then cursing the fate which weighed on Modigliani and spitting in disgust . . . what poetry', he said. Zborowski told Carco how he had taken fifteen canvases to a merchant the other morning and wanted very little money for them, but the merchant sent him away . . . 'They are stupid,' Zbo said fervently. 'They are not yet accustomed to him', and he added prophetically, '. . . but you will see later on, they'll all want Modigliani, and in the meantime he has no money and he suffers . . .' Carco asked if he could buy a painting, 'The Standing Nude', and Zbo was so overcome with emotion because Carco appreciated Modigliani that he refused to take any money for it. When Carco's concierge came to clean his room the next day, she almost fainted at the sight of the nude picture hanging over his bed.

Simone Thiroux, the Canadian student so enamoured of Modigliani, was still shadowing him; by now she was pregnant and claiming he was the father. Modigliani adamantly refused to admit paternity of the child. Simone had happened to come into his bed, he said and shrugged. Her clinging

rapidly brought the affair to an end. Gossip in the quarter reported that Rosalie's son had overheard that Simone had decided to 'have' Modi for a bet and, when that story came to Modi's ears, he turned from her disgusted. Lipchitz's version was that Modi found Simone in bed with a painter friend of his. Simone had a reputation for sharing her favours and Modi felt no obligation towards her.

In March 1917 when news of the Russian revolution reached Paris, Modi went running to find his writer friend Ilya Ehrenburg, embraced him and began 'screeching enthusiastically', so that Ehrenburg could barely make out what he was saying.[28] Ehrenburg was convinced that Modi had a gift of prophecy. When he told Modi that the police had been to question him because his neighbour had hidden stolen goods in the wardrobe in Ehrenburg's room, Modigliani merely smiled. 'They'll lock you up soon,' he said. 'You want to blow up France and everyone knows it.' Later, as Modigliani predicted, Ehrenburg was arrested and charged with subversive activities.

War and revolution were in the air. One night Modi was sitting at the Rotonde with Rivera, Boris Savinkov, a revolutionary writer, and Max Voloshin, a poet. Fernand Léger and Lipinski the revolutionary were earnestly discussing the political situation at the next table. Late at night Modigliani persuaded them all to go back to his place to continue the discussion. Ehrenburg reported it, and he is one of the few who described Modigliani in serious mood, not merely hitting the bottle or making a scene. Fernand Léger, on leave from the Engineering Corps, was a socialist, profoundly affected by his army service. 'I found myself on a level with the whole of the French people; my new companions . . . were miners, navvies, workers in metal and wood. Among them I discovered the French people. At the same time I was dazzled by the breech of a 75-millimetre gun which was standing uncovered in the sunlight: the magic of light on white metal. This was enough to make me forget the abstract art of 1912–13!'[29]

Léger determined that in future the motifs of his paintings would be more closely connected to working people. He was optimistic about the future and told the others that the politicians would be driven out after the war and the people would find their inspiration in science, technology, work and sport. Voloshin argued against him and then Modi interrupted: 'You're all a lot of bloody innocents. Do you think anyone is going to say to you: "My dear fellows, take your choice?" You make me laugh. The only people who make a choice today are the ones with self-inflicted wounds, and they get shot for it. When the war is over, everyone will be put in prison . . . Everyone will have to wear a convict's uniform. At the most the academics will be entitled to wear

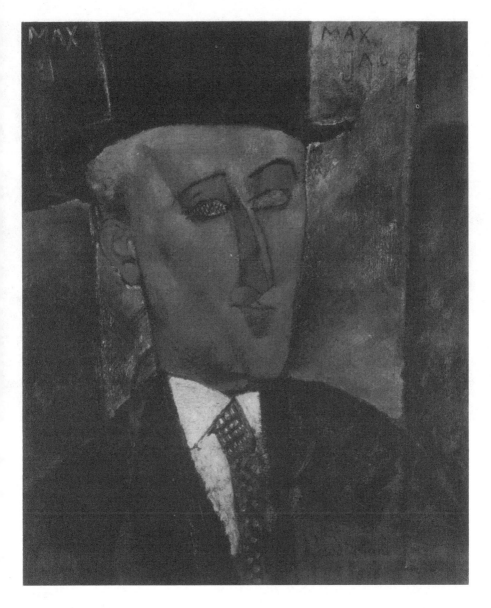

Max Jacob, 1916

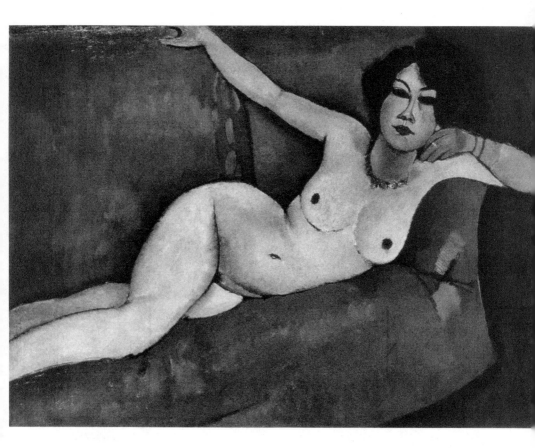

Nude on Divan, 1916

checked trousers instead of striped ones.'

The others disagreed with Modigliani's pessimistic vision of a grey and uniform post-war world. Léger insisted that a new approach in art was necessary. Rivera felt that that was hopeless. Art was dying: no one in Paris needed it. And Modigliani was wrong because the worst was over. 'The socialists could . . .' Then Modigliani interrupted again: 'Do you know what the socialists are like? Bald-headed parrots. I said so to my brother. Please don't take offence: the socialists are better than the rest all the same. But you don't understand anything . . . what's the difference between Mussolini and Cadorna? [Luigi Cadorna was Chief of Staff and Commander-in-Chief of the Italian armies, 1915–1917.]

'Rubbish!' Modigliani went on. 'Soutine has painted a marvellous portrait. There's a Rembrandt, believe it or not. But he'll be caged behind bars like everyone else'. He turned to Léger. 'Listen, you want to organize the world. But the world can't be measured with a ruler. There are people . . .'[30] Ehrenburg noted down Modigliani's remarks, remembering everything he could. But before Modi could continue, Rivera shut his eyes, a sign that he was about to break into one of his fits, when he would erupt and turn white. Modigliani and Ehrenburg edged towards the door whilst Rivera hoisted the stout and sturdy poet Max Voloshin from the floor as if he were a baby, but fortunately he quietened down before any damage was done.

Modigliani's profound humanism and pessimism made him distrust political systems. He put his faith in the genius of individuals. Ever since Zborowski took him on, Modigliani had been urging Zbo to act as Soutine's dealer, pointing out his greatness. But Soutine's painting was even less accessible than Modigliani's. Besides, Hanka Zborowska could not bear to have Chaim Soutine in her house. She found him uncouth and dirty and he often smelt of abattoirs and of the chicken carcases or sides of beef he had been painting. In exasperation Modi painted a portrait of Chaim Soutine on a door of the Zborowskis' apartment in the Rue Joseph Bara, as a permanent reminder of his friend's great talent, to Hanka's fury.

When Georges Braque, badly wounded and invalided out of the infantry, came back to Paris in 1917, Marie Wassilieff gave a banquet for him at her canteen. The numbers were limited to thirty-five, and Marie and a committee including Picasso arranged the guest list. She produced a striking table with a black paper tablecloth, white plates and red napkins. Two crowns of laurels were offered to Braque and his wife. When Marie saw Modigliani she said to him: 'For heaven's sake don't come tomorrow. I haven't invited you. Do me a favour and I'll give you three francs instead of your fifty centimes [which she gave him daily].'

Among the invited guests were Beatrice Hastings and the lover who replaced Modigliani, Alfredo Pina. The meal was peaceful, but when it was over the doors burst open and in surged a crowd of painters and models who hadn't been invited. When Pina saw Modigliani he drew a revolver and pointed it at him. Marie Wassilieff relates that she seized the gun, forced Modigliani out of the door and rolled him down the stairs. The banquet went on all night and 'by six in the morning Braque and Derain were dancing with the bones of the lamb'.[31]

In 1917 Moise Kisling married, and the occasion gave the party-loving painter a wonderful excuse to entertain. After the ceremony, the wedding party and their guests went to the Rotonde and Libion, the popular patron, offered champagne on the house and toasts were drunk enthusiastically. After that Kisling expansively invited all the guests to dinner with him at Leduc's restaurant. Chana Orloff, who was sitting next to her husband and Modigliani, was a little worried by the grandiose gesture, but the men shrugged and said: 'We'll get a good meal'. Then in the middle of the grand dinner, when Kisling was sufficiently drunk, he announced to his guests that he would 'dance the dance of chastity'. 'He pulled his shirt out of his trousers and galloped around us; after which he declared "you take care of the bill", and he skipped'.[32]

There was a stunned silence, then the guests scrambled to leave, but the proprietors of the restaurant stood guard at the door with a policeman. Somehow or other the artists managed to pay or promise to pay, and most of the guests went good-humouredly back to Kisling's studio to continue the party. The evening ended in a terrible brawl. Drunks were making a din on the stairs and a sculptor was tearing up a collection of Kisling's drawings and throwing them down on to the head of the concierge. Kisling was livid, and with the help of some friends managed to grab the sculptor and throw him down the stairwell from the seventh floor. By clinging to a bannister he miraculously managed to land safely. As the guests left in a state of alcoholic haze, two policemen stood at the door.

After the wedding the Kisling parties grew even wilder. Renée Kisling, the daughter of an officer, was as ardent a party-goer as her husband, a powerful woman capable of blacking the eye of any guest who wanted to slip out before a rowdy party broke up. Modigliani did not like her and the two often quarrelled. The wild bohemianism of the life at Kisling's was stimulating and hectic but a drain on Modigliani's limited energy and he was looking for a change in his life.

—8—

Jeanne

IN April 1917, shortly after her nineteenth birthday, Jeanne Hébuterne was trying on her costume for the artists' fancy dress ball during the Carnival. She pulled on high boots, home-made poncho-style Russian blouse and long skirt and put up her gleaming chestnut hair in a chignon with a fashionable fringe. At a friend's studio she posed, head on one side and delicate long fingers hanging languidly from the enveloping sleeves of her home-made gown. Jeanne looks, in a faded photograph, as if she were a Modigliani model.[1] He was to paint her more than twenty-five times.

Jeanne Hébuterne studied art at the Academi Colarossi and the École des Arts Décoratifs where she met the sculptor, Chana Orloff, who claimed to have introduced Modigliani to Jeanne. As in all the important events in Modigliani's life, there are differing versions of the story. In Montparnasse artists and art students met each other in the cafés and at the life class and in the little restaurants. At the time Jeanne was fascinated by Foujita, the diminutive Japanese artist, who wore gold ear-rings to set off his owl-shaped face and a toga he had woven himself under the influence of Raymond Duncan's Greek worship. Foujita, an inventive witness, claimed that they were lovers, although Jeanne's friends insist that she was a virgin when she met Modigliani. Once in Amedeo's company everyone agrees that she 'only had eyes for him'.[2] Jeanne was drawn to Modi, not only by his looks but because of his talent, his sense of style and his dangerous reputation with women. All Montparnasse knew the stories of Simone and Beatrice. Like Modigliani, Jeanne was a romantic, a mysterious young woman with soulful blue eyes and a generous mouth. A talented student, she was immensely serious about her work and Modigliani helped and encouraged her. Unconsciously perhaps Jeanne was seeking to free herself from her narrow and oppressively respectable bourgeois family. Her parents were not Parisians, they came from the provinces and Jeanne herself combined

Jeanne, *c*.1918.

innocence with imaginative courage. After the flamboyant destructiveness of Beatrice, the cloying of Simone, Jeanne Hébuterne, talented and secretive, with her fresh looks which held a hint of sensuality, was enormously appealing. They shared a love of music; Jeanne played the violin more than competently; Bach was a favourite composer. She was also interested in literature, subjected at home to a diet of Plotinus, the third-century Greek philosopher, and especially Pascal, read to her by her father whilst she and her mother peeled potatoes. Achille Hébuterne worked as chief cashier in a perfumery. His passion for seventeenth-century literature had led the former atheist to a sudden conversion and during the war years he developed into a pillar of the Roman Catholic church. Jeanne's brother André, an academic landscape painter four years her senior, also became a convert whilst Jeanne's mother, Eudoxie Hébuterne, tried to enter into the spirit of ardent Catholicism. Like her mother Jeanne was of a more sceptical frame of mind

but she could not remain unaffected by the atmosphere of piety in the fifth-floor apartment.

With her milky complexion set off by chestnut hair the artists nicknamed her 'coconut'. She was one of the few members of the artistic community who admitted to religious observance. Modi's friends did not know what to make of the romance. In their eyes Jeanne was charming to look at but a timid, uninteresting little thing. They were all much older than she was, many of them well known, and wisely she kept quiet in their company. Her youth and looks aroused envy of Modi in the men and jealousy of Jeanne in the women. But with student friends like Chana Orloff and Germaine Labaye, known as 'Red Bean', Jeanne's friend from the Colarossi, she could be herself, intelligent, interested in fashion, with a style of her own. Jeanne and Germaine went to the Dôme or the Rotonde regularly at aperitif hour to meet Modigliani and Roger Wild (who was to become Germaine's husband). Modi was fourteen years older but so attractive and youthful that they enjoyed his company and often ate together at Rosalie's restaurant or Les Trois Portes, another eating-place favoured by artists.[3]

The two of them, both intensely introverted people, conducted their love affair in secret. Surprisingly, no anecdotes exist of conversations or scenes between the lovers. Jeanne and Modigliani walked hand in hand through Montparnasse but no one really understood the attraction. For three months Jeanne kept her love for Modigliani a secret from her family, went to Mass and appeared gentle and dutiful, if somewhat abstracted. Years later her parents made a sworn statement testifying that the couple had met in July 1917. By then Jeanne had taken the extraordinarily courageous step of leaving her comfortable home to live openly with Modigliani in a seedy hotel room. From her family's point of view she could scarcely have chosen a more unsuitable lover. He was fourteen years older than Jeanne, barely able to support himself, let alone a wife, a weakling unfit for army service, a bohemian, a drunk and, worst of all, a Jew. But Jeanne was surprisingly strong-minded. Nothing that her family could say, none of their warnings, could dissuade her. Her elder brother André, an academic painter, was fond of Jeanne and close to her. He did not mix with the crowd at the Rotonde and had little sympathy with the wild scenes of the moderns. Besides, he remained living at home, and had to side with his parents.

Although the couple lived in poverty, through Modigliani Jeanne was introduced to the high point of the Montparnasse adventure. In June 1917 his paintings were on exhibition again at the improvised gallery in the Rue Huyghens, where Modigliani, Kisling and Zadkine each had a wall with their

works displayed. At the same time the contemporary composers Satie, Auric, Honegger, Poulenc, Milhaud and Germaine Taillefer had their works played on the piano by the Brazilian pianist Ricardo Vines. Cocteau and Cendrars read their poems. 'Worldly Paris mingled in these sessions with artists in sweaters who had come from the Rotonde and the Dôme . . . There were in this dingy, badly heated studio, moments of rare artistic quality of a kind that occurs but rarely in a century'.[4] Jeanne was there, proud of Modigliani, although as usual his work did not sell. Now when she saw him drinking, wild-eyed and aggressive, in her inner eye she kept the vision of the distinguished and striking man she knew him to be.

During the summer of 1917 Léon Bakst, the designer of Diaghilev's Russian ballet, commissioned a portrait by Modigliani. Almost certainly Bakst visited the exhibition of modern art at the Rue Huyghens. He was a man of advanced tastes who appreciated African art and the films of Charlie Chaplin. A Russian Jew, he lived in an elegant and beautifully ordered apartment, No. 112 Boulevard Malesherbes, his drawings all catalogued and filed in cabinets. The designer surrounded himself with exquisite objects – Chinese porcelain vases, a life-sized bronze reproduction of Donatello's David, the paintings of Rousseau. He also grew cacti enthusiastically. Modigliani knew how to adapt himself to his surroundings and made a great impression on the day he came to sketch Bakst. The following day, when Modigliani was due to begin painting his portrait, the writer Michel Georges-Michel paid a visit and was just about to leave when Bakst persuaded him to stay on. 'You will see an Italian painter who is really somebody. He is going to paint my portrait. Look, here is the drawing he gave me: see how fine it is, how accurate, how personal . . . Modigliani must be poor, but he has the air of an aristocrat.' Bakst spoke with admiration of Modigliani's erect carriage, of the air of inner fire that lighted up his face.[5]

By now Modigliani could not transform overnight into a conventional husband, and Jeanne accepted him with his failings. In her silent way, she had committed herself entirely to a life for art's sake. Gradually he did begin to stay with her in the evenings and to neglect the cafés. Sometimes they sat together and worked, or Jeanne would play the violin whilst Modigliani painted. She had the right – as no other woman had ever had – to fetch him when it grew late. He often went out alone, Italian style, and Jeanne would wait for him in the street after the cafés closed. He would sit slumped on a seat near a bar or a café waiting for her. Then Jeanne would say very quietly, 'Let's go, Amedeo', and half dragged, half led him home. Zborowski was enthusiastic about the love affair. With a loyal and loving woman behind him and the semblance of domestic life, he hoped that at last Modi would

Modi at a café with Adolphe
Basler, *c.*1918.

settle down and produce more paintings.

There was still the bitter disappointment of his failure to win the recognition he deserved. That autumn Zbo worked hard to arrange a one-man show for Modigliani. After many earnest conversations with Berthe Weill, who dealt in the works of modern artists such as Dufy, Vlaminck, Utrillo, Pascin and Picasso, he persuaded her to put on an exhibition for Modigliani. She took on the 'difficult' painter more out of sympathy for Zborowski's hopeless task than of belief in Modigliani. By December 1917 Madame Weill had moved from her tiny shop on the Rue Victor-Masse, where she pinned up her pictures with clothes-pegs on an overhead wire like washing, to a more imposing venue, Galerie B. Weill, 50 Rue Taitbout in the 9th arrondissement. Zborowski decided to feature Modigliani's nudes as well as his portraits.

The dealer himself was intrigued by the nudes. When Modigliani was working, Zbo could not resist peeping through the door once or twice to watch, with the excuse of seeing that everything was all right. For Modigliani painting was a very private encounter between artist and sitter. When Zbo interrupted he flew into a rage at the violation. On one occasion Zborowski came in when Modigliani was painting a standing nude. The artist became so angry that he started to slash the canvas. Lunia, the sympathetic friend and neighbour, who was herself interested in Modigliani, managed to calm him

and after that she stood guard at the door to prevent any intrusion. The exhibition of paintings and drawings was to run from 3 to 30 December to catch the Christmas crowds. Jeanne herself had posed for the model of the drawing of a young girl, her hands covering one breast, a triangle of pubic hair prominent. Blaise Cendrars, the vagabond poet who had shared many a bottle with Modigliani, wrote these mysterious lines as preface:

On a portrait of Modigliani

The interior world
The human heart with
Its 17 impulses
Of the soul
The come-and-go of passion.

The Sunday before the private view, Modigliani, Zborowski and Berthe Weill spent all day hanging the paintings and drawings. Zbo insisted on placing a bold and magnificent nude in the window to attract passers-by in the street. Distinguished visitors were invited, including M. Henry Simon, the Minister for the Colonies, and fashionable men and women as well as Modigliani's friends from Montparnasse. Unfortunately Zborowski was too successful in attracting attention. Outside the gallery a group of curious bystanders gathered, staring and leering at the nude painting. As the crowd grew, pressing against the window, the Divisional Police Commissioner Rousselet, who had been keeping an eye on events, sent a policeman down with orders to have the nude painting removed from the window. The guests milled round in confusion; Madame Weill, a tiny woman in a tailored suit, tried to fob the policeman off. She told him she was too busy to attend to the matter, whilst the guests gave up all pretence of looking at the pictures to stare at the intruder. Then the policeman raised his voice and said in an insolent tone: 'The Commissioner orders you to remove that nude'. Anxious to be rid of the interruption, Madame Weill carefully brought the offending nude inside. But before he left the policeman peered round the walls and noticed other equally frank nudes. Meanwhile the crowd outside, sensing a scandal, pressed even more closely against the windows of the gallery and grew so thick that the traffic was held up. In a few minutes the same policeman forced his way through the mob to the gallery. 'Monsieur le Commissaire wants to see you upstairs in his office', he announced importantly. Berthe Weill protested that she could not leave the gallery for the moment, she hadn't the time, there were all the guests to look after. Again the policeman ordered her sharply to

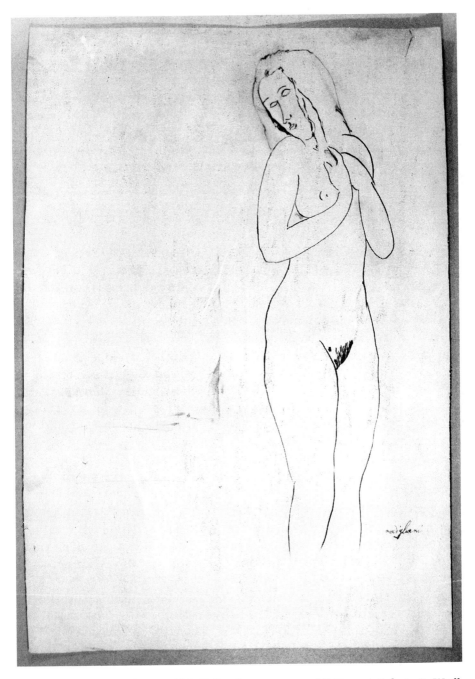

The cover of the Catalogue of Modigliani's one-man exhibition at Galerie B. Weill, 1917.

come with him. Berthe Weill shrugged and crossed the street after him to the catcalls of the crowd.

In the Commissioner's office she put on a brave front. 'You asked me to come here?' 'Yes,' he replied sternly, 'and I order you to take down all that filth.' Madame Weill tried to reason. 'Fortunately there are some connoisseurs of art who are not of that opinion.' 'But those nudes,' said Rousselet growing red-faced, 'they have h-h-hair.' Until that time the convention in painting nudes had been to omit pubic hair altogether. Modigliani painted hair when he saw it as part of his design. But the Commissioner, enjoying a high state of moral indignation, looked for no explanation. The paintings, in his view, were an affront to public morality. 'If you don't see that my orders are obeyed immediately, I'll have a squad of policemen seize the lot,' he barked.[6]

In wartime the police enjoyed special powers and abused them. Madame Weill had little choice. She went back to the gallery, furious, shut the door, pulled down the blind, and those other guests still inside helped her to remove the paintings from the walls. Modigliani's one-man show, scheduled to last throughout the month of December, closed on the day that it opened. Despite the débâcle, two drawings were sold for thirty francs each and Madame Weill bought five of the paintings herself 'to help out Modigliani'. Modigliani's luck was appalling. For a brief moment the one-man show had seemed so promising and he had dared to hope. The episode could only have increased his distrust of authority and his disdain for the bourgeois. Modigliani's nudes, neither prostitutes nor wives, are equal partners unashamedly enjoying their sexuality and inviting a response. That frank acknowledgement of the new freedom between the sexes, which Modigliani and the women he loved enjoyed, was what offended the respectable Parisians. His nudes do not titillate, caught unawares. They invite. The rather coy nude which featured on the catalogue cover is so uncharacteristic that it was possibly suggested by Zborowski, to attract attention. As late as 1949, when *Life* magazine featured Modigliani nudes in an article on the painter, they continued to offend high-minded citizens. Many American subscribers rang to cancel their subscriptions in protest.[7]

Soon the story of the scandalous exhibition was all over Paris and, ironically, the unlooked for publicity did make his work more saleable – although when Zborowski offered Jacques Lipchitz four nudes from the show for five hundred francs, he refused. He had not the room, he pleaded. 'Where will I put those four nudes with all those triangles?'[8] However, a trickle of collectors and speculators began to arrive at Zborowski's flat early in 1918, buying up Modigliani's oil paintings, worth millions of pounds today, for

three or four hundred francs. Jacques Netter, a well-known collector, asked Zbo to put aside several Modiglianis for him. Zamaron, the friendly policeman who was now promoted to Secrétaire Général of the Prefecture of Police and had bought Modigliani's early work, came to the apartment to buy. Louis Libaude and William Kundig also purchased paintings and finally a banker named Schenemayer hurried over to see Zborowski and bought six portraits for four thousand francs without even bothering to look at them. After the terrible disappointment of the one-man show, Modigliani was overjoyed. 'We're saved,' he shouted. For the first time in all his years in Paris, his future and Jeanne's seemed assured. Francis Carco, who was a friend who had bought Modigliani's work before the crowd, also bought Modigliani's paintings, but he was given them for what he himself described as a ridiculously cheap price.

The cost of living continued to rise in wartime. In January 1918, which was another freezing month, gas, electricity and coal were rationed. All food was scarce, milk, eggs and butter were in short supply and expensive. Because of the frost vegetables too were hard to find. Butchers closed their doors for three days in the week. Air-raids, which the Parisians had become accustomed to, now intensified. On 30 January 1918 the Germans sent fifty much larger bombers over the city. They dropped ninety-three bombs and caused casualties and damage at a rate Paris had not experienced before. By March, with the Germans driving forwards toward Paris from the north-east and renewed heavy air-raids, Parisians were spending more and more time in cellars and shelters. But worse was to come. On 23 March the city suffered twenty-five shattering explosions during the morning without an aircraft in sight, killing and injuring the civilian population. The Germans, some seventy-five miles north-east of Paris, had begun to pound the capital with shells from three extra-long-range guns. No warning, of course, had been given of the shelling from the 'Big Berthas' and the public feared that an advance on Paris would soon follow. As the shells hit the city, banks and Ministries began to send their records and documents, and sometimes their personnel, out of the capital. The British Embassy made arrangements to evacuate the British colony and by April almost half a million Parisians were travelling to safety in the south of France.

Art dealers too left the city, and as many artists as could afford the fare. The art market, which had fluctuated greatly during the war, collapsed, with the price of the modern painters Derain, Vlaminck, Valadon completely depressed. The sales boom that Modigliani had enjoyed at the beginning of the year faded. Zborowski boldly decided to leave the city and take Modigliani and Jeanne with him. Zbo had been impressed, when he convalesced in the

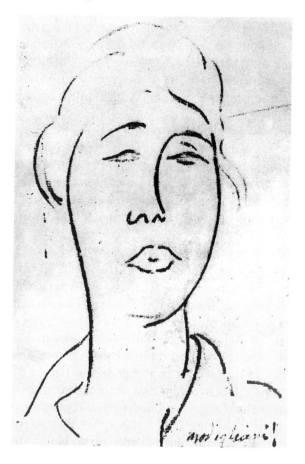

Madame Dorival.

south in 1916, by the rich residents there and he believed, somewhat
naïvely, that he would find important clients to buy his paintings. He bought
himself a smart new suit for the purpose. On a human level he hoped that the
change from the shelling and bombing in Paris would benefit Modi's health.

Another pressing reason for leaving was that Jeanne Hébuterne had just
discovered that she was pregnant and she had confessed as much to her
mother. Despite her disapproval Madame Hébuterne felt that her daughter,
just turned 20, could hardly fend for herself and decided to accompany her.
The ill-assorted travelling party grew and grew. Almost certainly at
Modigliani's insistence, Soutine was included. During the war years, the
Russian artist had rarely been able to sell his work and he took to following
Zborowski round like a shadow, hanging about outside the Rotonde.
Zborowski had to find the money for Soutine's trip. Then Foujita, the
Japanese artist, and his beautiful domineering wife Fernande Barrey joined

the party. Fernande openly admitted to starting life as a street-walker and Madame Hébuterne must have felt she was travelling with a menagerie. Although Modigliani had promised openly to marry Jeanne, it was just a question of arranging the papers . . . Not such an easy matter in wartime, and Modi had an abhorrence of officialdom. Jeanne's father wanted nothing to do with the couple.

'Amedeo, excited like a virgin by the bombardments, has gone to Cagnes near Nice over a month ago . . . He took the girl with the braids and her mother,' the writer André Delhay gossiped in a letter of 13 May 1918, adding, in the malicious tone of Montparnasse, 'The little Thiroux is running after Scandinavians – and rich Americans – anybody famous will do'.⁹ Although Modigliani had rejected Simone Thiroux's claim on his paternity, and her child, a boy, was born in the spring of 1917, he was happy to acknowledge that Jeanne was carrying his child. His relations with her mother, however, were anything but happy. Madame Hébuterne was constantly disapproving and interfering. Zborowski had rented an apartment in the Rue Masséna, but Modigliani was restless and unsettled living in a constrained atmosphere. After all those years in Paris he found the bright sunshine and the sparkling translucence of the air disturbed his concentration and made it difficult for him to work. In his portraits he looked for shade, for intimate interiors. During his long stay in the south he made only one portrait with an out-of-doors setting; the pretty shopkeeper, sitting on a chair in front of her shop, looking out with uncomprehending suspicion against a white wall. In Nice, as in Paris, he looked to the impersonal comfort of the café and the solace of red wine for his escape. Jeanne's mother nagged and poor Jeanne, left with her, was desperately unhappy. Relations between Modi and Madame Hébuterne became so strained, with Jeanne refusing to give him up and Madame cursing him and his art, that after a time he moved away to stay in the Hôtel Tarelli, 5 Rue de France.

In Nice Modigliani was delighted to meet a man he had recently painted, the Russian-born Cubist painter, Leopold Sturzvage (known usually as Survage). Anyone from Paris was reassuring, and Survage was a congenial man, who offered Modigliani one of his two rooms to work in. He began to paint feverishly, as if he had time to make up. In Nice he got up early and went to Survage's room and painted until midday, then took a swig of alcohol, made a face and returned to the canvas.¹⁰

He was plagued in the south by the lack of models. In Nice the people were not used to painters and felt embarrassed at the idea of posing for them. In Paris, if he strolled into the Dôme or the Rotonde, he would find interesting types, émigrés, intellectuals, beauties or bohemians, or Zbo could hire models

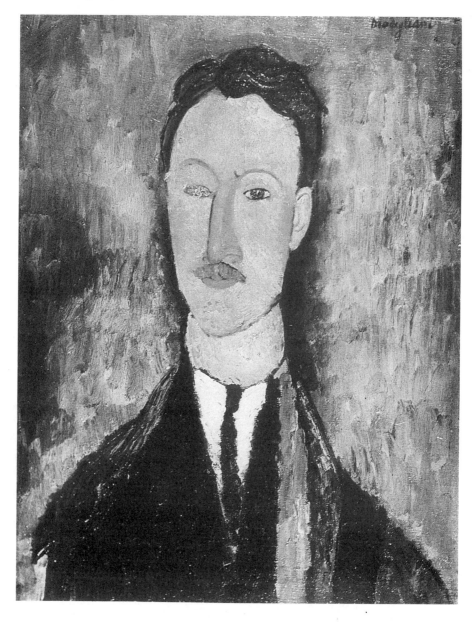

Leopold Survage, 1918.

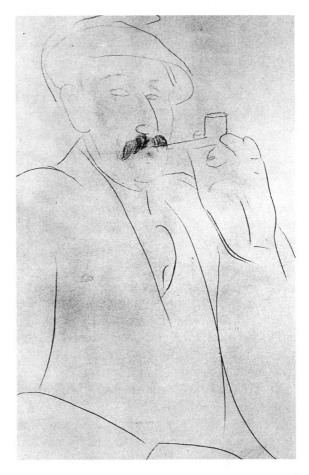

Man with pipe, 1918–19.

for him. He painted Jeanne many times, but was often glad to escape from the apartment and from Madame Hébuterne's endless criticism of him. When he visited the Russian sculptor Archipenko and his wife, who were living in a villa in Nice, Modi grumbled of the women who bossed him around. At the end of the visit Archipenko told Modigliani to help himself to the fruit and vegetables in their garden which he took back to Jeanne and her mother as a peace offering.[11]

In the apartment, Jeanne sketched and painted whenever she had the peace. She herself was a talented artist, but all her energies were taken up in caring for Modigliani, keeping the peace between her lover and her mother. The few examples of her work that exist show her to have a strong sense of composition and a bold yet sensitive line. She drew Modigliani reading by lamplight in Nice, absorbed and distinguished with an air of apartness.

Jeanne was quiet, appeared timid but had an immensely strong will. Modigliani would never have stayed with a nonentity. She made the choices in her life. More than a hint that, although deeply in love, she could grow exasperated with her impossible husband appears in a poem in Modigliani's drawing of his friend Fabiano de Castro in 1918:

> *Un chat se gratte la tête*
> *Comme un poète qui cherche une rime.*
> *Ma femme pour un prêtre*
> *Me jette une verre a là tête.*

> A cat scratches his head
> Like a poet seeking for a rhyme.
> My wife for a priest
> Throws a glass at my head.

An indication, perhaps, that Jeanne, or more particularly her mother, wanted Modigliani to marry in the Catholic Church.

The accounts of the journey to the south remain contradictory. Some report that at the beginning of the journey south, the party stayed at the little village of Cagnes-sur-Mer close to Nice.[12] There Zborowski rented rooms for them all from Papa Curel, an elderly eccentric who let out rooms in his villas and 'knew all about artists.' The Zborowskis with Jeanne and her mother took rooms in Le Pavilion des Trois Soeurs, a villa set on a hill at the back of the village, two miles from the sea. To prevent quarrels between Modi and Jeanne's mother, he was housed with the other artists in a villa higher up on the hill. Angry at being separated from Jeanne, Modigliani spent much of his time drinking in a windowless little bar where local artists met, where he drank and ran up debts. But Madame Zborowska, who seems to have spent most of her time smoothing out the quarrels between the artists, asserted that Modigliani also worked 'passionately'.

Whether Modigliani and Jeanne lived in Nice or in nearby Cagnes-sur-Mer, or more probably both, can never be definitely proved and is of little consequence. The accounts are third-hand, told years after the events. Apparently the party returned to Nice because Zborowski had failed to sell enough paintings to pay the rent. Papa Curel, who had plagued their lives by playing the trumpet at all hours in the artists' villa, retained their luggage but allowed the party to take their paintings with them. Later when the prices soared he was said to be furious. Before long Foujita and Fernande returned to Paris, and after August 1918, the Germans stopped shelling the city.

The people Modigliani painted usually remembered the circumstances vividly. In July 1918 the actor Pierre Bertin, who became a member of the Comédie Française, was introduced to Modigliani one day when he was strolling along the Promenade des Anglais with Zborowski. The painter looked handsome but shabbily dressed. Sensing that Bertin was an art-lover, Zbo showed him some paintings and made a sale. In conversation Bertin remarked that his young wife played the piano well and was particularly fond of Ravel. Modigliani disliked social gatherings but was persuaded by the promise of music to visit the couple. Jeanne came with him to accompany Bertin's sister-in-law, Germaine Meyer, who was later to marry Survage, on the violin. Germaine Meyer was wearing a sky-blue blouse that summer afternoon and Modigliani was immediately arrested by her colouring, a blend of rose and white, and asked her eagerly if he could paint her. To his relief she agreed, and the following day Modigliani arrived. First he asked Germaine to play something by Ravel for him, presumably to glean an impression of her personality. After about ten minutes he stopped her. 'That's fine,' he said. 'Let's begin.' He sketched her deftly in a few minutes. 'Then he drew my face, my clothes and put on the colour. The portrait was painted in a few hours without Modigliani stopping for a single minute.'[13]

In Zborowski's apartment in Nice, Modigliani drew a second portrait of Germaine, very similar, only this time she was wearing a black dress. A good model was a wonderful aid to him in Nice. Germaine fell ill with influenza and the sessions had to be interrupted. Once she was better, he insisted on starting again, explaining to the young woman that he could never resume a canvas that had been abandoned. Like all the women he painted, Germaine remembered his attraction and details of his appearance. 'His only shirt, blue and white check, was always spotless and though friends offered him clothes to replace his worn velvet suit he would not accept them.' Germaine also saw him with Jeanne and her mother in the Rue de France. She found him utterly sympathetic and charming. 'He loved Jeanne. She adored him,' she explained.[14] The Modigliani that Germaine described was the man that so many women admired: fascinating, intelligent, with beautiful manners. Always generous, he invited her to drink coffee in the evening and she never saw him drunk. Germaine lived with her mother and Modigliani was courteous and considerate towards the older woman. Sometimes he spoke to the girl lovingly of Eugenia, his mother.

To Leopold Survage he also spoke of his mother with affection and respect. But Leopold knew the other side. Modigliani was plagued and anxious because of the difficulty of finding models, and when one had been found he waited in a state of tension for fear of being let down. In the evenings after the

two painters had been working, they would often stroll towards the café. Late at night, when he had drunk quantities of red wine to relax, Modi would begin to hum and sing, badly out of tune, Italian and Hebrew melodies, obviously still hankering for his home.[15] He was, said Frans Hellens, a Belgian writer whose portrait Modigliani painted in Nice, a charming and a strong-minded man but 'completely out of his element in this world'. Modigliani's penetrating artistic judgement and his talent for graphology made him 'a sort of magician'. Hellens did not like the portrait painted of him but later came to recognize its prophetic qualities. His youngest son looked exactly like the portrait. And Hellens said he sensed a terrible mystery at the heart of the man.[16]

As the war dragged on Modigliani's horror at the waste of life increased. The sight of a wounded soldier left him raw and angry. Sometimes he would throw away his francs to the soldiers and go home without a sou. At Nice when he heard the devastating news that his Portuguese friend, the artist Amedeo de Sousa Cardoso, had died of Spanish flu he broke down and sobbed like a child. Modigliani himself contracted the flu and his illness left him badly frightened. For a time he gave up drinking and smoking altogether.

His dealer, Zborowski, found to his chagrin that the rich pleasure-seekers in the south of France were not in the least interested in buying modern paintings. More often than not he came back to his apartment empty-handed and crestfallen. The painters were envious of Zbo's life, strolling round the big hotels in style. According to Foujita, the dealer's 'method' was 'to sit reading a paper on the esplanade or to go into hotels, presumably with a rendezvous with a duke or some important person, but nothing came of all this'.[17] When he approached a group of well-known writers, they refused to buy even a drawing. Others better informed bought paintings at twenty francs.

There is no doubt that Zbo played on Modigliani's illness to excite sympathy in a way which the artist did not appreciate. He pleaded with the writers to help to save Modigliani. They merely shrugged: 'Hmm, it's normal. A painter doesn't need to live in luxury if he is poor. Let him look after himself.' And when Zbo explained that Modi was coughing up blood they chased him away. Zborowski travelled along the coast trying to sell, with little success. In Toulouse that summer one of Modigliani's nudes, prominently displayed in the window of the Choppe-Lautier Gallery, again caused a scene. Local students were so excited that they threw stones at the painting. The commotion caused a young couple passing by to go into the gallery to have a closer look at the paintings. They were so impressed that they asked the owner whether he had any other works by Modigliani. After some bartering they acquired both the nude and a splendid portrait of a

servant girl for five hundred francs. The young couple, the Castaings, were taking refuge from the Paris bombing, staying with M. Castaing's parents. When the paintings were delivered the older couple were almost apoplectic at the sight of them and refused even to store them in their house.[18]

Modigliani's 'dry' period lasted for two or three months. Then Modigliani's old friend, Blaise Cendrars, came to Nice to work on a film script and was shocked to see Modigliani looking so ill. He told the story himself.[19] 'You must start to drink again', he said, and invited Modigliani to his hotel room. He put a thousand-franc note on his bedside table and told the porter to let Modigliani in whenever he wanted. For some days the note lay untouched on the table. Then one evening, Cendrars was delighted to find it gone. The convivial bohemian made a round of all the bars and cafés in Nice, looking for Modigliani. Returning late to his hotel, he noticed a man asleep in the middle of the Place Iéna: Modigliani. After that, Cendrars swore that Modi recovered his health and resumed his Parisian habits.

In a more sober account, Cendrars' first wife Félicie remembers seeing Modi, poor and preoccupied, escorting Jeanne, who was wearing a white shawl which served as a cloak to hide her figure, across the Avenue de la Gare.[20] Jeanne was expecting the baby at the end of November 1918. Some of Modigliani's most beautiful paintings in the south of France were of children and young people. From paintings like 'The Peasant Boy' in the Tate Gallery it is clear that Modigliani did not patronize or talk down to his models. They are submissive but dignified, with that look of yearning that brings to mind Ehrenburg's comment that Modigliani saw all his subjects as lost children: his own Jeanne, Zborowski, and perhaps most of all, although he would never admit it, he himself come into that category.

One of his most affecting pictures, bordering on the sentimental, is of 'The Little Girl in Blue'. The blue eyes of the child look out sadly, with a hint of reproach. She stands almost in the corner, her feet awkwardly placed, her hands clasped tightly, not folded in resignation as is usual with Modigliani paintings. According to a popular anecdote, the little girl had been told to bring a bottle of red wine but bought lemonade instead, to Modi's fury.

On 11 November 1918 bells and cheers rang out all over France on Armistice morning, and Modigliani cannot have missed out on the celebrations. Shortly after peace was declared, Madame Hébuterne quarrelled violently with the almost full-term Jeanne and left the lodgings to take rooms nearby.[21] Modigliani moved in to be with her for the last few days and at the end of November Jeanne entered the Nice Maternity Hospital. Félicie waited with him for news of the birth, and during the anxious time Modi asked her for advice, knowing that Jeanne was too preoccupied in looking

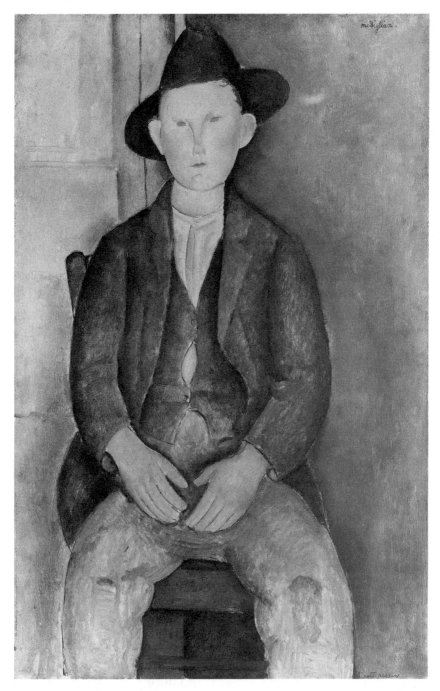

The little peasant.

after him and coping with her mother's often unhelpful interference to look after a new baby alone. He confided to her his anxiety for the well-being and safety of the new baby.[22]

The baby, a girl, was given her mother's name: Jeanne Hébuterne. Modigliani always called her Giovanna, the Italian version. He was excited and overjoyed and turned out to be an enthusiastic and forgetful parent. After the baby was born, he was so elated that he did not manage to get to the Town Hall to register his daughter's existence. Although his brother later made the excuse that it was too hot that day, late November, it seems far more likely that he simply got drunk. To say that he did not care, however, would be a gross over-simplification. He wrote to his mother and told his brother about the baby; he said more than once that he intended to marry Jeanne.[23] Eugenia responded enthusiastically to his news. In an undated letter he wrote to thank her:

> Darling Mother,
> A million thanks for your loving letter. The baby is well and so am I. You have always been so much a mother that I am not surprised that you feel like a grandmother, even without 'legal sanction'. I'll send you a photograph. I have changed my address again: write to me 13 Rue de France, Nice.
> <div align="center">I kiss you warmly</div>
> <div align="right">Dedo[24]</div>

Modigliani's fears for the baby were realistic. When Félicie Cendrars saw them again Jeanne and Modi were looking for a reliable wet-nurse, since neither she nor her mother 'could do anything with little Jeanne. The baby was only three weeks old and Jeanne was still very tired. A tangerine that Modigliani gave me – we were in front of a fruit-shop – and another that he gave to his wife: that is my last memory of them.'[25] Modigliani took great trouble to find a suitable nurse for the baby and after some time found a compatriot, a woman from Calabria. In happy mood on 31 December, he saw the New Year in. Presumably Jeanne stayed at home with her baby daughter. Warmed with wine and the festive spirit he wrote to Zborowski, now back in Paris:

> <div align="right">'On the stroke of Midnight'</div>
> Dear Friend,
> I embrace you as I would like to have done on the day you left. I am living it up with Survage at the Coq d'Or. I have sold all my pictures. Send

me some money soon. Champagne flows like water. We send you and your dear wife best wishes for the New Year. *Resurrectio Vitae. Incipit vita nova. Il nuovo Anno.*

Modigliani[26]

At the foot of the card Survage scrawled: 'Happy New Year', in Russian and underneath: 'Long live Nice: Long live the first night of the New Year'.

Zborowski took his words literally and was alarmed that Modi had sold his paintings himself. A few days later Modigliani set him straight:

My dear Friend,

You're a fathead who doesn't understand a joke. I haven't sold a thing. Tomorrow or the day after I will send you the merchandise [that was the way Modi always referred to his paintings]. Now for something real and very serious which has happened to me. My wallet with 600 francs in it has been stolen. This seems to be a speciality of Nice. You can imagine how annoyed I am. Naturally I am broke, or almost. It's idiotic of course, but since it's neither in your interest nor mine that I'm stuck like this here is what I suggest: wire me, care of Sturzvage, 500 francs . . . if you can. And I'll repay you 100 francs a month; that is, for five months you can take 100 francs out of my monthly allowance. I'll keep track of the debt in every way I can. Apart from the money, losing all my papers is a terrible worry. That was all I needed . . . just when I had found a little peace at last. In spite of this, nothing vital is broken I hope.

Please believe in my loyalty and friendship and give my best wishes to your wife.

And a cordial greeting to you.

Modigliani[27]

The loss was important and embarrassing to Modi and the somewhat impatient tone of his next letter to Zbo suggests that he was annoyed at having to return to the subject:

My dear Zbo,

Here is the question or 'That is the question' [written in English], see Hamlet. That is: 'To be or not to be'. I am the sinner or the bloody idiot. I recognize my fault (if there is a fault) and my debt (if there is to be a debt) but the question now is this: if I'm not completely broke, I am at least in serious trouble. Understand. You sent me 200 francs, 100 of which

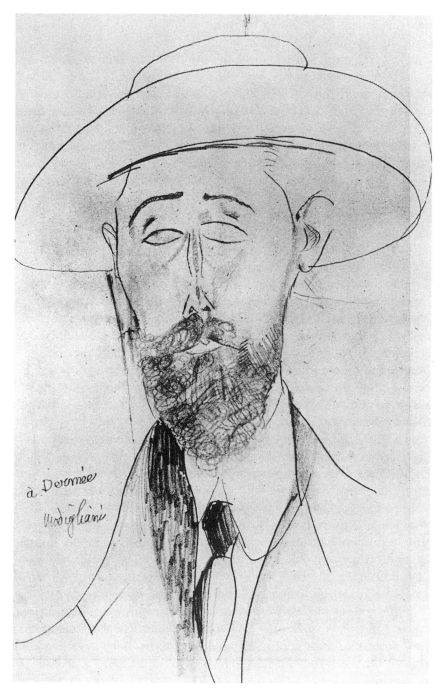

Paul Dermée, 1918.

naturally went to Survage, without whose help I would have been completely broke . . . but now . . .

If you free me I will acknowledge my debt and keep going. If not I'll remain immobilized at my place, tied hand and foot . . . and in whose interest would that be? There are actually four canvases. I have seen Guillaume. I hope that he will be able to help me with my papers. He gave me some good news. Everything would be going well except for that damn business [of the lost wallet]. Why can't you put it right immediately so as not to stop something that is going well?

I've said enough about it. Now, do what you will or can, only it's urgent. Time presses.

Say hello to Madame Zborowska,

Affectionately,

Modigliani[28]

A street photographer snapped Paul Guillaume and Modigliani walking along the Promenade des Anglais, Guillaume looking natty and brisk, with knife-edge creases in his trousers, Modigliani in shabby, baggy clothes, shoes unpolished, very much the poor relation. Without his mask, the brave public face he put on to hide his sickness and anxiety, Modigliani looks ill and depressed. Guillaume was interested in him again as his work was beginning to command higher prices. The dealer had recently exhibited some of his paintings in a mixed show with Picasso, Matisse and Derain. Modi asked Guillaume, as a Frenchman, to make a recommendation to the authorities for replacement of his papers. Guillaume, it appears, did not exert himself to keep the promise and Modigliani repeatedly asked Zbo about them. Although no saint, Zborowski was genuine in his interest in Modigliani as an extraordinary, if exasperating, human being. Modigliani was pleased when Zbo responded quickly to his pleas for money and told his dealer he was going back to work: 'I must explain – though real explanations are impossible in letters – that there has been a "vacuum". I had a charming letter from your wife. I don't want you to wipe out any of my debts – on the contrary. Set up, or let us both set up, a credit for me.'[29] A generous gesture always provoked a generous response in Modigliani, it was a point of honour.

To find the right models was proving so difficult that Survage suggested that he should paint landscapes. In his twelve years in Paris Modigliani had painted portraits almost exclusively and had lost the 'habit of contemplating landscape' that had fired him as a boy. 'I need a human figure in front of me to paint', he told Survage. 'In landscape there is nothing to express.'[30] And he warned Zborowski not to expect too much: 'I am trying to do some

landscapes', he wrote. 'The first canvases might possibly look like a beginner's'.[31]

The four surviving landscapes Modigliani painted are dry, limpid scenes with an air of desolation; trees dominate, cypress trees or leafless trees, standing like sentinels in front of the houses and buildings, as if waiting for the people to emerge. Modigliani disliked writing letters, but during the winter of 1919 he wrote several times to Zborowski in Paris on practical matters, asking urgently for money and canvases, thanking Zbo for sending money and, rather touchingly, explaining his progress or the lack of it to his dealer. Most of his correspondence was written in cafés, with a glass of wine at his elbow, using the establishment's writing-paper. From the Café de Paris in Nice he wrote again:

Dear Zbo,

Thank you for the money. I am waiting until a head of my wife is dry before sending you – with the ones you know about – four canvases.

I am like the Negro, I just go on. I don't think that I can send you more than four or five canvases at a time because of the cold. My daughter is wonderfully healthy. Write if all this is not too much trouble.

My best wishes to Madame Zborowska and warm greetings to you.

Modigliani

Please send the canvases *as soon as possible*. Don't forget the Place Ravignan business and write to me.[32]

In 1914, Paul Guillaume had found Modigliani a studio in the Rue Ravignan. Possibly there were some canvases left there. If Zbo did rescue some of the earlier work, that may explain some of the muddle about the authenticated chronology of Modigliani's work. Zbo would probably have dated them 1919, when Modigliani's prices were beginning to rise. All this is speculation. By now Modigliani put an enormous physical effort into his painting: 'His shoulders heaved. He panted. He made grimaces and cried out. You couldn't come near him.'[33] Yet his work appeared effortless and flowing. He had adopted what he called the 'grand style', an aura of peace and elegance surrounds his subjects, painted in fastidious and arresting harmonies of colour. Again and again he painted Jeanne in what one writer described as a series of 'love letters'. In some of the later portraits her body is thickened by pregnancy, her face saddened by experience. In April 1919, just turned 21 she was pregnant again.

Spring comes early to the Riviera and it made Modigliani, always sensitive to change, more restless than ever. He was on the move again, whether he

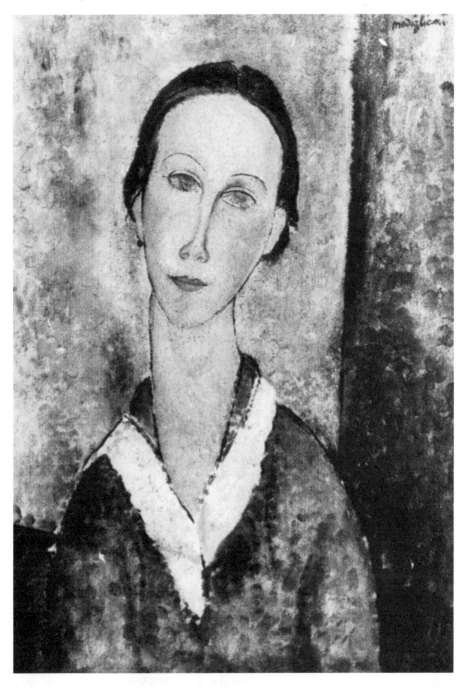

Portrait of a Young Woman, 1918.

had annoyed the proprietor at his cheap hotel by his late night rowdiness, or quarrelled with one of the pimps because the girls staying there posed for him free or simply grown tired of the place, is not clear. But it was a new start. In a letter to Zborowski dated 27 February, he told his dealer that he was going to work at No. 13 Rue de France. 'All these changes, changes of circumstances and the change of the season, make me fear a change of rhythm and atmosphere. I've been loafing a bit for the last few days. Fertile idleness is the only real work'.[34] Apparently he had quarrelled with Survage too, although he does not explain why. 'Are you coming in April?' he asks his dealer. The question of his papers, thanks to his brother Emanuele, was almost arranged, he explained. Before he knew whether he could obtain replacement identity documents, Modigliani had been haunted by the fear that he would be trapped in the south. Typically, now that he could leave when he pleased, he was tempted to remain longer and return to Paris in July.

After almost three years of backing Modigliani's work, Zborowski scented the first whiff of success in the spring of 1919. Sacheverell Sitwell, a young aesthete from England, had crossed the Channel to look at the new painting in post-war Paris with a view to putting on a comprehensive exhibition in London. After making the rounds of the galleries and dealers, Sitwell had concluded that Picasso and Modigliani were the most exciting modern painters. Young Sitwell visited Zborowski in his apartment and suggested that Zbo should help to choose and supervise the shipping of all the canvases and then travel to London to help in the hanging and selling of the pictures. Sitwell had wanted to buy a Modigliani painting to take back with him to show to his brother Osbert, who was to sponsor the Exhibition jointly with him. But his funds only ran to buying a Modigliani drawing. Still an 'amateur' working from his apartment, Zborowski contacted other dealers about the proposed exhibition and wrote enthusiastically to Modigliani. This was the opening Zborowski had worked for, a chance for Modigliani's work to be appreciated by a wider public outside France. In his letter he asked Modi for his name, date, and place of birth for the catalogue and for press publicity. Grateful and overjoyed Modi replied:

My dear friend,
 I was sincerely moved by your letter. I am the one who must thank you. So far as publicity is concerned, I naturally leave it up to you if it is indispensable . . . Your affairs are ours, and if I don't believe in it on principle, or because I am not mature enough for publication, neither do I despise 'vile money'. But since we are in agreement, let's go on to other things. Here is my date and place of birth: Amedeo Modigliani, born on 12

July 1884, at Livorno. I wrote to my brother two or three days ago and am awaiting an answer.

Also my 'real' identity card (I only had the receipt for it) is in the Commissioner's office on the Rue Camp Premier. It shouldn't be too difficult to arrange this matter. Another thing: You speak of coming here towards the end of April. I think I can easily wait for you here until that time. In the meantime you should look into the possibility of settling in Paris as there is a great 'hic'. [Perhaps Zborowski had considered opening a gallery in the south.] (Are you ever going to look into the Montmartre business?) My daughter is growing marvellously. I find great comfort in her and an enthusiasm that can only increase in the future. [The baby was not yet six months old.] Thanks for the toys. It's a little too soon for them perhaps . . . The only thing I can do now is to let out a great shout with you, 'Ça ira' for men and for people, believing that man is a world worth many times the world and that the most ardent ambitions are those which have the pride of Anonymity.

Non omnibus sed mihi et tibi . . .

Modigliani[35]

The idealism of Modigliani's youth re-emerges in this letter which reveals him as modest, humane and a proud father. His delight and sense of wonder at the growth of his baby were erratic as other interests pressed, but real enough. During 1919 he painted a mother and child which took him more than forty sittings, perhaps because the subject was of such personal interest.[36]

Modigliani left Nice for nearby Cagnes in the first half of April. On the 13th of that month he sent his mother one of his cryptic postcards: 'I am here near Nice very happy. As soon as I am settled I shall send you my permanent address'.[37] It was probably at that time that Zborowski took Modigliani to visit Anders Osterlind, a Swedish painter whom Modi had met in Paris years earlier when they visited the Cézanne retrospective together and almost cried with excitement. Worried by Modigliani's condition, Zborowski brought him, ill and coughing, to the quiet of Osterlind's house, into a garden of olive and orange trees.

Modigliani . . . had the beautiful features of an Italian prince but he was tired and dirty . . . as if from having unloaded in the port of Genoa. With him was his shadow, the poetic Zborowski, who, in brotherly friendship, wanted to protect him from the dangerous life of Nice.[38]

Osterlind and his wife Rachel did their best to make Modigliani comfortable. A dark-haired, gentle beauty, Rachel Osterlind was fatally ill with intestinal tuberculosis, as a result of Spanish influenza. The couple, with their daughter of 9 or 10, lived quietly, drank only tea. Modigliani was given the best room, all white and clean, 'where he never did sleep very much'. Sometimes he worked in his room and painted a haunting portrait of Rachel Osterlind, her cheek resting gently on her hand, as a thank-you to his hosts. During his stay Modigliani strolled in the garden and often trudged up a winding road, overlooking the sea and shaded by palms and eucalyptus trees, to the village café bar for a drink. There he drank absinthe on a rustic table, like a table by Cézanne, Modigliani said. The advertisement for Pernod on the wall, of a bottle and two glasses painted on a black background, struck him forcibly. Poster art, he assured Osterlind, was the art of the future. At the same time, he realized how much poster artists had derived from the 'fine' artists of the past.[39]

During those peaceful weeks Modigliani would occasionally break out from his comfortable existence, as if afraid that he might become sucked into bourgeois life. One evening Anders Osterlind was astonished to find Modi in the nude, spitting on the white walls of his room. 'It's too nice in here,' he complained. Sometimes Soutine, who was living in the village, came over to enjoy a good chicken dinner, and after eating their fill the two artists reproached their host for living in such luxury.[40] 'Everything dances round me like a landscape by Soutine,' Modigliani said when he was in his cups. At that time Soutine was painting turbulent and violent landscapes and the two were said to have shared a studio at Cagnes-sur-Mer owned by a M. Nicolai, the proprietor of the general store. When they left, owing money for rent, alcohol and meals, the studio was filthy, with broken dishes and a disgusting mess everywhere. The owner kept the canvases they had left behind and used them to cover his chicken coops and rabbit hutches. A few years later he discovered, to his fury, that the painters' prices had soared and the paintings that he despised would have been immensely valuable.[41]

There is much legend attached to Modigliani's life in the little village of Cagnes-sur-Mer. The visit to Osterlind's neighbour Renoir is another story told with many variations. Osterlind himself told it this way. As a close friend and neighbour of the elderly painter, Osterlind used to visit Renoir every day. He lived two hundred metres higher up than Osterlind in a rambling house overlooking the sea, Les Collettes. The building intrigued Modigliani, and he asked Osterlind to take him up to see Renoir. Osterlind extracted a promise from Modi that he would stay sober. Crippled with arthritis and wheelchair-bound, at 77 Renoir detested meeting strangers but he had heard about

Modigliani from Osterlind and, almost certainly, from Zborowski and agreed to the visit. Modigliani arrived quite sober for the occasion but when the two painters came to discuss their work the conversation became dangerously frigid. Renoir had some of his canvases taken down from the wall so that Modigliani could look at them more closely. Modi scanned them carefully, his face grim. 'So you paint, young man?' Renoir remarked mildly. Modi nodded. 'You must paint with joy, the joy with which you make love to a woman. Before I paint, I caress the buttocks for hours . . .' 'I don't like buttocks,' Modigliani ground out and left, slamming the door.[42]

From the styles of the two painters their difference is apparent. Renoir, with his earthy delight in flesh, offended the fastidious Modigliani whose nudes, for all their frankness, are stylized and elegant. Obviously Modigliani also found the old man's lasciviousness offensive. Despite the legend, he was extraordinarily discreet and reserved about his relations with women. With Osterlind he discussed art and philosophy but not his personal life. The Swedish painter was surprised to learn later that Modigliani had a wife and child. Modi's reserve might have sprung from a desire to shield Jeanne from gossip, and perhaps a feeling of shame in front of a married man, at his own role in the affair. Apparently the elderly Renoir bore Modigliani no malice. Zborowski had been trying to find a way of flattering the old man ever since the party arrived in Nice. Shortly afterwards, Renoir even sold two canvases to Zborowski in order to help Modigliani.

For Jeanne the time in the south had been desperately unhappy, with the endless rows between Modigliani and her mother. Although he referred to her in letters to Zbo as 'his wife' and was concerned and excited about the baby, Modi was very much the Italian husband, leaving his woman alone while he visited the cafés, living inside of himself for much of the time, coming home drunk and moving restlessly from place to place. She was deeply in love with him. That he loved 'his charming companion' cannot be in doubt, but for him work always took precedence. Just turned 21, Jeanne had sacrificed any hope of fulfilling herself as an artist to Modigliani.

On 27 May the Cagnes police issued Modigliani a safe conduct c/o Osterlind and he travelled by train to Paris on the last day of the month. Jeanne and the baby were to follow as soon as a wet-nurse could be found near the capital.

Life is a gift

MODIGLIANI returned to Paris eagerly, looking forward to meeting old friends, visiting their studios and returning to his old haunts. He found the city greatly changed. Food was in short supply and certain wartime restrictions were still in force, but an air of febrile gaiety pervaded post-war Paris. Jazz blared out from the new American bars, bathed in electric light, the girls wore shorter skirts and motor cars and racing-cars were all the rage. Everyone was dancing the foxtrot and the new cheek-to-cheek dance from Argentina, the tango. After the grim years of war the public looked for extravagant, glittering spectacle in their entertainment. At the Casino de Paris Mistinguett, all feathers and sparkle, wearing a head-dress the size of a grand piano, teetered down a staircase to delight the crowd. American movies were popular, American officers and men dominated the music-halls and, attracted by the exchange rate and fleeing the gloom of prohibition at home, American expatriates could be seen 'doing the city' nightly in evening clothes. They brought with them a taste for cocktails and 'mixed drinks' taken at the bar. Even in Montparnasse Modigliani was disturbed to find the 'snob' places, the American bar and the English tea-room, replacing the simple, pre-war cafés with their zinc counters where artists and artisans drank on the terraces together. The Rotonde now had a grill room and Libion, the tolerant and kindly old patron who had cherished his artists astutely, realizing that they attracted the tourists, was no longer there. He had been forced to sell the business during the war to pay a fine for trafficking in illegal substances. The new proprietor did not order his waiters to remove the pile of saucers with a bill on them tactfully as Modigliani ordered drink after drink. Now they insisted on cash on the nail and women who smoked on the terraces were politely asked to leave.

Lunia Czechowska, the beautiful fine-boned Polish woman who was a friend of the Zborowskis, was to remember that hot month of June 1919 all

her life. Since he first met her Modigliani had found Lunia intriguing to him as model and woman. In the portraits he made of her she looks aloof and mysterious, a great lady. Back from Nice, where he had been starved of models of distinction, Modi worked in a frenzy, delighted to have such a beautiful and complex model on hand. He painted Lunia in Zborowski's apartment in the Rue Joseph Bara with its Empire furniture. In all, including the earlier portraits he had made of her, Modi painted Lunia fourteen times.

After his work, sweating and exhausted, Modigliani bathed in a tub in front of the window, and, to Hanka Zborowska's annoyance, splashed water all over the floor. Late one afternoon he toppled the wash-basin and it fell into the street. That brought the concierge out, the redoubtable Madame Salamon. She stood screaming up at the window and Modi yelled back. He perched on the ledge singing and refused to leave, saying he wanted to speak to Zborowski. Lunia managed to calm him down by inviting him to dinner with the Zborowskis, and while she was preparing the meal, Modi came into the kitchen and asked her to look up for a few moments whilst he sketched her. On the drawing, made by candlelight, Modigliani wrote an inscription in Italian: 'Life is a gift from the few to the many; from those who have and know to those who have not and do not know'.

Though not Modigliani's own,[1] the passage conveys so much of himself that one senses that he was sharing his code with Lunia. A young woman, almost 25 at the time, she had not seen her husband, a Polish revolutionary, for three years. During 1919 she learnt that he would not be returning to France. Women always wanted to save Modigliani, always believed that they could achieve the miracle. Lunia asserts that Modigliani did not drink when he was with her, ate sensibly and dreamt of living like everyone else in a house with a dining-room, with his daughter close by. It is hard to imagine that Modigliani ever wanted to be like everyone else; the dream seems more likely to have been Lunia's projection, since Jeanne Hébuterne does not figure in it at all.

Whether Modigliani's innate tact with women prevented him from introducing the name of another woman in their tête-à-tête, or whether Lunia remembered the conversation in that way, can never be known. That he admired her, respected her, can be seen in his pictures, where she appears unattainable and remote. For two or three weeks they were inseparable. After his work he strolled with Lunia towards the Closerie des Lilas, where Modi could watch the passing show, and then made their way to Rosalie's for supper. Rosalie scolded Modi for misbehaving or drinking and they argued volubly in Italian. If Rosalie became too shrill, Modi ended the dispute by speaking in French, which she could not follow. But she still cooked Italian

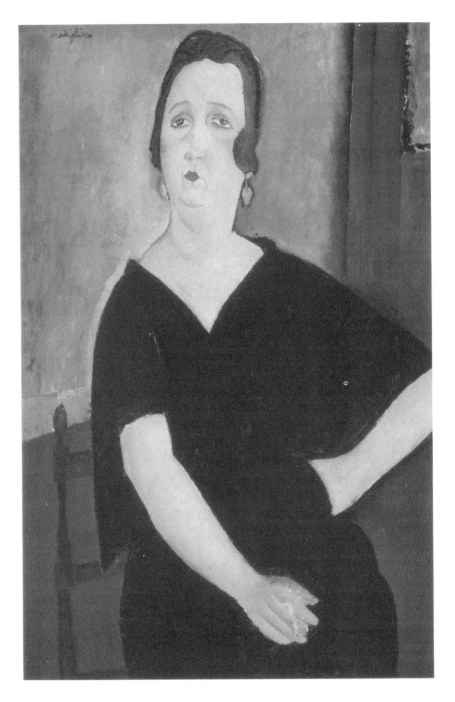

Madame Amédée, 1918

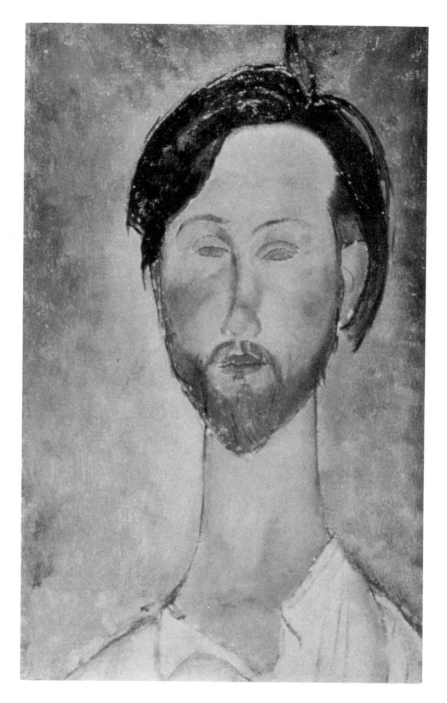

Léopold Zborowski, 1917

dishes highly flavoured with garlic especially for him. After the meal the two walked in the Luxembourg park, took in a movie, or just wandered round the city. Modigliani escorted Lunia to a street fair where Louise Weber, known as La Goulue, one of Toulouse-Lautrec's favourite models in the nineties, stood bloated and swollen in a cage with mangy wild animals. He spoke to her of the painters of that day, Gauguin, Van Gogh, Munch but, as usual, Modigliani said nothing of his own work. For Lunia it was an enchanted time. 'He had so many things to talk about that we were never able to say goodnight . . .'[2] And she hints in her tone of what might have been. For Modigliani, too, the joy of being in Paris, of reliving his bachelor days was a reprieve from responsibility. 'I'm getting fat and becoming a respectable citizen at Cagnes-sur-Mer',[3] he told Marevna, the Russian artist, when he met her in the street. 'I'm going to have two kids,' he mocked. 'It's unbelievable. It's sickening.'

In the south of France Jeanne was impatient to come home. Three weeks after he left, on 24 June, she wired: 'Need money for trip. Wire seventy francs plus thirty for nurse. Letter follows. Arriving Saturday morning at eight by fast train. Let nurse know'. The reality of his responsibilities was in front of him when Jeanne arrived with the baby. Modi had been living in a small seedy hotel room in the Port Royal quarter and, as Lunia wrote, that was no place to care for a small baby. Anxious to remain important in Modigliani's life, Lunia must have suggested that she should take charge of little Jeanne until a suitable nurse could be found outside Paris. She took the baby with her to the Zborowskis' large comfortable apartment, where she had been living for some time. Modi was drinking again, depressed at the thought of his new responsibilities. Utrillo, temporarily out of the sanatorium, went out to the bars with him and came home rowdy. One night, at the long-suffering Rosalie's, Utrillo and Modi ordered a meal and then found they could not pay her so they decided to paint a mural on one of her walls, competing and working furiously beside each other. Rosalie saw only that they had dirtied her wall and made them clean the wall-painting off with rags and turpentine which cost her, in the end, a fortune. Often in the early hours the two could be heard singing and shouting several blocks away. They would sit on the pavement facing the Zborowskis' apartment building for hours. Modigliani wanted to catch a glimpse of his daughter. 'We didn't turn on the lights so he would think we had all gone to bed. Then he'd go off sadly with his friend,' Lunia said. Sometimes she pleaded with the Zborowskis to allow Modi in. '. . . he'd come up and sit next to his child, looking at her with such intensity that he ended up falling asleep himself; and I watched over both of them.'[4]

Soon after he came back to Paris Modigliani painted the portrait of

fourteen-year-old Paulette Jordain, who was lodging at the Zborowskis' whilst studying at a commercial college. As soon as he met the eager adolescent, Modigliani asked her to come to his studio the following day to sit for him. She arrived in the morning, climbing the steep, dark stairs to the studio, rather scared when she walked into Modigliani's vast, empty room. He was waiting for her, a canvas ready on his easel. Modigliani told Paulette to sit down. He did not impose an attitude on her but allowed her to settle herself and sit naturally, her hands on her lap. Then he began to work, chatting with the young girl, asking her questions about her studies and her family and laughing good-humouredly at her replies. Several times he said to her: 'One day we'll all go to Rome'. When she asked practically where the money would come from, Modi said nothing but remained thoughtful. Sometimes Modigliani would sing a melody from *La Traviata* or recite verses from Dante in Italian. And during the sessions he would send her out with an empty bottle to the shop to fetch some rum. 'Say it's for Modigliani', he called after her. The first time Paulette was a little embarrassed while she waited for a measure of rum to be poured into the bottle. She never saw him drunk in the studio or in the Zborowskis' house, but she did sometimes notice him drunk in the street. Then, with commendable tact, young Paulette would attempt to hide or walk in another direction. And the next day Modigliani referred to his drinking bout obliquely, saying 'the street wasn't wide enough last night'.[5]

Once or twice Modigliani told the young girl that he was feeling a little tired and suggested that they pack up early, but it did not occur to her that he was ill. When Paulette studied in the mornings, she came to sit for Modi in the afternoon. Occasionally Jeanne Hébuterne would appear in the studio. But if Modigliani was still working she would not disturb him and waited in the next room. Paulette often took money from Zborowski to Modigliani on her way to school when he was still in bed. His voice, with its beautifully modulated tones, rang in her ears for years, and like all the women who had a chance to be with Modigliani quietly for a time she was to remain a little bit in love with him.

No wonder Jeanne Hébuterne was jealous. Her situation was increasingly difficult. Her own family was repeatedly urging her to marry and legitimize her baby, especially with another child on the way. Five days before his thirty-fifth birthday, Modigliani pledged himself to marry her in a curious document, surely designed to reassure: 'I pledge myself today, 7 July 1919, to marry Mademoiselle Jane [sic] Hébuterne as soon as the papers arrive'.[6] The document is signed 'Amedeo Modigliani', and Zborowski, Jeanne and Ludnska (Lunia) Czechowska added their signatures to the declaration of intent.

Je m'engage, aujourd'hui
7 Juillet 1919 à épouser Mademoiselle
Jane Hebuterne . aussi Tôt les papiers
arrivés

Amedeo Modigliani
Leopold Zborowski

Jeanne Hébuterne
Ludwika Czechowska

Paris 7 juillet 1919

Marriage Pledge.

Jeanne's parents no doubt insisted on a marriage in the Catholic Church, which was deeply antipathetic to Modigliani, as was their attitude towards his Jewish heritage. 'I'm a Jew, you know,' Modigliani told Anselmo Bucci, a friend from Italy who looked up Modigliani after the war. 'I've never thought about it', Bucci replied. 'It's true. There's no "Jewish question" in Italy. I'm a Jew and you know the family feeling we have. I can say that I've never known misery. My family has always helped . . . they never abandoned me.'[7] Jeanne joined the two friends for dinner at Rosalie's and Modi was loving and considerate towards her, but after dinner, when the two made for the Rotonde, Jeanne returned to the apartment. And Modi explained: 'We're

going to the café, just the two of us. My wife goes home in the Italian way . . .'
Despite his intention to marry Jeanne, the matter was delayed.

Zborowski travelled to London in July to prepare for the exhibition of
modern French art. Two weeks before it opened, Francis Carco, who owned
several works by Modigliani, wrote an article about him in *L'Eventail*, a Swiss
revue of literature and art, which sent his prices up and encouraged a
number of Swiss buyers.[8] Zborowski arrived in charge of one hundred and
fifty-seven works of art, including canvases by Picasso, Matisse, Derain, Dufy,
Utrillo, Renoir, Soutine, Ortiz de Zarate, André l'Hote, Kisling and Suzanne
Valadon, as well as sculpture by Zadkine and Archipenko. On this, his first
visit to London, not speaking a word of English, Zbo found himself somewhat
at a loss. The two Sitwell brothers were on hand to supervise the hanging and
placing of the pictures and the distinguished art critic Roger Fry also gave his
advice.

The Exhibition of Modern French Art opened for a month on 1 August in
the Mansard Gallery, a large room in Heals. Although Roger Fry described it
as the 'most representative show of modern French art seen in London for
many years,' most of the artists were unknown to the British public. Picasso
was well known to ballet-lovers, as was Derain, as they had both designed
sets for Diaghilev's Ballets Russes, a tremendous social event in London that
summer. When the *Three-Cornered Hat* opened Picasso made a personal
appearance, and Derain took a bow at the opening of *La Boutique Fantasque*.
Most of the other names in the Exhibition were unknown, and even the critics
were wary of committing themselves: 'I must confess that some of these
pictures are to me like poems written in a foreign language',[9] wrote the critic
of *The Burlington Magazine*. 'The two painters whose works will probably be
the greatest surprise are Modigliani and Vlaminck. Modigliani's uncommon
feeling for character finds expression through an extreme simplification of
colour and contour and the most astonishing distortions.'

Other critics thought highly of Modigliani, notably Roger Fry, T.W. Earp,
Gabriel Atkin and the writer Arnold Bennett, who wrote a foreword to the
catalogue. The British public, however, found the new art baffling and
unnatural. 'Every day the tantrums, whether inside the Mansard Gallery or
in the columns of the newspapers, increased.'[10] Osbert Sitwell was
continually asked, by infuriated gallery-goers, why Modigliani painted his
people with necks like swans. And when photographs of Modigliani's
paintings were published in the press, maddened and enraged correspon-
dents wrote in to protest. Osbert Sitwell held the theory that the thicker the
neck of the letter-writer, the more vehement his protest. When Clive Bell
wrote a notice in *The Nation*, praising the paintings in the Exhibition, Greville

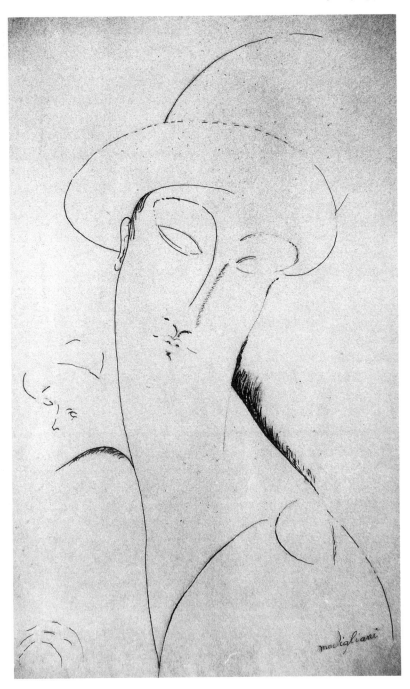

Portrait of a woman, 1917.

MacDonald, a man of strong opinions, wrote in to the journal from the Reform Club to denounce the moral implications of French modern art: 'I felt the whole show to be a glorying in prostitution.' Nevertheless Osbert Sitwell believed that the introduction of Modigliani's paintings to the British public was one of the most important services of the Exhibition. Every day the two Sitwell brothers came into the gallery and sat at a table in the middle of the room to sell catalogues, answer enquiries and try to quell protests from the public. An enormous wicker basket full of Modigliani's drawings stood beside the table; the visitors could choose a specimen for a shilling, threepence less than the price of a ticket of entry to the Exhibition. But very few drawings were sold.

Arnold Bennett bought one of Modigliani's portraits of Lunia Czechowska on the opening day for fifty pounds. (His paintings were priced at between thirty and one hundred pounds.) Apparently Bennett admired Modigliani's work and felt that Modigliani's women were reminiscent of the heroines in his novels. Another good friend of the Sitwells bought a Modigliani and a Utrillo for seventy pounds and sold them five years later for £2,600. Zbo, elated at the sale, sent a telegram to his wife telling her of the sale of the portrait. When he heard it was going well Modigliani asked his dealer to buy him a pair of good English shoes.

By 27 August Modigliani sent the usual brief postcard to his mother with some good news:

> Dear Mother,
>
> Thank you for your postcard. I am having a magazine, *L'Eventail*, sent to you with an article in it about me. I am exhibiting with some others in London and I have asked to have the newspaper clippings sent to you. Sandro [the brother of his boyhood friend Uberto Mondolfi] is in London and will be passing through Paris before returning to Italy. My baby whom we had to bring back from Nice and whom I sent to the country near here is wonderfully healthy. I am sorry not to have photographs.
> Kisses.
>
> Dedo[11]

By now Modigliani's baby was in the care of a 'good, honest girl' employed by an infants' home near Versailles. Jeanne visited her baby once a week and Modi wrote to the nurse. 'The correspondence with the nurse (telegrams, presents and baby bonnets) alternating with long silences'[12] were a chart of Modigliani's ups and downs, his daughter commented many years later.

In London the Sitwell brothers had been anxious to buy a Modigliani before the show opened. But Zborowski, who had arranged the Exhibition with the Parisian dealers who represented the other artists in the show, had first to ask their permission. In the end, they allowed Osbert Sitwell to buy a magnificent painting, 'The Peasant Girl', for the trifling sum of four pounds as an expression of thanks to them for arranging the Exhibition.

Osbert Sitwell was not entirely convinced about Zborowski, with his Slavonic features, brown almond-shaped eyes and beard. '. . . Ostensibly he was a kind, soft businessman and a poet as well. He had an air of melancholy . . .'[13] But during the Exhibition Zbo received a telegram from his fellow dealers in Paris reporting that Modigliani had suffered a 'grave relapse' and suggesting stopping all sales until the outcome of Modi's illness was known. Zborowski asked the Sitwells to refuse to sell and Sacheverell, who saw the telegram, was profoundly shocked at the callousness of the businessmen. The Paris dealers were counting on an astronomical rise in Modigliani's prices after his death. Since everyone knew the precariousness of his health they decided, when they heard of his success in London, to capitalize on it. Modigliani did not oblige the vultures. He was in no better or worse health than when Zbo left, but the incident does call into question the romantic picture in all the literature of Zborowski as the dedicated friend who sacrificed himself for Modigliani. Zborowski, with his gambler's temperament, took on Modigliani when the painter was virtually unknown and he himself was peddling books and prints from the quays.

Zbo came back to Paris in September bringing Modi the pair of good English shoes he had asked for and a woollen scarf as a present. Before he left, the Sitwell brothers, who admired Modigliani and knew how badly he needed money, wanted to buy a hundred or more of Modi's paintings. They were both young men, in their twenties, and could not raise the capital themselves but they tried to persuade their father, Sir George Sitwell, an eccentric aristocrat, to buy up the Modiglianis for just under a thousand pounds. They showed him the superb painting, 'The Peasant Girl', which they had obtained for four pounds. Unfortunately a friend of the family disapproved of the picture, found it static and without expression, and the opportunity was lost.

Modigliani's fortunes had not been greatly changed by the Exhibition although his reputation was vastly enhanced. In *L'Eventail* in August, a number of Modigliani drawings were reproduced and, thanks to the favourable exchange rate, one or two Swiss collectors were buying Modigliani's works, but the shrewd Parisian dealers waited. But in one important aspect Modi's life did change. Persuaded, no doubt by Lunia, Zbo

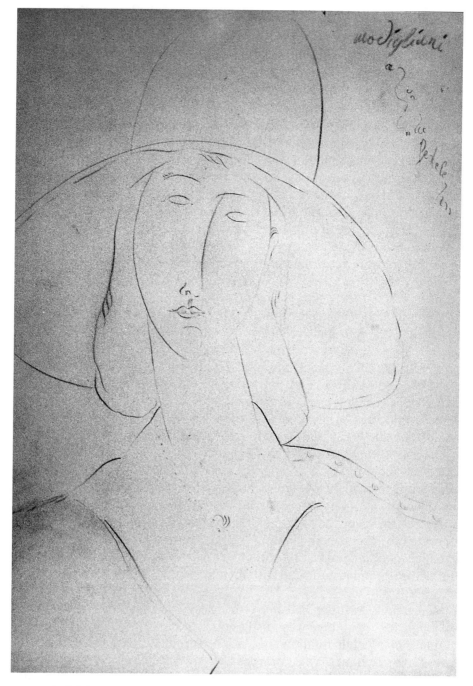

To my faithful (Jeanne) 1919.

rented a studio in Modigliani's name, in an old apartment building, No.8 Rue de la Grande Chaumière, where Gauguin had once lived. Modi's studio was at the back of the house, up three flights of steep, lopsided stairs. 'The house looked as if it were going to fall down at any moment and one could see the sunlight shining through a part of the wall.'[14] Modi's old friend, Ortiz de Zarate, lived in the studio below with his wife and two children. Before Modigliani was told about his new home, Lunia and Hanka Zborowska cleaned the apartment thoroughly, dusting, sweeping and mopping. They painted the walls a light grey but could not reach to paint the ceilings and daubed whitewash decorations on the windows as they had no money for curtains. Nina Hamnett described the studio as 'very uncomfortable', with no gas or electricity. A divan, table and a few chairs made up the furniture. Yet when Modigliani saw the modest apartment, he was overwhelmed. 'His joy was such that we were all shaken by it', Lunia remarked.[15] Later, Modigliani painted parts of the walls of his studio in the colours of the Italian Primitives, orange and ochre, to make different backgrounds for his painting.

Lunia's omission of any mention of Jeanne's reaction to her new home is significant. Clearly she felt that Jeanne was an obstacle to her in looking after Modigliani and saving him. Jeanne herself was increasingly hemmed in. At 21 she was pregnant again, her own family disapproving, with a man she could never be sure of. Modigliani was tender towards her, depended on her emotionally, she was the only woman he was committed to in his fashion. In a drawing he made of her, in 1919, the dedication reads: 'To my faithful'. One or two of his portraits reveal reproach in her eyes but more often there is tenderness and a great yearning.

In the autumn Modigliani was still working, although he was slower now and had less strength. Roger Dutilleul, a well-known collector, commissioned a portrait. Dutilleul had a marvellous collection of paintings by all the best modern artists and he enjoyed showing them to Modigliani. Modi spent some time gazing at a still-life by Picasso, lost in admiration. 'How great he is,' he exclaimed, 'he's always ten years ahead of the rest of us.' All the irritation Modigliani had felt at Picasso's air of superiority, his technical 'tricks' and his arrogance, vanished when confronted by Picasso's artistry. He asked Dutilleul if he could have the Picasso in the room with him as an inspiration whilst he painted the portrait for sixty-five francs a day, plus the canvas and several bottles. Modigliani made the most revealing comment on himself in a self-portrait of 1919. The artist sits holding his palette, a blue scarf tucked into his bronze corduroy jacket, the face burnt free of passion, a beautiful mask looking at the world through narrowed eyes with a touch of ironic pity in his expression, longing for sleep. He painted Jeanne Hébuterne against a

chest of drawers in a rhythm of sadness and yearning.

Lunia Czechowska, who believed she had a 'kind of monopoly on Modigliani', began to plan a trip to the south in the winter. Modigliani was coughing and very tired. She acknowledged that Jeanne loved him 'and for me that was sacred . . .'[16] She also conceded that Modi loved Jeanne, but obviously felt that she could have done more for him. Lunia was going out with another man and Modi criticized her for her 'infidelity so cruelly that she felt guilty. I was to remain the spiritual friend', Lunia complained. 'Such was my destiny . . . I forced myself not to fall in love with the man I had met'. Concerned for his friend and his investment, Zborowski apparently encouraged Lunia to take Modi with her, anything that would make him take care of himself and prolong his life. Lunia insists that Modigliani wanted to go south, but Jeanne refused point-blank. Her time in the south had been painful and left her with sad memories. In Paris she had her own friends and her family but she could not bear the thought of Modigliani going without her. Modigliani called Lunia 'The Sphinx' and no doubt a great part of her attraction to him was that she remained inaccessible. 'Just think,' Lunia told Jeanne Modigliani, the artist's daughter, when she was trying to tease out the truth about her father, 'if I had given in to Modigliani you would have been my daughter.' By the autumn Lunia, feeling depressed and drained emotionally and physically, travelled south and then moved to a rural spa in central France at Bourbon-l'Archambault to take the waters.

All his friends saw Modi that autumn growing weaker, getting more and more drunk on less alcohol. Both Zborowski and Jeanne tried to persuade him to see a doctor but he disliked doctors and any talk of illness. By now he was afraid of what he might hear. According to Chana Orloff Jeanne went to the police station nightly where Modi had been picked up for drunkenness, to wait for his release and persuade him to come home. Friends who ate with him noticed that his appetite had diminished.

Much of the legend of Modigliani comes down the years from artists and writers. Thora Klinckowstrom was 20 when she visited Paris, an art student who looked at Paris with a youthful clarity. When she visited La Rotonde that autumn, the notorious café that she had heard so much about, her first impression was one of disgust: 'A dirty, stinking rough-house with sawdust on the floor and most horrible types at every table . . . Open the glass door and step in. A cold damp wind from the street sends a shiver through those near the door . . .' Inside, Thora was almost overpowered by the hot stifling smell of cigarette-smoke mingled with liquor fumes. After finding a seat with difficulty, Thora looked round to see the artists and their models. 'The negress Aicha in a light-green turban plays backgammon with the little girl from the

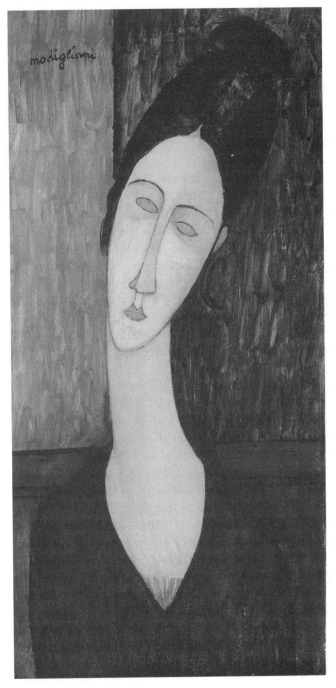

Jeanne Hébuterne, 1918.

Midi in the white turban. Those two live together . . . Over there in the corner sits beautiful Lily with an American. Now the "cocaine gang" turn up. The man with two depraved women: Amy with red and fiery lips looks really terrible. There is an unmistakable expression in her dark eyes buried under black make-up . . . of course the traffic to the toilet will soon start for the cocaine trade . . .'[17]

That young Thora had been reading the romantic literature of the time is not difficult to see, but she was remarkably observant. 'Through a mirror on the wall I see the Swedish writer, Ivan Bjarnes, in profile. He sits drinking brandy with the withdrawn violinist Rolf. But who's shouting? Oh, it's Modigliani, the beautiful little Italian, drunk as usual. Now he and Kisling are singing and the whole of his table join in. The patron crosses to Modigliani's table to ask the artists to be quiet, but they refuse to stop. On their table stands a huge pile of saucers with the price of each glass they have drunk.' The young girl, fresh from the clinical cleanliness of Sweden, was appalled by the dirt in the café, on the floor, ingrained in the marble table-tops, the dust accumulating on the mirrors, the stifling foul-smelling air, but her attention is soon diverted by the lively scene. She notes the girls preening themselves, opening their powder compacts to apply fresh lipstick; two playing chess; a couple kissing and other customers trying to read their newspapers, looking up occasionally annoyed by the noise. Like the others, Thora soon senses the seedy attraction of La Rotonde where everyone gossips, yet if one of the regulars is missing everyone remarks on it and is pleased when they come back. She found her visits to the café 'rather like treading on thin ice'. Thora was often invited to La Rotonde by Nils Dardel, a Swedish painter, generous with his money, who liked to gather an international group of painters around him. They were only too happy to accept a free drink. Modi was among the crowd, his friend and neighbour Ortiz de Zarate, Kisling, Abdul Wahab, an Arab, and others. Although Modigliani was noisy Thora immediately found him attractive. 'You only had to look at him to see that he was dangerous.' She described Modi as quite small, with a weather-beaten complexion, black untidy hair and 'the most wonderful hot dark eyes. In he marched wearing a black velvet suit with a red silk scarf knotted carelessly around his neck. Kisling wearing similar dress only succeeded in looking comic!' Modi never lost his sense of style. The other man at the table who made an impression on Thora was a handsome Arab 'trying to dress like an Englishman'.

But everyone talked about Modigliani and his love affairs, and Thora decided that he was trying to flirt with her when he drew her portrait on several pieces of the thin, poor-quality Rotonde writing-paper laid edge to

edge. He drew her with 'an exaggeratedly long neck', wrote verses from Dante on the drawing and presented it to her with great courtesy. The young Swedish girl, of course, fell for him. Later when they all went to eat a meal at Rosalie's Thora was distressed to see Modi thrown out of the café for being drunk and disruptive without one of his friends trying to help him. For them it was a routine occurrence.

Evidently Thora had made an impression on Modigliani, because a few days later he asked Nils Dardel whether he could paint Thora's portrait. To Thora the confusion between admiring a woman's beauty as a potential model and admiring the woman herself was now complete. She was captivated at the notion of an artist painting her. When she arrived at Modi's studio Thora noticed with a housewifely eye that the sloping floor was covered with charcoal that had been trampled in and with burnt-out matches. When she suggested, trying to be helpful, that she should sweep it up for him she was rebuffed. 'Modigliani nearly had a fit. I think he had worked for years to get it into that state,'[18] she commented. She made a mental note of the furniture, a large, scarred table which held his painting materials, two chairs, an easel and some canvases. A glass and a bottle of rum stood on the table and Modigliani drank freely from it. 'For my cough,' he explained and Thora noticed that he did cough badly. A coal stove in the corner warmed the room and despite the cold November weather she found the temperature quite pleasant. Modigliani put a large canvas on his easel and sketched her.

Thora was not too impressed by the 'El Greco-like lines and figure' that Modigliani gave her. She felt she was being painted like all the women in his repertoire. 'The likeness therefore was not striking,' she remarked. She came back several times in the afternoon to have her portrait painted. Modigliani had slowed up noticeably. A few years earlier he would have completed her portrait in two or three sittings. Although Thora and Modigliani could barely speak to each other she liked him more and more. One day she took Annie Bjarne, a Swedish friend, with her for the session and Modigliani immediately asked if he could paint Annie. He was desperately keen to find suitable models. Loath to part with Modi, Thora acted as 'chaperone' and kept them company during the time he worked on Annie's portrait.

Thora occasionally saw Jeanne, 'a very young French girl he called his wife'. Although Jeanne was six months pregnant, to Thora she seemed a 'delicate and fair little creature who looked at me with horror in her eyes and always treated me with the greatest suspicion'. Thora was well primed by now with the gossip at La Rotonde and could understand Jeanne's misgivings at seeing yet another female in the studio. The whole of La Rotonde knew

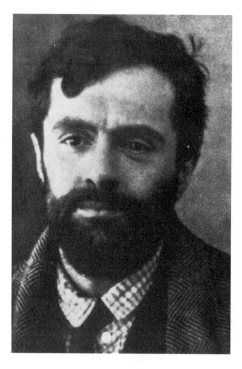

Last photograph of Modigliani.

Simone Thiroux, the Canadian girl who claimed to have had a child by Modi, and she had heard Beatrice Hastings, whom she described as a 'somewhat muddle-headed Englishwoman', loudly claiming ownership of Modigliani. He was an alluring companion and Thora was extremely regretful to leave him when she went south to Algeria to find the sun.

At the Salon d'Automne that year Zborowski entered four of Modigliani's paintings, 'A Peasant Girl', 'The Portrait of a Man', a nude and 'The Portrait of a Young Girl'. The show was held in the Grand Palais from 1 November to 12 December and even at this stage, when he was beginning to be recognized as an important painter by critics abroad, Modigliani's work seems to have been ignored in Paris.

The winter months of 1919 were unusually cold and in December Modigliani must have felt very ill, because he agreed to stay in bed with flu for a few days but insisted on going out soon afterwards. One December evening Modi and Jeanne were eating at Rosalie's in the company of the Polish painter Simon Mondzain when Modigliani remarked that in March 1920 he was going to leave France and live permanently in Italy. It was a plan he had had in mind for some time and Mondzain thought it must be because of Jeanne's second pregnancy. To Carco, too, Modigliani spoke of going with his

'family to Italy' and he even wrote a postcard to his mother mentioning the possibility.

> Dear Mother,
> I am sending you a photograph. I'm sorry that I do not have one of the baby. She is in the country with the nurse. I am thinking of travelling to Italy in the spring. I'd like to spend a 'period' there. But I'm not certain.
> I hope to see Sandro again. It appears that Uberto [who was to become mayor of Livorno in 1920] is launching himself into politics. I hope he does well.
> All my love
> Dedo[19]

Modigliani was talking in his card of the Mondolfi brothers, sons of Eugenia's old friend, Rodolfo Mondolfi, who had helped her to launch her school years ago. One gains the impression that for the first time for years Modi felt a yearning to be in touch with his own country again.

In Italy, Eugenia felt an extraordinarily strong tug towards her youngest son during December. On the twenty-seventh of the month she wrote:

> I hope my very dear Dedo that this arrives on the first morning of the year, as if it were a faraway embrace from your old mother, bringing with it every blessing and every good wish. If there is such a thing as telepathy, you will feel me very near you and yours.
> A thousand kisses.
> Mama[20]

Modigliani was coughing blood, very ill and haggard-looking. And yet, when he picked up his pencil, his hand was as confident as ever. The Florentine painter, Umberto Brunelleschi, had seen him in Paris earlier in the year, looking worn and dishevelled. To his surprise Modigliani was hard at work, making a drawing of a beggar sleeping on a bench.[21]

Glimpses of Modigliani, even in his last weeks of illness, remain conflicting and contradictory. There were those who said he was deliberately destroying himself, refusing all efforts to see a doctor and becoming irritable and violent, even with Jeanne. André Salmon, who was never a friend of Modigliani's, gave a detailed 'eye-witness' account of one night when Jeanne went to visit her parents. Modigliani, who disliked her leaving him even for a short time, asked her to be back early. He wouldn't go back to the studio, he said, he would stroll around Montparnasse and meet her at the Latin Quarter at a

little bistro. At the appointed time Jeanne arrived to find Modigliani, who had been waiting for her for a long time, completely drunk. Salmon says he saw Modigliani pulling Jeanne along the road, seizing her arm and one of her long plaits, letting go only for an instant to hurl her against the railings of the Luxembourg Gardens, until Salmon, unable to bear the scene any longer, called out from the safety of the shadows: 'Modigliani! Enough of that.'[22]

Modigliani was capable of hitting out at anyone, even Jeanne, when he was drunk but the account, out of context, distorts the nature of what was an extraordinary love. Modi drew a devastating devotion from his women. On the last day of the year Simone Thiroux, the girl who still linked her name with Modi, wrote him an imploring letter. She had tried to see him to talk to him and, of course, Jeanne was furiously jealous. Simone's son, Serge Gérard, now two and a half, was so beautiful that she was sure he was Modigliani's child. Simone had been turned out by her aunt and was struggling to support herself and her baby by working as a nurse at the Cochin Hospital in Paris. Like Modi, she was ailing, and her letter sounds only too sincere:

Dearest Friend,

My most tender thoughts turn to you on the occasion of the New Year which I so much want to be a year of moral reconciliation for us. I put aside all sentimentality and ask for one thing only which you will not refuse me because you are intelligent and not a coward: that is a reconciliation which would permit me to see you from time to time. I swear on the head of my son, who is everything to me, that no wicked thought crosses my mind. No – but I loved you so much and suffer so much that I crave this as a final plea. My health is very bad, the pulmonary tuberculosis is sadly doing its work. Some good moments, some bad. I will be very strong. You know my present situation: materially I lack nothing and earn my own living. But I can't go on. I would like you simply to find me a little less hateful. I beg of you to think well of me. Console me a little. I am too unhappy and ask for just a little affection that would do me so much good. I swear to you again that I have no ulterior motive. I feel for you all the tenderness that I must have for you.

Simone Thiroux[23]

The next day, New Year's Day, Modigliani burst into the Zborowskis' apartment at seven in the morning, dead drunk and carrying a huge bunch of flowers, according to legend. More convincing evidence of his whereabouts on New Year's Eve may be found on a drawing he made of Mario Varvogli, a Greek musician. They had been drinking together and Modigliani wrote on

the drawing: 'Here begins a new life'. Modigliani seems to have both known and suppressed the reality of his condition. 'I know I am done', he told Libion, the former owner of the Rotonde when they met at the café. Yet when Libion ordered two aperitifs and tried to console him, he became more cheerful and said he was going back to Italy to get cured. Several people saw him coughing up blood. Louis Latourettes, his journalist friend from pre-war days, came across Modigliani in early January at the Closerie des Lilas and was appalled by his feverish, emaciated looks. Knowing that Zborowski was beginning to have some success in selling Modigliani's work, he asked the painter about his progress. 'Oh, I've made some money,' Modi answered sardonically, 'but since you're in finance and my family was in banking, you should consider me as a colleague and give me a few tips on how to make more.' Modi refused to take Latourettes' concerned queries about his health seriously. 'I'm all right,' he shrugged. 'Maybe I ought to try an altitude cure on the Butte [the hill of Montmartre]. I'd like to see some of the old haunts again. Say goodbye to the cherry tree on the top of the Rue Lepic for me,' he said. 'We'll dine at Labille's one of these days and I'll settle an old debt.'[24]

Modigliani apparently did go up to the Butte late one night and found Suzanne Valadon and André Utter (Utrillo's mother and stepfather) having dinner at Guérin's restaurant. Modigliani insisted on sitting next to Suzanne. 'She is the only woman who can put up with me', he cried. Suzanne accepted Modi's weaknesses; she knew of his kindness to her son and was always fond of him. While the rest of the party laughed and joked, tried to jolly Modigliani into a better mood, he sat silent, drinking. Then he began to chant a mournful Jewish prayer, the Kaddish, the prayer for the dead. He was inconsolable that night.[25]

Modigliani was a late riser, but at seven o'clock one morning early in January he got up and went outside Paris to visit his daughter, who was by then just over a year old; he came back very happy. His friends could not believe that Modigliani was seriously ill. Late at night he might turn melancholy, but at other times he clowned and laughed as usual and mentioned going back to Italy to get some sunshine. He had one last glorious night out with Utrillo. Utrillo, who had just escaped from his gloomy room with its barred windows in the lunatic asylum, burst into Rosalie's and the two men hugged each other. Modi cadged a free meal for Utrillo from the long-suffering Rosalie and then brought Utrillo back to his studio. He had a plan. Maurice painted two street scenes of Montmartre from memory and Modigliani took them over to sell to Zborowski. With the money the two went on a last bid for freedom. 'What money they did not drink up was folded into air planes and sent gliding into the trees along the Boulevard Raspail'. They

stomped the streets until they were dropping with exhaustion and staggered up the stairs to the studio. Faced with two hopeless drunks, and nine months pregnant, Jeanne could do little. In the morning, whilst Modi and Jeanne were still asleep, Utrillo vanished, carrying Modi's corduroy suit. A little later he came in triumphant with the bottles of wine he had bought with money from the pawned clothes. Soutine dropped in at the studio and Modi told Utrillo to take off his clothes so that Soutine could hock them at the pawnshop and buy more wine. Soutine had the sense to hurry round to Zborowski to alert him of the state his friends were in. Zbo, used to such crises, went to the pawnbroker and redeemed the clothes, then ran to Modigliani's apartment. Modi was persuaded to go to bed; Utrillo was taken away, and the two friends never saw each other again.[26]

A young woman friend of Jeanne's, Chantal Quenneville, who first met Modigliani during the Christmas holidays of 1919 and often sat for him at the Closerie des Lilas, believed he was clinging to life. To her surprise, late one night, she saw him twice going to get sandwiches from the little all-night café on the Boulevard Vaugirard. 'Over-eating is the only thing that can save me', he told her. It was the first time he had spoken of his illness.

There are many other distressing accounts of Modigliani early in January, drunk, cantankerous and terribly thin and grey, refusing to put on an overcoat in a furious wind, cursing, kicking, scratching friends who tried to help him, imagining enemies in the shadows and monsters in the monuments. Interestingly enough most of them were written ten years after his death for a special number of *Paris-Montparnasse*, which helped to boost the tourist trade. The first article in the supplement of the newspaper was headed: 'One night when he was drunk . . .'

Chana Orloff met Jeanne one winter day and Jeanne told her that she went almost every night to the police station to fetch Modi home. According to Roger Wild, the husband of Jeanne's best friend Germaine (Haricot Rouge), not long before Modigliani was taken to hospital they all dined together at the Trois Portes, a restaurant popular with artists, with the Derains, Isadora Duncan (who was to die tragically seven years later) and Modigliani.[27] Although so many friends were to claim intimacy after death, the couple were increasingly isolated during that terrible January.

Ortiz de Zarate, a loyal friend, occasionally took up food cooked by his wife Hedwige, although they too were living on a tight budget. Hedwige disapproved of Modi and would not receive him in her home. He ate very little, yelled for drink, and told Zborowski and others who pleaded with him to see a doctor, 'not to lecture'. Modigliani desperately wanted to ignore his illness and even Jeanne could not override him.

On 14 January Modigliani suffered terrible pains in the kidneys and agreed at last to see a doctor. By some extraordinary misjudgement nephritis was diagnosed and, according to Zborowski, the doctor came every day and so did Zbo until 20 January, when Zbo felt ill himself and sent his wife round to see Modigliani. Hanka came back alarmed and reported that Modigliani was spitting blood, and in another incomprehensible judgement, the doctor pronounced that only after a two day wait for the bleeding to stop must Modigliani be taken to hospital. When the ambulance came for him two days later Modigliani was already unconscious. Tubercular meningitis began to take hold.

That was the account Zborowski sent to Emanuele, Modi's brother.[28] But in 1930, ten years after the events, Modi's friend and neighbour recalled the crisis quite differently. Ortiz, who had been in the habit of arranging for coal to be delivered to Modigliani, was away working for eight days. When he came back he was appalled at the state in which he found Modigliani and Jeanne, lying on a repellently filthy mattress. 'Are you eating, at least?' he asked. At that moment someone brought in a tin of sardines, and Ortiz noticed that the two mattresses, as well as the floor, were covered with spots of grease and oil. He concluded that they had been living on sardines for the past eight days. Ortiz asked the concierge to bring up a *pot-au-feu* and sent for a doctor, who ordered Modigliani to go to the hospital immediately. 'I have only a little piece of brain left . . . I know this is the end', Modigliani said in a weak, husky voice. And added: 'I have kissed my wife and we have agreed on eternal happiness'.[29] At that time Kisling, who lived near Zborowski in the Rue Joseph Bara, called in other doctors to advise on Modigliani's condition and also sent special delivery letters to Modigliani's friends. For three days Montparnasse buzzed with the news of Modigliani's grave illness. Young girls who knew him so vividly alive could not believe that he was fatally ill. Just back from her holiday in Algiers, Thora Klinckowstrom asked Simone Thiroux for news. Modigliani lay at the Charity Hospital suffering from severe lung inflammation, Simone told her tearfully. Thora did not dare visit but bought a bunch of white lilac and sent it to him with a card. Fourteen-year-old Paulette Jourdain badly wanted to go to see Modi in hospital, but was told that a child of her age would not be allowed in. Two days later, on Saturday 24 January at 8.50pm Modigliani died of tubercular meningitis. The disease had been present for a long time, but the doctor had failed to recognize the symptoms. In a welter of anecdotes and contradictory accounts, that was not in dispute.

After Modigliani's death, Zborowski was so deeply depressed that he left it to Kisling to make the funeral arrangements. Chana Orloff went to see Jeanne

and found her 'calm as a statue. Too calm. It frightened me. Jeanne had just come back from a visit to the maternity clinic, but they had told her it was too soon and sent her away.'[30] Zborowski did not want Jeanne to go back to sleep alone in the studio in Rue de la Grande Chaumière, and asked young Paulette to take Jeanne to a small hotel, Hôtel de Nice, on the Rue du Seine. 'She was already waddling like a duck,' Paulette said, 'but she seemed calm'.[31] In the morning the chambermaid found a razor underneath her pillow. Jeanne went back to the hospital to see Modigliani for the last time. Although he had despised Modigliani as a degenerate Jew who had seduced his daughter, her father went along to support her. Jeanne's father stood silently on the threshold of the room whilst Jeanne 'looked at him for a long time without a word, as though her eyes were trying to take the measure of her tragedy. She walked backwards as far as the door and when we came up to her she was still holding on to the memory of the dead man's face and was trying not to see anything else'.[32] (Other witnesses gave contradictory evidence, stating that Jeanne went over to the corpse.) Kisling, in the version in *Artist Quarter*, had Jeanne emitting 'the most piercing cry that ever a woman uttered when confronted by the corpse of her man.' But somehow that does not ring true. In a state of icy numbness, Jeanne went back to the Zborowskis' apartment on the Rue Joseph Bara the day after Modigliani's death, overwrought and very pregnant. A room had already been booked for her at the Tarnier clinic in Paris. Little Paulette Jourdain says Jeanne took her hand and murmured: 'Don't leave me.' But when Jeanne's father arrived at the apartment and asked her to go home with him, she agreed silently. What prayers, anxieties and recriminations met Jeanne that dreadful Sunday one can only imagine. Her brother, André, was extremely fond of her; her mother realized how deeply she loved Modigliani, whilst Achille Hébuterne, her father, wanting to do his duty by his daughter, was appalled at the disgrace and the prospect of caring for two illegitimate children.

Exhausted, and half demented with grief and weakness, Jeanne eventually lay down in her old room. It was only two and a half years since she had lived at home but it must have seemed like a lifetime. Whatever she herself may have felt, she could not bear the spoken and unspoken reproach to Modigliani she sensed in every word. Her family said her brother was desperately worried about Jeanne and looked in at her from time to time. But at dawn he dozed off and at four o'clock on Monday morning Jeanne pushed open the fifth-floor window and threw herself out. The men in her family did not want her mother to see the mutilated little body, and Jeanne was taken to Modigliani's studio in Rue de la Grande Chaumière in a cart. There too the concierge refused to admit Jeanne's body on the ground that she was not a

tenant! The workman next took the corpse to the police station and it was only after police intervention that the body was returned to Modigliani's studio.

The details of her tragic death, like Modigliani's, were to be picked over, wrangled about, and embellished for years to come.

The loss and the legacy

MODIGLIANI lived prodigally, and as soon as he died friends and contemporaries began to realize their loss. Reckless, beautiful, defiantly poor, he summed up in his short span the ideals and achievement of an epoch. Through his private life, which was to become so publicized, artists and writers caught a glimpse of their own, less heroic, less stylish youth. In the twenties many of Modigliani's contemporaries – Picasso, Derain, Soutine, Foujita – became prosperous, if not bourgeois and moved out of the Quarter. Montparnasse smartened up in the post-war world to accommodate a wave of would-be bohemians who drove fast cars and drank champagne in the new night-clubs. At a time when it was 'the fashion to represent painters as over-sexed, alcoholics, brilliant, immoral and full of a dangerous fascination',[1] writers and restaurateurs of the quarter sensed the need to preserve the myth and the glamour of Modigliani. They grew rich on his false reputation and Montparnasse developed into a leading European tourist attraction, with night-spots offering sophisticated vice, far beyond the means of the poverty-stricken artists of the First World War.

The process of the deification and desecration of the memory of Modigliani began at the Charity Hospital soon after his death. Moise Kisling sketched Modigliani and then decided to make a death-mask as a memento for his family and friends, with the aid of Conrad Moricand, a Swiss writer and astrologer. Neither man had had any experience of sculpture and since the hospital authorities were anxious to transfer the body to the morgue, the work had to be done hurriedly. The result was a disaster. The plaster mould did not solidify and strands from the eyebrows and strips of facial tissue clung to the plaster. In despair, the two men took dozens of pieces to Jacques Lipchitz, the sculptor. Lipchitz had to reconstruct the mask completely. In repose, the features are restored to their classical beauty.

'Cover him with flowers,' Emanuele had telegraphed from Livorno, and the

fresh flowers Modigliani had loved smothered his coffin. There were also two wreaths: one which read 'to our son' and the other 'to our brother'. A crowd gathered at the Charity Hospital to escort the hearse to the cemetery. At 2.30 in the afternoon of 27 January, artists, writers, models, art students, French, Russian, Italian, Chinese followed the horse-drawn hearse on foot for the seven to eight kilometres to the Père Lachaise Cemetery. Among the mourners were Picasso, Léger, Suzanne Valadon, Moise Kisling, André Salmon, Leon Indenbaum, Zborowski and Simone Thiroux. Picasso, walking with Francis Carco, noticed the policeman who had so often arrested Modigliani for disorderly behaviour, standing at attention as the procession slowly passed. 'Do you see?' he muttered to Carco. 'Now Modi has his revenge.'

At the graveside, a rabbi recited prayers and Modigliani was laid to rest. 'The world of young artists made this a moving and triumphant funeral for our dear friend and the most gifted artist of our time . . . He was a son of the stars for whom reality did not exist,' Zborowski wrote in a letter to Emanuele in Livorno. But even at his funeral there were those present interested only in exploiting the situation. Two dealers came up to Francis Carco, who owned some Modigliani paintings, and tried to barter with him. 'They talked about it quite naturally as we followed the coffin, as if it were none of the deceased's business.'[2] One can almost hear Modigliani repeating a favourite phrase at the story: 'No kidding.' The dealers even approached Zborowski, overcome by grief, and offered him seven or eight times the price they had proposed when the artist was alive. Even when Modigliani lay dying in hospital another dealer, Louis Libaude, had scuttled round Paris buying up all the Modiglianis he could at what were to become bargain prices. After the painter died he boasted of his luck. 'I managed to pick up some Modiglianis for nothing . . .'[3]

Jeanne committed suicide the day before Modigliani's funeral, and their friends had wanted a double funeral but Jeanne's father was horrified at the idea. They held her funeral at eight in the morning, to escape attention, the day after Modigliani's funeral and asked Jeanne's friends not to come. 'There has been enough scandal.'[4] A suicide was an affront to Catholic orthodoxy in those days, but her friends were loath to allow Jeanne to be buried so bleakly. Chantal Quenneville, the Kislings, the Zborowskis and the Salmons arrived at the Hébuternes' apartment in the Rue Amyot early in the morning, carrying a huge wreath made up of the flowers left over from Modigliani's funeral. The coffin was placed on a small truck which drove off as fast as possible, but 'we pursued it in taxis. But we could only stay at the entry of the cemetery: we were forbidden to enter,' wrote Chana Orloff.[5]

The day before Modigliani's funeral, Jeanne's body was lying in their studio in the Rue de la Grande Chaumière. A number of friends later claimed the privilege of caring for the corpse. Chantal Quenneville, a friend of Jeanne's from art school days, said she went to the studio with Jeannette Léger and swept up the rooms, which were full of empty tins, coal and bottles of wine. On the easel she noticed 'a fine portrait of a man which was not finished'. This was the portrait of the Greek composer, Mario Varvogli. Modigliani had sketched him on New Year's Eve when they were out drinking together and must have painted the portrait in the first two weeks of January before he became too ill to work. Paulette Jourdain also remembered seeing a portrait on the easel, the colours still wet.[6] Chantal also found some drawings Jeanne had made of herself in the act of committing suicide by stabbing herself in the breast. Jeannette Léger, in the meantime, had gone to look for hospital attendants to dress the body.

Foujita also claimed to have been the first to tend to Jeanne's corpse. 'There was no one to look out for her.' He and Ortiz de Zarate offered to clean up her body, but then some hospital attendants arrived.

The third claimant to be first to enter the studio after Modigliani's death was Waclaw Zawadowski, a Polish painter who was a friend of Zborowski's. Zawado (as he was always called) mentioned drawings littered everywhere, a very bad painting on Modigliani's easel and a studio thick with bottles. According to Zawado he and a Tunisian painter, Abdul Wahab Gelani, stayed in the studio during the night to ward off the rats. Marie Wassilieff contributed some magnificent Russian sheets so that Jeanne could be laid out with proper ceremony and Ortiz de Zarate gave his suit so that Modigliani could be buried decently. Over the years the stories with a macabre interest in the last moments increased. Modigliani had died in France, extolling his beloved Italy. He had said to Zbo: 'You have nothing to worry about, I am leaving you a genius in Soutine.' He had asked his wife to follow him to the grave 'so that I can have my favourite model in Paradise and, with her, enjoy eternal happiness'. There were, as Jeanne Modigliani remarked wisely, 'too many last words'.[7] Some of Modigliani's friends behaved with the understanding and generosity they had shown during his lifetime. But there were others who could not resist the temptation to dramatize and capitalize on their part in the Modigliani story. Zawado sold Modigliani's palette for one hundred and fifty francs to an American sightseer who dropped into the studio. Then he began to hang up worn-looking palettes on the wall and made a useful profit.[8] Modigliani had distrusted publicity profoundly during his lifetime. Ironically, it was his death and Jeanne's suicide that gave rise to a mammoth, money-spinning 'Modigliani' industry. That the promotion was

calculated cynically seems clear from the telegram the dealers had sent to Zborowski in London in August 1919, telling him to hold up all sales until Modi was dead. With the suicide of his mistress and the loss of the unborn child, the dealers had a 'bonus'.

Francis Carco was a loyal friend, even if his accounts of Modi's life are sometimes highly coloured. A week after Modigliani died Carco warned, in an obituary, of the false reports that had appeared about the painter. '. . . Much nonsense was spoken about him; he was ignored and all too often unjustly treated. Today we know that nothing can keep his memory unscathed from the worst slanders . . . no doubt because of excesses so often repeated that they have given birth to a legend. Modigliani outraged the feelings of certain collectors, thus causing a scandalous outcry . . .'[9]

Carco went on to praise Modigliani's work. Modi had, of course, refused to truckle to the wealthy, to haggle, to sign his drawings if he did not want to, to compromise. As the boom in his paintings grew after his death, landlords advertised free lodgings for artists who would 'finish' Modiglianis and painters were employed to forge his signature and complete his work, with the result that an alarming number of false Modiglianis, from blatant fakes to borderline cases, appeared on the market. Charles-Albert Cingria, another loyal friend, tried a number of times to set the record straight, notably in introductions to Modigliani's works.[10] 'I remember [Modigliani] as a courteous and reserved man. No doubt he drank too much and sometimes got a bit uproarious, but no more than other young men at the time. What struck one was the quality of his uproariousness; however overexcited, he always remained a gentleman.'

Compared with others, Modigliani's endlessly repeated exploits, weaving across the traffic in front of the tramways, even, according to one story, ending the night in a dustbin, were unexceptional. At a wild party, Oscar Dominguez, a painter from Teneriffe, threw a bottle across the room and knocked out the eye of Victor Brauner, a Rumanian painter. Derain, who liked to paint with a model on his knee, wrecked the bar of La Coupole, smashing mirrors and glasses. Pascin and Man Ray adjourned to a brothel after a rowdy dinner and five or six of Man Ray's artist friends, including Pascin, committed suicide.[11] The intriguing notion that Modigliani was singled out to become the symbol of bohemian life, scapegoat and demi-god seems inescapable.

'Poor Modigliani', said Rosalie, who had fed him so often at her dingy little restaurant, 'he would go and die like a dog.' None of Modi's family benefited from his posthumous fame or the boom in the prices of his paintings. He had sent their last remittance back, presumably after the small success at the

London exhibition.[12] For years after his death, the Modigliani family was publicly reproached for leaving the artist to starve. No half-measures in the Modigliani myth; he was either starving or else very comfortably off if he had not squandered his allowance on dissipation. Modigliani was never destitute, nor abandoned by his family, nor did he at any time in his life have the money to lead even a moderately comfortable life. As soon as the Modigliani family heard of Amedeo's death, they wrote to Jeanne asking her to come, with her children, to live with them. That was before news reached them of Jeanne Hébuterne's suicide. Emanuele had not been able to obtain a passport for a month. He arrived in Paris late in February 1920 to try to settle Amedeo's affairs. Little Jeanne, almost fifteen months old and beginning to walk, was still with her nurse. Zborowski was in charge and had been to see her with his wife. He would, he wrote, 'willingly take her as his daughter', but added that 'Amedeo had always expressed the wish that she should be brought up in Italy among the Modigliani family'.[13]

When Emanuele came to Paris a number of girls came to his hotel room claiming that Modigliani was the father of their child. Emanuele explained that he could not acknowledge any child that his brother had not acknowledged. They all gave up except Simone. She came again and again, with Serge Gérard, her little boy, crying and insisting: 'Can't you see that this child looks like Amedeo?' Later she turned up with two male friends who were prepared to swear that the little boy was Modigliani's son.

About a year later, Simone died of tuberculosis and her son was adopted by a well-to-do elderly couple who stipulated that the boy's origins must never be revealed. Modigliani's 'son' would, by now, be a man just turned seventy.

The adoption of Jeanne by Margherita, Amedeo's sister, proved complicated. Emanuele referred the problem to a well-known lawyer in Marseilles, who let the matter lie dormant for so long that it was then pronounced too late to regularize the matter. Fortunately Emanuele, with his lawyer's training, found a way. When looking through his brother's effects in the studio, Emanuele had found a roll of drawings, studies of male figures, poems, three reply-paid postcards from Eugenia, a postal order for Jeanne's nurse, the 'marriage contract', and the document that was to prove most effective to the legal mind, a large sheet with a detailed horoscope which agreed with the hour and day of birth of the baby. Conrad Moricand, who had helped Kisling to make the death-mask, charted the horoscope. Emanuele took the horoscope personally to the Government lawyer responsible and, curiously, that paper convinced the lawyers. Everybody said 'only a father would do that for his child.'

Emanuele also went to visit Jeanne's family, who were extremely relieved

to hear that the Modigliani family was taking charge of the baby. In 1923 the Hébuternes made a sworn declaration to a notary to clarify their grand-daughter's legal position. It began: 'From our marriage there was born on 6 April 1898 a daughter, Jeanne Hébuterne, who from her birth until the age of which we will speak lived with us in Paris. In the month of July, 1917, our daughter met an Italian painter, Amedeo Modigliani of Livorno, who lived in Paris. They fell in love . . .'[14]

Two years later, when Mussolini was in power in Italy, as a Socialist politician Emanuele was in exile in Paris. He persuaded the Hébuterne family to allow Jeanne's remains to be exhumed from the Bagneux cemetery and reinterred next to Modigliani in the Jewish section of Père Lachaise Cemetery. Their friends had always wanted them to lie side by side. 'Finally they sleep together', Emanuele wrote home to his family. The inscription on their tombstones read:

AMEDEO MODIGLIANI	JEANNE HEBUTERNE
Pittore	Nata a Parigi il 6 Aprile 1898
Nato a Livorno il 12 Luglio 1884	Morta a Parigi il 25 Gennaio 1920
Morto lo colse il 24 Gennaio 1920	Di Amedeo Modigliani compagna
Quando	Devota fina all'estremo
giunse alla gloria	sacrifizio

Jeanne died in reality on the Monday morning, 26 January; the date on the tombstone, like so much of the Modigliani story, is false.

Jeanne grew up with the Modigliani family in Italy, where Eugenia spoke to the little girl of her father 'with sorrowful tenderness' and Margherita, her aunt and adoptive mother, in tones 'at once heavy with innuendo'.[15] Margherita and Amedeo had never liked each other. Jeanne Modigliani, an art historian, traced her father's life with a clear-eyed truthfulness which her father would have admired.

Despite the rise in the price of Modigliani's paintings and the enhancement of his artistic reputation, which continued from his death to our own day, over the years neither Modigliani's family in Livorno nor his daughter ever benefited. When Emanuele came to Paris in 1920 to deal with Modi's effects he was told that all the paintings were sold; when he explained that he didn't want to buy the works (for the family made no pretence of understanding Modigliani's art), merely to look at them out of interest, a number came to light. Zborowski and Modigliani's close friends 'organized a little committee to collect the work of different painters and sell them to the benefit of his daughter',[16] Zborowski wrote to Emanuele. 'The sale will probably bring 25

to 30,000 francs which you can accept in her name', he added expansively. Modigliani would, of course, have preferred that his daughter could have benefited from the sale of a few of his paintings rather than rely on the charity of friends.

Unfortunately the people who had helped Modigliani did not benefit from the boom; friends were often forced to sell the paintings he had made for them. Modigliani had left Rosalie, who had let him have so many free meals, 'notebooks stuffed with drawings.' She couldn't stand his work with its distortions and had thrown the books into the cellars where rats and mice nibbled away at his exquisite work.

Another friend, C.R.W. Nevinson, was a little luckier. He had bought a painting by Modigliani and after Modi's death, when he needed the money, offered it to the Leicester Galleries for sixty pounds. They turned it down, so Nevinson took it to Paris with him in the early twenties. Outside a dealer's, he noticed a sign: 'We buy Modiglianis', and took in his picture. The dealer refused to buy it, saying it was not quite the type of Modigliani he was looking for, but asked Nevinson to leave it with him for an hour or two so that he

Nude.

could study it. It was the lunch hour and Nevinson guessed that the dealer was ringing round all his colleagues to fix a maximum price; afterwards they would share out the profits.

Nevinson returned to the gallery about half-past two. The dealer suggested several colleagues who would be interested in the Modigliani, but advised Nevinson not to approach Paul Guillaume as it would be a waste of time. Nevinson felt sure that Guillaume had been out when the dealer telephoned and went straight to him. Guillaume immediately offered the artist one hundred and twenty pounds in cash. Later, Nevinson heard that the painting was bought by an English dealer for a thousand pounds. The price had risen 200% in less than ten years. 'The art world in Paris was becoming something like the Stock Exchange',[17] he commented.

Modigliani's work gradually began to gain in standing in the international art world. During his lifetime he had had only one one-man show, in December 1917, which was closed before it officially opened. During the 1920s, five exhibitions of his work were held in Paris, two in London and one in New York. The Museum of Grenoble was the first to buy one of his works. Yet in his native Italy, where twelve of his works were displayed at the Venice Biennale in 1922, neither the critics nor the public were enthusiastic about his work. 'These twelve ugly, misshapen heads could have been drawn by a child of five', an eminent reviewer pronounced.[18] The American patent-medicine millionaire, Dr Albert Barnes, came to Paris in 1922 and bought up paintings by both Soutine and Modigliani, and by 1929 Modigliani paintings were fetching high prices in New York galleries.

In Italy too, by 1930, a group of admirers of the work of Modigliani had managed to persuade the Italians of his importance. A major exhibition of his work was held at the Biennale that year which traced his evolution as an artist from 1905, the year that he had studied in the Venice Accademia, to 1920. The exhibition comprised forty paintings, two sculptures and numerous drawings. Ten years after his death *Paris-Montparnasse*, a local newspaper, published a 'tribute' to Modigliani with a special supplement. The issue managed to convey the impression that Modigliani was little more than a handsome drunk, the 'prince' who fought and quarrelled and took drugs. The front page article by André Salmon was headed 'One night when he was drunk . . . Homage to Modigliani'. The same year *Homage to Modigliani*, an anthology of tributes to the artist from eminent painters, writers and critics, including Braque and de Segonzac, was published in Milan to honour the artist in his native country.[19] Modigliani disliked rhetoric and the inflated and perfunctory tributes, some of them from his detractors, would not have escaped his notice.

'Your life of a simple grandeur was lived by an aristocrat and we loved you . . .', wrote Max Jacob, who was later to excoriate Modigliani in a private letter. Jean Cocteau, who disliked intensely the portrait that Modigliani had painted of him, commented on Modigliani's death as 'the end of an era of profound elegance in Montparnasse and we did not know it . . . My portrait by Modigliani is worth a lot of money but what augments the value is the prestige of our immortal memories . . .'

Those who were close to him wrote with more simplicity. 'I loved him very much and I transfer my affection to his daughter,' said Blaise Cendrars. Vlaminck, a loyal friend: 'He was a great artist . . . his paintings have great distinction – vulgarity, banality and coarseness are absent from them . . .' And Soutine, who had no pretensions as a literary man: 'It is Modigliani who gave me confidence in myself.' The anthology also contained three poems by Modigliani, presumably from among those found by his brother in his studio. The tributes, brief and elegiac in tone, helped to canonize the sinner and lose all trace of Modigliani's very human qualities.

A novel published in 1919, *Les Montparnos*, further coloured Modigliani's image.[20] Michel Georges-Michel wanted to capture 'the new bohemia' in a novel about Montparnasse which he saw as a successor to Henri Murger's *Scènes de la Vie de Bohème*, the source of Puccini's opera. When he asked in the Quarter for a suitable hero, everyone mentioned Modigliani's name. In the novel Modigliani becomes Modrulleau, Jeanne '*Haricot Rouge*', and the hero takes his mistress to Rome, which was for Modi an unrealized dream. The hero dies young, of drink, and his pregnant mistress throws herself out of the window. The memories of the 'real' Modigliani began to become confused with the mythical hero in the infinite variations on the story. Even the critics, when writing of Modigliani's art, would eulogize or more often moralize. They described his work as 'neurotic, unhealthy, pessimistic and melancholy', even claimed to see in the eyes of his models 'a kind of torpor such as follows on indulgence in drugs'.[21] He was taken to task for ambition as well as dissipation. 'Did he know that his life would be short, or as a Jew was he eager to succeed?'[22] The 'anxious, tense intellectualism which he shared with numerous Jewish artists of his day' came in for reproof too, although others insisted that Modigliani had nothing Jewish about him in judgements that had little to do with the visual content of his work.

Bias of all kinds encumbers opinion of Modigliani's life and work. In the Parisian Journal *Beaux Arts*, Henri Lormian criticized Modigliani's high-handed attitude towards money, claimed (rightly) that he was no worse off than many other artists before the First World War, reproached him for allowing a woman to pay his board and lodging and for bartering his work in

exchange for a meal or a haircut. Most damning of all, in the writer's view, was Modigliani's extraordinary success with women. 'They were mad for him',[23] he wrote. And added that although people said he had the air of a prince, of a grand seigneur, a Roman profile, he had a runny nose and the watery eyes of a drunk. But women didn't see that. They said he was so rich in conversation.

That article, still throbbing with sexual jealousy, fourteen years after Modigliani's death, illustrates the depth of passion and prejudice Modigliani aroused among his peers. And, since a web of anecdote and hyperbole entangles much of the story, the controversy continues.

In 1984, to mark the centenary of Modigliani's birth, the civic authorities at Livorno, who up to that time had boasted a bust of Emanuele, Amedeo's politician brother, in their park, and only a few examples of the artist's early works in the civic museum, decided to dredge the canal. According to anecdote, Modigliani had dumped some of his strange, elongated heads there because he had nowhere to store them and his friends had advised him to 'throw them into the ditch'. Three heads were discovered on the bed of the canal, but many critics dispute their authenticity and at present they remain locked up in an Italian bank, another Modigliani mystery.

The Modigliani paintings of the later years, with their long necks and concentrated gaze, are easily recognizable and for that reason he is sometimes considered too facile a painter; but that judgement is superficial. The legend that Modigliani's greatness grew out of a drugcrazed vision and his exceptional fluency of line compounded the notion that his work lacks depth. Perceptive critics point out that it is the viewer who must look with more profundity. Walter Sickert, the painter, realized the discipline that lay behind the apparent ease. '. . . no draughtsman has ever freed himself to a greater extent from the exhibition of anxious effort,'[24] he wrote. 'If his drawings have the freedom of an exhilarated bubble, they display, on examination, a wealth of form under the most rigid control'. 'Modigliani had great natural gifts . . . but they were not all precocious in their expression and only a profoundly serious and coherent artist could have brought them to the degree of fulfilment which he attained in the months before his death'.[25] John Russell explained. 'The art of Modigliani is not accessible immediately to everyone,' wrote Arthur Pfannstiel. 'To approach it one must enter it deeply and with effort. Then this work radiates a grandeur which emanates from the most secret and eternal laws of art.'[26]

Modigliani worked hard and purposefully all his life, frail, unsuccessful and unappreciated. He loved and was loved by women; he drank; he experimented with drugs. But that does not define the man. Nor does it

Rose Caryatid (L'Audace) *c.*1913.

explain the lasting impression of his dense body of work, especially since, apart from his voluptuous nudes, he confined himself almost entirely to single figures, painted indoors against an obscure background. In his work he rejected trends of the times and discovered his style in a fusion of the art of the past with his own flowing and inventive line.

His style of painting was inimitable, too personal to attract followers, a language he evolved to express his view of the world as a gallery of individuals: the rogue, the poseur, the dreamer, the lost and the lonely.

Other painters tried to imitate his way of living and failed comically. A natural distinction marked him out; he had no possessions to impress; no influential friends; no wealthy patrons. You accepted him on his own terms or not at all. He was prescient; he saw too much. Although he lived his life as if on a stage, he had such a heightened sensibility to others that his life was inextricably entangled with theirs.

As a painter he triumphed after death and Modigliani's work today graces major museums all over the world. Art lovers crowd Modigliani exhibitions. In the years since he died, mass entertainment, mass advertisement, complex technology threaten to swamp individual human effort. Perhaps that is why we honour Modigliani the man, with his fierce defence of individual freedom and his celebration in paint of the individual psyche.

Notes

Eugenia Modigliani's diary and other family documents, lent to the author by the Modigliani family provided important source material for this book, as well as Jeanne Modigliani's own study of her father, *Modigliani: Man and Myth*, André Deutsch, 1959.

1 – Origins

1. Gérard Philipe starred as Modigliani in a French film entitled *Montparnasse* made in 1962. In August 1988, the New End Theatre, Hampstead staged *Modigliani*, a play by Dennis McIntyre.
2. Drawing of Paul Guillaume, Private Collection, Paris.
3. Jeanne Modigliani, *Modigliani: Man and Myth*, André Deutsch, London, 1959.
4. Ibid.
5. Ibid.
6. Margherita Modigliani, 'Recollections of Modigliani by those who knew him', collected by Frederick S. Wight, *Italian Quarterly*, University of California, Los Angeles, Spring 1958.
7. Jeanne Modigliani, op. cit.
8. Poem by Eugenia Modigliani, lent to the author by Jeanne Modigliani.
9. Umberto Modigliani, in conversation with the author.
10. Jeanne Modigliani, op. cit.
11. Ibid.
12. Ibid.
13. Eugenia Modigliani's diary, July 1898.
14. Jeanne Modigliani, op. cit.
15. Ibid.

16. Silvano Filipelli, 'Testimonianze livornese per Modi', *Rivista di Livorno*, July-August 1956, Livorno.
17. Ibid.
18. Umberto Modigliani in conversation with the author.
19. Jeanne Modigliani, op. cit.
20. Margherita Modigliani, op. cit.
21. Ibid.

2 – *The artist's creed*

1. Jeanne Modigliani, *Modigliani: Man and Myth*, André Deutsch, London, 1959.
2. Margherita Modigliani, 'Recollections of Modigliani by those who knew him', collected by Frederick S. Wight, *Italian Quarterly*, University of California, Los Angeles, Spring 1958.
3. Ibid.
4. Amedeo Modigliani to Oscar Ghiglia, n.d., as quoted in *Cinque lettere giovanili al pittore Oscar Ghiglia*, L'Arte, Turin, May 1930, etc.
5. Ibid.
6. Ibid.
7. Ibid.
8. Ibid.
9. Anthony Rhodes, *The Poet as Superman, a life of Gabriele D'Annunzio*, Weidenfeld & Nicolson, London, 1959.
10. Margherita Modigliani, op. cit.
11. Charles Douglas, *Artist Quarter*, Faber & Faber, London, 1941.
12. Jeanne Modigliani, op. cit.
13. Ugo Ojetti, *Amedeo Modigliani*, Corriere della Sera, Milan, 28 January 1930.
14. Jeanne Modigliani, op. cit.
15. Ardengo Soffici, *Ricordi di Modigliani, Ricordi di Vita Artistica E Litteraria*, Vallechi Editore, Florence, 1942.
16. Elio Zorzi, *Acqua Forte* (includes reminiscences by Fabio Mauroner) Arti grafiche Friulane, 1955.
17. Jeanne Modigliani, op. cit.

3 – The real world

1. André Salmon, *Modigliani: A Memoir*, Jonathan Cape, London, 1961.
2. Charles Douglas, *Artist Quarter*, Faber & Faber, London, 1941.
3. C.R.W. Nevinson, *Paint and Prejudice*, Methuen, London, 1937.
4. André Salmon, op. cit.; Jeanne Modigliani, *Modigliani: Man and Myth*, André Deutsch, London, 1959.
5. Louis Latourettes, *Preface to Modigliani*, Arthur Pfannstiel, Éditions Séheur, Paris, 1928.
6. Ibid.
7. Anselmo Bucci, 'Modigliani dal Vero' *Panorama Dell'Arte Italiania*, Marco Vallsecchi and Umbro Apollonio, Editori Lattes, Turin, 1951.
8. Gino Severini, *Tutta la vita di un pittore*, Cernusco sul Naviglio, Milan, 1946.
9. Ludwig Meidner, 'The Young Modigliani', *Burlington Magazine*, London, May 1943.
10. André Warnod, *Ceux de la Butte*, Rene Juillard, Paris, 1947.
11. Louis Latourettes, op. cit.
12. M. Chwat, in conversation with the author.
13. Fernande Olivier, *Picasso et Ses Amis*, Éditions Stock, Paris, 1933.
14. André Salmon, op. cit.
15. Ludwig Meidner, op. cit.
16. Géo Cim, *Montmartre, mon vieux village*, Grassin, Paris, 1964. (The author wrote the draft of this book before World War I.)
17. Marc Chagall, *My Life*, Peter Owen, London, 1965.
18. Louis Latourettes, op. cit.
19. Catalogue, Salon D'Automne, Paris, 1907.
20. Amedeo Modigliani to Umberto Modigliani, n.d., lent to the author by Umberto Modigliani.
21. Herbert Read, *A Concise History of Modern Painting*, Thames & Hudson, London, 1968.
22. Roger Shattuck, *The Banquet Years*, Faber & Faber, London, 1959.
23. Gino Severini, op. cit.
24. Paul Alexandre, in conversation with the author.
25. André Warnod, *Fils de Montmartre*, Librairie Arthème Fayard, Paris, 1955.
26. Charles Douglas, op. cit.
27. Constantin Brancusi, in conversation with the author.
28. Jeanne Modigliani, op. cit.

4 – Transition

1. Jeanne Modigliani, *Modigliani Sans Légende*, Librairie Grund, Paris, 1961.
2. Jeanne Modigliani, *Modigliani: Man and Myth*, André Deutsch, London, 1959.
3. Paul Alexandre, in conversation with the author.
4. Jeanne Modigliani, *Modigliani: Man and Myth*, op. cit.
5. Alfred Werner, *Modigliani the Sculptor*, Arts Inc., New York, 1962.
6. Carol Mann, *Modigliani*, Thames & Hudson, London, 1980.
7. Jean Cassou, *The Sources of Modern Art*, Thames & Hudson, London, 1962.
8. Giancarlo Vigorelli, *Modigliani e Anna Achmatova, Modigliani a Montparnasse*, Catalogue Galleria D'Arte Moderna e Contemporanea, Verona, Arnoldo Mondadori, Milan, 1988. (Anna Achmatova's recollections of Modigliani were first published outside Russia in *L'Europa Letteraria*, 27 March 1964.)
9. Laure Garsin, in conversation with the author.
10. Gotthard Jedlicka, *Modigliani*, Eugen Rentsch, Zurich, 1953.
11. Alberto Lorenzi, in conversation with the author.
12. Jeanne Modigliani, *Modigliani: Man and Myth*, op. cit.
13. *Correspondance de quatre artistes Portugais avec Robert et Sonia Delaunay*, Presses Universitaire de France, Paris, 1972.
14. Pierre Sichel, *Modigliani*, W.H. Allen, London, 1967.
15. Jacob Epstein, *An Autobiography*, Hulton Press, London, 1955.
16. C.R.W. Nevinson, *Paint and Prejudice*, Methuen, London, 1937.
17. Jacques Lipchitz, *Amedeo Modigliani*, Harry N. Abrams, New York, 1952.
18. Pontus Hulten, *Brancusi Catalogue Raisonné*, Faber & Faber, 1987.
19. Augustus John, *Chiaroscuro*, Jonathan Cape, 1975.
20. Jeanne Modigliani, *Modigliani, Man and Myth*, op. cit.
21. Gotthard Jedlicka, op. cit.

5 – The turbulent years

1. Charles Douglas, *Artist Quarter*, Faber & Faber, London, 1941.
2. Léon Indenbaum, *Modigliani Vivo*, Enzo Maiolino, ed., Fògola Editore, Turin, 1981.
3. Jacob Epstein, *An Autobiography*, Hulton Press, London, 1955.

4. Gustav Coquiot, *Les Independants*, Librairie Óllendorf, Paris, 1920.
5. Marevna, *Life with Painters of La Ruche*, Constable, London, 1972.
6. Léon Indenbaum, in conversation with the author.
7. *Ossip Zadkine Paris-Montparnasse*, February 1930, Special Edition dedicated to Modigliani.
8. Nina Hamnett, *Laughing Torso*, Constable, London, 1932.
9. Ossip Zadkine, op. cit.
10. Pierre Sichel, *Modigliani*, W.H. Allen, London, 1967.
11. Miron Grindea, Editor, *Adam 300*, Adam Books, Curwen Press, London, 1966.
12. Beatrice Hastings, *The New Age*, London, 15 January 1914.
13. Beatrice Hastings writing as Alice Morning, *Impressions of Paris*, 28 May 1914.
14. Ibid, 18 June 1914.
15. Ibid, 16 July 1914.
16. Marevna, op. cit.
17. Beatrice Hastings writing as Alice Morning, *The New Age*, 13 August 1914.
18. André Level, *Souvenirs d'un Collectioneur*, Alain C. Mazo, Paris, 1959.
19. Beatrice Hastings writing as Alice Morning, *The New Age*, London, 27 August 1914.
20. André Salmon, *Modigliani, a Memoir*, Jonathan Cape, London, 1961.
21. Ilya Ehrenburg, *People & Life*, Volume I, MacGibbon & Kee, London, 1961.
22. Beatrice Hastings writing as Alice Morning, *The New Age*, London, 8 October 1914.
23. André Pevre, *Max Jacob Quotidien*, Joske Millas-Martin, Paris, 1976.
24. Ilya Ehrenburg, op. cit.
25. Berthe Weill, *Pan! . . . dans l'Oeil*, Librairie Lipschutz, Paris, 1933.
26. Charles-Albert Cingria, *Aujourd'hui*, No. 65, Lausanne, 26 February 1931.
27. Maurice Vlaminck, *Portraits avant décès*, Flammarion, Paris, 1943.
28. Ilya Ehrenburg, op. cit.
29. Beatrice Hastings writing as Alice Morning, *The New Age*, London, 26 November 1915.
30. Ilya Ehrenburg, op. cit.
31. Beatrice Hastings writing as Alice Morning, *The New Age*, 8 January 1915.

6 – *Will he flower?*

1. Leopold Survage in conversation with author.
2. Ibid.
3. Marie Wassilieff, 'Recollections of Modigliani by those who knew him', collected by Frederick S. Wight, *Italian Quarterly*, University of California, Los Angeles, 1958.
4. Léon Indenbaum, *Modigliani Vivo*, Enzo Maiolino, ed., Fògola Editore, Turin, 1981.
5. Beatrice Hastings writing as Alice Morning, *The New Age*, London, 21 January 1915.
6. Max Jacob to Guillaume Apollinaire, 7 January 1915, *Correspondance de Max Jacob*, Éditions de Paris, Paris, 1955.
7. Beatrice Hastings writing as Alice Morning, *The New Age*, London, 28 January 1915.
8. Katherine Mansfield to John Middleton Murry, 21 March 1915. *The Collected Letters of Katherine Mansfield*, edited by Vincent O'Sullivan and Margaret Scott, Clarendon Press, Oxford, 1984.
9. Ibid, 8–9 May 1915.
10. Miron Grindea, ed., *Adam 300*, Adam Books, Curwen Press, London, 1966.
11. Ibid.
12. Ilya Ehrenburg, *People and Life*, Volume I, MacGibbon & Kee, London, 1961.
13. Marevna, *Life with the Painters of La Ruche*, Constable, London, 1972.
14. Charles Douglas, *Artist Quarter*, London, Faber & Faber, 1941.
15. Gotthard Jedlicka, *Modigliani*, Eugen Rentsch, Zurich, 1953.
16. Paul Guillaume, *Les Arts à Paris*, 1920.
17. Beatrice Hastings writing as Alice Morning, *The New Age*, London, 4 February 1915.
18. Irene Patai, *Encounters, The Life of Jacques Lipchitz*, Funk & Wagnalls Ltd, New York, 1961.
19. Charles-Albert Cingria, *Aujourd'hui*, Lausanne, 26 February 1931.
20. Max Jacob, *La Défense de Tartuffe*, Paris, 1919.
21. Mss 15, Max Jacob Letters, Special Collections, University of Saskatchewan Library, Canada.
22. Chana Orloff in conversation with the author.
23. Chaim Soutine, *Omaggio a Modigliani*, edited by Giovanni Schweiller, Milan, February 1930.
24. Madame Gris in conversation with the author.

25. John Russell, Introduction to the Catalogue of the Arts Council of Great Britain Modigliani Exhibition, Tate Gallery, London, 1963.
26. Gotthard Jedlicka, op. cit.
27. Léon Indenbaum in conversation with the author.
28. Jeanne Modigliani, *Modigliani: Man and Myth*, André Deutsch, London, 1959.

7 – *Towards the intense life*

1. Jean Cocteau to Valentine Gross, 13 August 1916, Francis Steegmuller, *Cocteau*, Macmillan, London, 1970.
2. Ibid.
3. Jacob Epstein, *An Autobiography*, Hulton Press, London, 1955.
4. Jeanne Modigliani, *Modigliani: Man and Myth*, André Deutsch, London, 1959.
5. Jean-Paul Créspelle, *Montparnasse Vivant*, Librairie Hachette, Paris, 1964.
6. Francis Steegmuller, op. cit.
7. The author met Jean Cocteau early in 1957.
8. Roger Shattuck, *The Banquet Years*, Faber & Faber, London, 1959.
9. Robert Motherwell, ed., *The Dada Painters and Poets: An Anthology*, Wittenborn Schulz, New York, 1951.
10. Lunia Czechowska's memoirs in Ambrogio Ceroni's *Modigliani*, Edizione Del Milione, Milan, 1958.
11. Leopold Zborowski, poem, quoted in San Lazzaro's *Modigliani*, Editions du Chêne, Paris, 1953.
12. Lunia Czechowska's memoirs, op. cit.
13. Charles-Albert Cingria, *Aujourd'hui*, No 65. Lausanne, 26 February 1931.
14. Lunia Czechowska, *Modigliani Vivo*, Enzo Maiolino, ed., Fògola Editore, Turin, 1981.
15. Gotthard Jedlicka, *Modigliani*, Eugen Rentsch, Zurich, 1953.
16. Irene Patai, *Encounters, The Life of Jacques Lipchitz*, Funk & Wagnalls, New York, 1961.
17. Ibid.
18. Francis Carco, *L'Ami des Peintres*, Librairie Gallimard, 1953.
19. Chana Orloff, 'Recollections of Modigliani by those who knew him', collected by Frederick S. Wight, *Italian Quarterly*, University of California, Los Angeles, Spring, 1958.

20. Blaise Cendrars, in conversation with the author.
21. Charles Douglas, *Artist Quarter*, Faber & Faber, London, 1941.
22. Ibid.
23. Jeanne Modigliani, op. cit.
24. Carol Mann, *Modigliani*, Thames & Hudson, London, 1981.
25. Max Jacob to Rene Rimbert, 24 July 1923, *Lettres à Rene Rimbert*, Rougerie, Mezières-sur-Issoire, 1983.
26. Maurice Vlaminck, *Portraits avant décès*, Flammarion, Paris, 1943.
27. Francis Carco, op. cit.
28. Ilya Ehrenburg, *People and Life*, Volume I, MacGibbon & Kee, London, 1961.
29. Douglas Cooper, *Fernand Léger et le nouvel espace*, Lund Humphries, London, Edition des Trois Collines, Geneva, Paris, 1949.
30. Ilya Ehrenburg, op. cit.
31. Marie Wassilieff, 'Recollections of Modigliani by those who knew him', collected by Frederick S. Wight, *Italian Quarterly*, University of California, Los Angeles, Spring 1958.
32. Chana Orloff, op. cit.

8 – Jeanne

1. Jeanne Modigliani, *Modigliani: Man and Myth*, André Deutsch, London, 1959.
2. Chana Orloff, 'Recollections of Modigliani by those who knew him', collected by Frederick S. Wight, *Italian Quarterly*, University of California, Los Angeles, Spring 1958.
3. Jean-Paul Créspelle, *Montparnasse Vivant*, Librairie Hachette, Paris, 1962.
4. Ibid.
5. Michel Georges-Michel, *From Renoir to Picasso*, Gollancz, London, 1957.
6. Berthe Weill, *Pan! . . . dans l'Oeil*, Librairie Lipschutz, Paris, 1933.
7. Janet Hobhouse, *The Bride Stripped Bare*, Jonathan Cape, London, 1988.
8. Irene Patai, *Encounters, The Life of Jacques Lipchitz*, Funk & Wagnalls, New York, 1961.
9. William Fifield, *Modigliani*, London, W.H. Allen, 1978.
10. Leopold Survage, in conversation with the author.
11. Pierre Sichel, *Modigliani*, W.H. Allen, London, 1967.
12. Charles Douglas, *Artist Quarter*, Faber & Faber, London, 1941.
13. Modigliani vivo, Enzo Maiolino, ed Fuzola Editore, Turin, 1981.

14. Ibid.
15. Leopold Survage in conversation with the author.
16. Frans Hellens, *Documents Sécrets*, Albin Michel, Paris, 1958.
17. Foujita, 'Recollections of Modigliani by those who knew him', collected by Frederick S. Wight, *Italian Quarterly*, University of California, Los Angeles, Spring, 1958.
18. Pierre Sichel, op. cit.
19. Blaise Cendrars, 'Recollections of Modigliani by those who knew him' collected by Frederick S. Wight, *Italian Quarterly*, University of California, Los Angeles, Spring, 1958.
20. Félicie Cendrars, *Modigliani Vivo*, op. cit.
21. Charles Douglas, op. cit.
22. Félicie Cendrars, *Modigliani Vivo*, op. cit.
23. Gotthard Jedlicka, *Modigliani*, Eugen Rentsch, Zurich, 1953.
24. Jeanne Modigliani, op. cit.
25. Félicie Cendrars to Eugenia Modigliani, 6 February, 1923; Jeanne Modigliani, op. cit.
26. Ibid.
27. Ibid.
28. Ibid.
29. Ibid.
30. Leopold Survage, in conversation with the author.
31. Jeanne Modigliani, op. cit.
32. Ibid.
33. Foujita, 'Recollections of Modigliani by those who knew him', collected by Frederick S. Wight, *Italian Quarterly*, University of California, Los Angeles, Spring 1958.
34. Jeanne Modigliani, op. cit.
35. Ibid.
36. John Russell, Introduction to the Catalogue of the Arts Council Exhibition, Tate Gallery, London, 1963.
37. Jeanne Modigliani, op. cit.
38. Ernest Brummer, *Paris-Montparnasse*, February 1930.
39. Anders Osterlind in conversation with the author.
40. Ibid.
41. Marevna, *Life with the Painters of La Ruche*, Constable, London, 1972.
42. Anders Osterlind, in conversation with the author.

9 – *Life is a gift*

1. Modigliani wrote '*La Vita e un dono dei pochi ai molti de coloro che sanno e che hanno a coloro che non sanno e non hanno*' on his drawing of Lunia Czechowska. The inscription is a misquotation from D'Annunzio's *Convito*, published in 1895.
2. Lunia Czechowska's memoirs in Ambrogio Ceroni's *Modigliani*, Edizione del Milione, Milan, 1958.
3. Marevna, *Life with the Painters of La Ruche*, Constable, London, 1972.
4. Lunia Czechowska's memoirs in Ambrogio Ceroni, op. cit.
5. Paulette Jourdain, *Modigliani Vivo*, edited by Enzo Maiolino, Fògola Editore, Turin, 1981.
6. Modigliani's pledge of marriage, lent to the author by Jeanne Modigliani.
7. Anselmo Bucci, *Modigliani dal Vero*, Panorama Dell'Arte Italiani, Marco Vallsecchi and Umbro Apollonio, Editori Lates, Turin, 1951.
8. Francis Carco, *L'Éventail*, 15 July 1919.
9. *The Burlington Magazine*, September 1919.
10. Osbert Sitwell, *Left Hand, Right Hand*, Macmillan, London, 1945.
11. Jeanne Modigliani, *Modigliani: Man and Myth*, André Deutsch, London, 1959.
12. Ibid.
13. Osbert Sitwell, *Laughter in the Next Room*, Macmillan, London, 1949.
14. Nina Hamnett, *Laughing Torso*, Constable, London, 1931.
15. Lunia Czechowska's memoirs in Ambrogio Ceroni, op. cit.
16. Ibid.
17. Thora Dardel, *I go to Paris*, Bonniers, Stockholm, 1947.
18. Ibid.
19. Jeanne Modigliani, op. cit.
20. *Jeanne Modigliani racconta Modigliani*, Edizione Graphis Arte, Livorno, 1984.
21. Umberto Brunelleschi, 'Rosalie L'ostessa di Modigliani', *L'Illustrazione Italiana*, Milan, September 11, 1932.
22. André Salmon, 'La Vie Passionnée de Modigliani', *L'International du Livre*, Paris, 1957.
23. Jeanne Modigliani, op. cit.
24. Louis Latourettes, preface to Arthur Pfannstiel's *Modigliani*, Édition Séheur, Paris, 1929.
25. Charles Douglas, *Artist Quarter*, Faber & Faber, London, 1941.
26. John Storm, *The Valadon Drama*, Longmans, London, 1959.
27. William Fifield, *Modigliani*, W.H. Allen, London, 1978.

28. Leopold Zborowski to Emmanuele Modigliani, 31 January 1920, in Jeanne Modigliani, op. cit.

29. Ortiz de Zarate, *Paris-Montparnasse*, February, 1930.

30. Chana Orloff, 'Recollections of Modigliani by those who knew him', collected by Frederick S. Wight, *Italian Quarterly*, University of California, Los Angeles, Spring, 1958.

31. Jeanne Modigliani, op. cit.

32. Ibid.

10. – The loss and the legacy

1. Douglas Goldring, *The Nineteen Twenties*, Nicholson & Watson, London, 1945.

2. Francis Carco, *Bohème D'Artiste*, Albin Michel, 1940.

3. Berthe Weill, *Pan! . . . dans l'Oeil*, Librairie Lipschutz, Paris, 1933.

4. Chana Orloff, 'Recollections of Modigliani by those who knew him', collected by Frederick S. Wight, *Italian Quarterly*, University of California, Los Angeles, Spring 1958.

5. Ibid.

6. Paulette Joudain, *Modigliani Vivo*, Enzo Maiolono, ed., Fògola Editore, Turin, 1981.

7. Jeanne Modigliani, *Modigliani: Man and Myth*, André Deutsch, London, 1959.

8. Pierre Sichel, *Modigliani*, W.H. Allen, London, 1978.

9. Francis Carco, *L'Événement*, Paris, 29 January 1920.

10. Charles-Albert Cingria, Preface to the Catalogue of the Modigliani Exhibition, Kunsthalle, Basle, 1943.

11. Man Ray, *Self Portrait*, Bloomsbury, London, 1988.

12. Margherita Modigliani, 'Recollections of Modigliani by those who knew him' collected by Frederick S. Wight, *Italian Quarterly*, University of California, Los Angeles, Spring 1958.

13. Jeanne Modigliani, *Modigliani sans Légende*, Librairie Grund, Paris, 1961.

14. Jeanne Modigliani, *Modigliani: Man and Myth*, op. cit.

15. Ibid.

16. Jeanne Modigliani, *Modigliani sans Légende*, op. cit.

17. C.R.W. Nevison, *Paint and Prejudice*, Methuen, London, 1937.

18. Lionel Venturi, *La Collection d'Art Moderne de M. Gualino et la Salle Modigliani*, Formes, Paris, July 1930.

19. Giovanni Schweiller, ed., *Omaggio a Modigliani*, Milan, January 1930.

20. Michel Georges-Michel, Les Montparnos, Fasquelle Editeurs, Paris 1929.
21. Bernard Borchert, *Modigliani*, Faber & Faber, London, 1960.
22. Gustave Coquiot, *Des Peintres Maudits*, André Delpeuch, Paris, 1924.
23. Henri Lormian, *Modigliani et sa légende*, Beaux Arts, Paris, 12 January 1934.
24. Walter Sickert, Introduction to a Modigliani Exhibition, Tooth's Gallery, London, 1926.
25. John Russell, Introduction to Arts Council Modigliani Exhibition, Tate Gallery, London, 1963.
26. Arthur Pfannstiel, *Modigliani*, Éditions Séheur, Paris, 1929.

Select Bibliography

CARADEC, FRANCOIS, *Isidore Ducasse, Comte de Lautréamont*, Editions de la Table Ronde, Paris, 1970.

CARCO, FRANCIS, *De Montmartre au Quartier Latin*, Albin Michel, Paris, 1927.

— *Bohème d'Artiste*, Albin Michel, Paris, 1940.

— *L'Ami des Peintres*, Gallimard, Paris, 1953.

CASSOU, JEAN, *The Sources of Modern Art*, Thames & Hudson, London, 1962.

CASTIEAU-BARRIELLE, THÉRÈSE, *Modigliani*, A.C.R., Paris, 1987.

CERONI, AMBROGIO, *Amedeo Modigliani* (including a memoir by Louis Lunia Czechowska), Edizione del Milione, Milan, 1958.

CIM, GÉO, *Montmartre mon vieux Village*, Grassin, Paris, 1964.

CRESPELLE, JEAN-PAUL, *Montparnasse Vivant*, Hachette, Paris, 1962.

DOUGLAS, CHARLES, *Artist Quarter*, Faber & Faber, London, 1941.

EPSTEIN, JACOB, *An Autobiography*, Hulton Press, London, 1955.

FIFIELD, WILLIAM, *Modigliani*, W.H. Allen, London, 1978.

GEORGES-MICHEL, MICHEL, *Les Montparnos*, Fasquelle, Paris, 1929.

— *From Renoir to Picasso*, Gollancz, London, 1957.

HAMNETT, NINA, *Laughing Torso*, Constable, London, 1932.

HOBHOUSE, JANET, *The Bride Stripped Bare*, Jonathan Cape, London, 1988.

JACOB, MAX, *La Défence de Tartufe*, Société Litteraire de France, Paris, 1919.

— *Correspondance de Max Jacob* Edited by P. Garnier, Éditions de Paris, Paris, 1953.

— *Lettres à Rene Rimbert*, Rougerie, Mézières-sur-Issoire, 1983.

JEDLICKA, GOTTHARD, *Modigliani*, Eugen Rentsch, Zurich, 1953.

JOHN, AUGUSTUS, *Chiaroscuro*, Jonathan Cape, London, 1952.

LIPSCHITZ, JACQUES, *Modigliani*, Collins, London, 1955.

LANTHEMANN, JACQUES, *Catalogue Raisonné*, Barcelona, 1970.

MANN, CAROL, *Modigliani*, Thames & Hudson, London, 1980.

MAIOLINO, ENZO, Ed., *Modigliani Vivo*, Fogola Editore, Turin, 1981.

MANSFIELD, KATHLEEN, *Collected Letters*, Edited by Vincent O'Sullivan and Margaret Scott, Clarendon Press, Oxford, 1984.

MODIGLIANI, JEANNE, *Modigliani: Man and Myth*, André Deutsch, London, 1959.

NEVINSON, C.R.W., *Paint and Prejudice*, Methuen, London, 1937.

PATAI, IRENE, *Encounters, The Life of Jacques Lipchitz*, Funk & Wagnalls, New York, 1961.

PFFANSTIEL, ARTHUR, *Modigliani*, Preface by Louis Latourettes, Éditions Séheur, Paris, 1929.

RAY, MAN, *Self Portrait*, Bloomsbury, London, 1988.

READ, HERBERT, *A Concise History of Modern Painting*, Thames & Hudson, London, 1959.

ROY, CLAUDE, *Modigliani*, Skira, Paris, 1958.

RHODES, ANTHONY, *The Poet as Superman, a life of Gabriele D'Annunzio*, Weidenfeld & Nicholson, London, 1959.

RUSSOLI, FRANCO, *Modigliani*, Thames & Hudson, London, 1959.

SALMON, ANDRÉ, *Modigliani, a Memoir*, Jonathan Cape, London, 1961.

SAN LAZZARO, G., *Modigliani*, Editions du Chêne, Paris, 1953.

SCHWEILLER, GIOVANNI, *Modigliani*, Chronique du Jour, Paris, 1928.

SELVER, PAUL, *Orage and the New Age*, Allen & Unwin, London, 1959.

SEVERINI, GINO, *Tutti la Vita d'un pittore*, Cernusco sul Naviglio, Milan, 1946.

SICHEL, PIERRE, *Modigliani*, W.H. Allen, London, 1967.

SITWELL, OSBERT, *Left Hand, Right Hand*, Macmillan, London, 1945
— *Laughter in the Next Room*, Macmillan, London, 1949.

STORM, JOHN, *The Valadon Drama*, Longmans, London, 1959.

VLAMINCK, MAURICE, *Portraits avant décès*, Flammarion, Paris, 1943.

WARNOD, ANDRÉ, *Les Berceaux de la Jeune Peinture*, Albin Michel, Paris, 1926.

WERNER, ALFRED, *Modigliani the Sculptor*, Arts Inc., New York, 1962.

ZADKINE, OSSIP, *Le Maillet et le Ciseau*, Albin Michel, Paris, 1968.

Selected Catalogues, Booklets, Newspapers and Periodicals.

LOS ANGELES COUNTY MUSEUM, BOSTON FINE ARTS MUSEUM, *Modigliani, Paintings and Drawings*, Foreword by William S. Lieberman, Introduction by Frederick S. Wight, University of California, 1961.

TATE GALLERY, *Modigliani Arts Council Exhibition*, Introduction by John Russell, 1963.

PALACE DES BEAUX ARTS, *Modigliani Retrospective Exhibition*, Preface by Maud Dale, Brussels, 1933.

GREY, ROCH, *Modigliani*, Action, Paris, December 6, 1920.

GRINDEA, M. Ed., *Adam 300*, Adam Books, Curwen Press, 1966.

MEIDNER, LUDWIG, *The Young Modigliani*, London, Burlington Magazine, May 1943.

OJETTI, UGO, *Amedeo Modigliani*, Corriere della Sèra, Milan, January 29, 1930.

ORAGE, ALFRED, Ed., *The New Age Files, 1910–1920*, Paris-Montparnasse, Special issue devoted to Modigliani, Paris, February 1930.

SCHWEILLER, GIOVANNI, Ed., *Omaggio a Modigliani*, Printed in Milan on the tenth anniversary of Modigliani's death.

SOBY, JAMES, *Modigliani*, New York, The Museum of Modern Art, 1951.

WERNER, ALFRED, *The Life and Art of Amedeo Modigliani*, Commentary, New York, May 1953.

Index

in exhaustibly
kind + patient